HELMAND

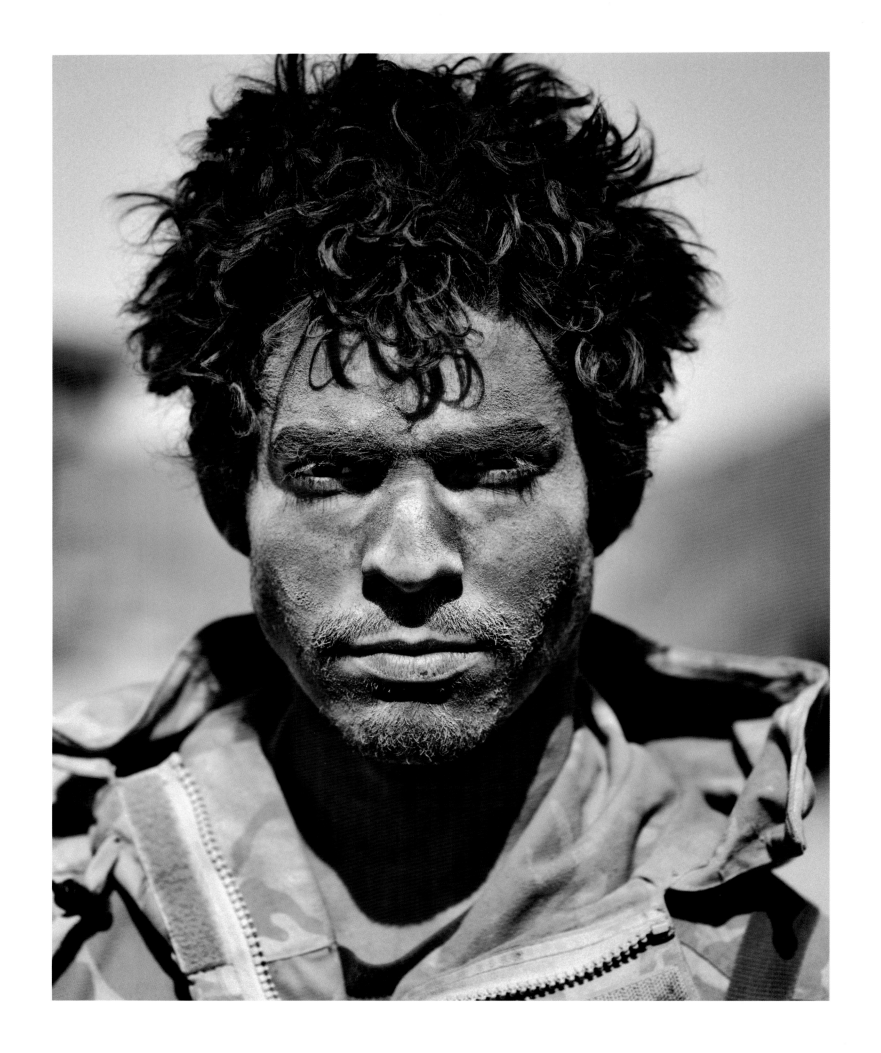

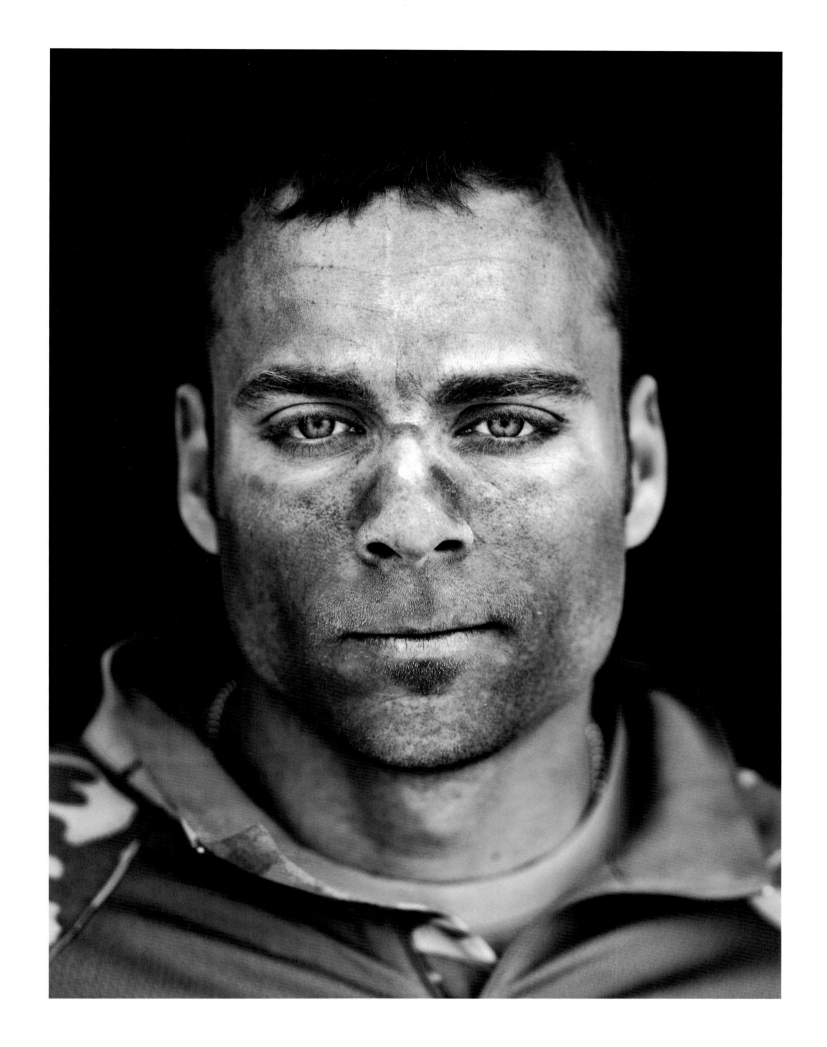

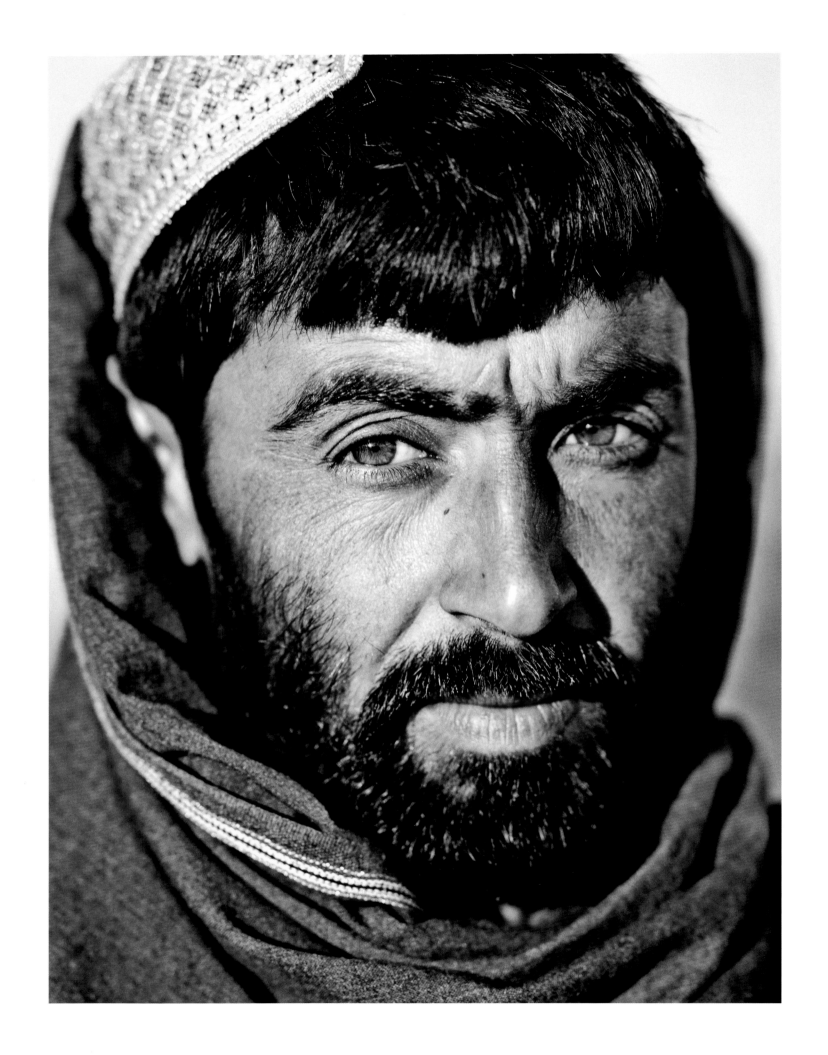

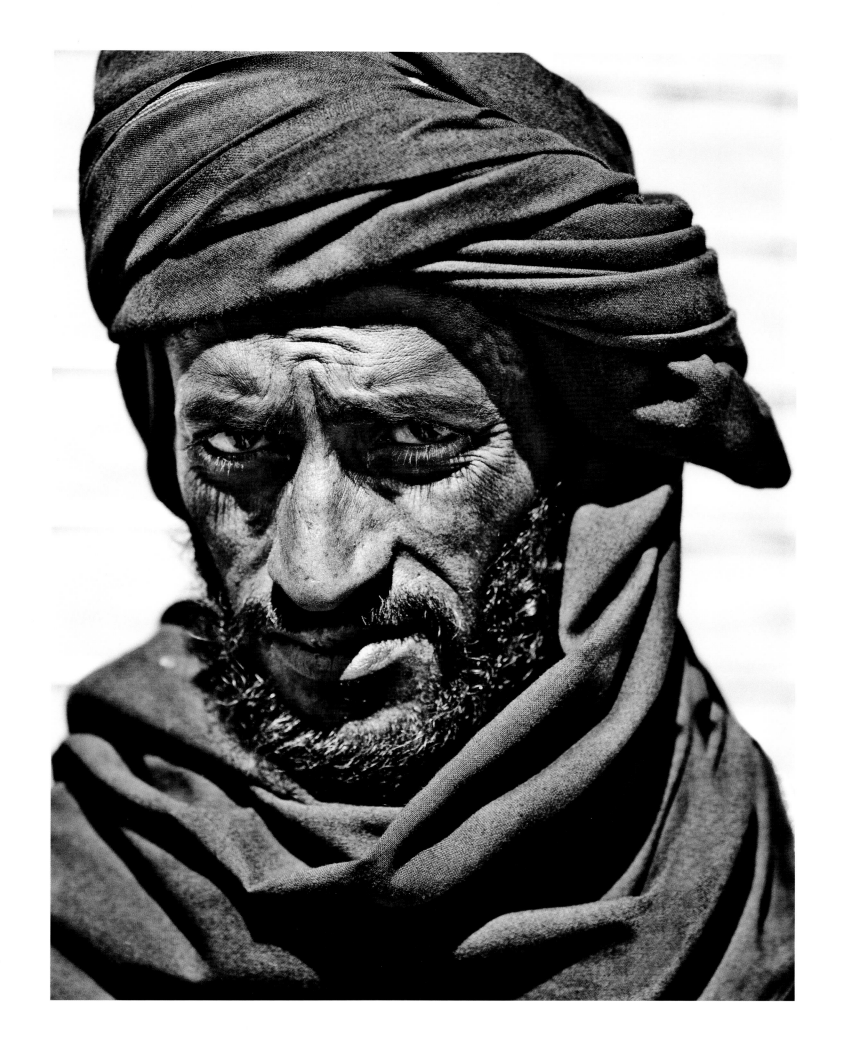

HELMAND

ROBERT WILSON

JONATHAN CAPE LONDON

INTRODUCTION
BRIGADIER ANDREW MACKAY

Guerrilla warfare has been a part of conflict since societies first began forming. Indeed Sun Tzu, the Chinese military theorist, sketched out some of the enduring principles of guerrilla warfare in his work *The Art of War* in 400 BC. The term 'guerrilla' is Spanish in origin and means 'little war'. As a military tactic the practice of guerrilla warfare was largely one of common sense. At its heart were largely military methodologies that allowed a minority (the weak) to take on and fight the majority (the strong). Critically it was often the response of the strong rather than that of the weak that set the parameters for success or defeat. The strong were invariably required to confront a modus operandi that was unconventional in nature, unanticipated or whose effect was underestimated. More often than not conventional orthodoxy would have to be addressed and changed, often in the midst of a struggle, if the weak were to be repelled, subdued or defeated.

As nations developed, became recognisable states and established territorial identities, so the guerrilla imbued his campaign with revolutionary fervour that addressed political doctrine, social and economic elements. In guerrilla warfare the population is the prize that both the insurgent and the counter-insurgent seek. For this reason there has always been particular emphasis on the role of propaganda, psychological operations and information operations, as they are integral components of a guerrilla campaign. The advent of the Internet, global communications and rapid urbanisation has served to increase the potency and ability of both the insurgent and counter-insurgent to deliver a 'message' to a worldwide audience. Both are seeking to influence (positive, benign and negative messages all have a role) a wide audience. In the aftermath of the Second World War and as the grip of the Cold War strengthened, a major shift in guerrilla warfare occurred. A number of 'little wars' were fought, more often than not sponsored by the key protagonists in the Cold War. The clash of political ideologies led to guerrilla warfare adopting a predominantly revolutionary hue and the insurgent and his opponent the counter-insurgent entered everyday language.

Inherently political in nature, insurgencies have at their heart a struggle to coerce and control an indigenous population sufficiently well to allow the insurgent to gain power, to gain authority, to exercise his will. Insurgencies invariably start small and gather momentum, provided the population supports the insurgent and allows him to gain mass. And such is the stuff of successful insurgencies. Ranged against the insurgent is the counter-insurgent, who may represent the government or the authority that the insurgent is trying to remove. The counter-insurgent can be indigenous to the country or can be outside powers seeking to ensure the insurgent fails in his ambition. Sometimes the insurgent only manifests himself when his land has been occupied by an invading power. If war is a continuation of politics by another means, then insurgency represents the point at which politics, military intent and the population – or, more widely, societies – coalesce. Insurgency represents war amongst the people.

Strip away the politics, the strategic purpose, the operational design, the clash of military machinery, and insurgency and its bedfellow – counter-insurgency – are fundamentally about individuals in often epic struggles of will, ideals and ideology. It is, more often than not, those that have the strength of purpose to continue, often against overwhelming odds, that succeed. Those who persevere, endure setbacks, regenerate, adapt, plan for the long term, maintain patience, who influence, who never give up, are those who win out. Uniquely these characteristics apply as much to the insurgent as they do to the counter-insurgent. Each adapts to the other, each learns from the other and each seeks to outwit and defeat the other.

In the midst of the fury, the chaos, the friction and the complexity of counter-insurgency are people, not machines. They are the tools (the means) of the institutions, forces and departments that make up the organisations that conduct insurgency or counter-insurgency and the means by which the policy, strategy, plans, tactics and

objectives are delivered. Be it the ragged, poorly equipped insurgent or the trained, well-equipped counter-insurgent they are the means of implementation, the deliverer of outcomes, the link between success or failure. And for these reasons the general population becomes the key element, whose consent, often unknowingly, becomes the battleground. The population finds itself in the midst of these competing forces for whom the population is the centre of gravity. For successful counter-insurgents the requirement is to be population- not enemy-focused yet at the same time to seek to destroy the insurgent without killing the innocent. It is a devilishly difficult and complex process. In modern insurgencies the counter-insurgent is also expected – or required – to conduct his battles within the rule of law, to obey strict rules of engagement, to seek absolutely to limit collateral damage, to provide assistance and medical care to wounded insurgents, to imprison them humanely. The insurgent, however, operates outside the norms of western liberal democracy yet is globally networked, willingly outsources terrorist activity and is adept at news management and the business of getting a clear, coherent message across. The message is indeed the medium. A modern insurgent also utilises indiscriminate killing as a means towards an end and taps into the globalisation of organised crime that has accompanied the growth and globalisation of markets. For both insurgent and counter-insurgent the population is indeed that most precious of prizes.

If insurgency at the point of conflict is fundamentally about human endeavour and the human spirit then it is also, by extension, about willingness to endure sacrifice, live with austerity and hardship, put up with failures, live with setbacks or celebrate success – in whatever form it appears. It involves patience, for insurgencies are not defeated in years but decades. It requires application, adaptation and constant innovation from those individuals involved in the conduct of the fight. Successful counter-insurgencies are invariably conducted by those who militarily are able to get the balance, be it kinetic or non-kinetic, or the application of resources right. More often than not it is those armies or cross-government institutions that constantly adapt – sometimes radically – who eventually succeed. In doing so they become 'learning organisations' that rapidly identify mistakes, acknowledge them, adjust training regimes and seek to apply the right resources to the 'adapted' solution. Because so much is dependent on the human dynamic and the skills and experience of individuals, considerable time is spent on identifying who they are, what made them successful and how individual success can be replicated, encouraged or improved.

Fundamentally, successful counter-insurgency requires clear political end-states, the will to succeed and moral authority. Ambiguity of strategy, competitive rather than creative tension between inter-governmental departments, discord amongst allies, poor multinational organisational structures all serve to undermine clarity of purpose and unity of command. There are no absolute military solutions to counter-insurgency, only inexact political ones. And getting all of this right is no easy thing. To enter the world of successful counter-insurgency requires acceptance of continual and rapid change as tactics are modified, organisations reorganised, technology absorbed, public support buttressed and attended to. Few insurgencies last the lifetime of the government of the counter-insurgent. Democracy sees to that. So policies shift, the political dynamic changes, good ideas are abandoned, bad ones put in place, better policies adopted, poor policies rejected. Changes to approach are managed to avoid irrelevancy, irrelevancy is maintained to avoid change. Under the pressure of seemingly obscure and competing demands, one can often forget how implementation at the sharp end is conducted, what it takes to get anything at all done in complex, unforgiving environments with populations who seem ungrateful, hostile, belligerent and afraid. Success in conducting counter-insurgency is often less to do with getting what you want but wanting what you've got. That way at least you plan and execute with the certainty of available resources rather than wait for resources to be more certain before you plan and execute. Crucially it makes you more innovative, proactive and adaptable. This is an important consideration for the individual fighting at the coalface. Modern counter-insurgency constantly seeks to devolve tactical responsibility downwards, in order that commanders and individuals can be

empowered. It is they, after all, who are in daily contact with the population, the environment and the enemy. At this level decentralisation is the key because people are the means of delivery.

Critically no two insurgencies are the same. Each is unique in its scope, design, impact and consequence. In Afghanistan the insurgency is unique in that the insurgent was formerly the government (although the term government is probably inappropriate for the former Taliban regime). This is very rare – it may even be a first – but it does mean that there is a population in Afghanistan that can vividly recall the brutality and excesses of the Taliban. It is not often in an insurgency that fifteen-year-olds can remember not being able to fly a kite, listen to music or, if they are female, be denied an education.

If counter-insurgency as a form of warfare has at its heart people, what is the role of, the demands on, and the actuality of life as a soldier – the counter-insurgent – in these circumstances? What are the soldiers in the vivid, brilliant, mesmerising images of this book doing in the harsh, uncompromising environment of Helmand? What are they enduring daily, what efforts are being undertaken on an hourly, daily basis, to make those unsteady progressive steps in countering the insurgent?

When 52 Brigade were warned in the autumn of 2006 that they would be the Brigade HQ around which the Helmand Task Force would be organised, it was, to say the least, a surprise. 52 Brigade had not conducted an operational role since the Second World War, and from its vantage point of Edinburgh Castle had been focused on regional issues in Scotland and on the units under its command. The story of how the Brigade assembled the Task Force, converted itself into an operational brigade, trained itself and the wider Task Force, deployed and fought as part of the counter-insurgency against the Taliban insurgency will be told elsewhere, but the story of those who fought can be told here by capturing the very essence of those individuals. It was reputedly Orwell who noted that 'people sleep peaceably in their beds at night only because rough men stand ready to do violence on their behalf'. These are those individuals. Words are not necessary such is the intensity and instant familiarisation that the images in this book engender. But what lies behind these extraordinary images? The subjects of these photographs should first and foremost be viewed not as soldiers but as husbands, wives, mothers, fathers, brothers, sisters, sons, daughters, aunts, uncles, nephews, nieces, cousins. Only then should they be viewed as soldiers, fighting men, commanders, warriors, officers and combatants. Why? The former category ensures that kith, kin and lives led are the factors that are remembered, the latter ensures that the means, the ends, the results are enshrined. In these images we seek to bring out the human dynamic of those people who have experienced the hardship, the austerity, the danger and who are, by extension, the representatives of those who came before them and those who will come after them. The eventual outcome of the insurgency in Afghanistan is uncertain and known to no one. All counter-insurgencies are a mass of uncertainties, contradictions and seemingly frequent tipping points that favour one side or the other. The people, landscape and images that have been captured by the 52 Brigade war artist Robert Wilson in this magnificent book are all in the conflict eco-system that makes up a complex counter-insurgency. The effects are etched onto rock, desert, clothing and faces. The results imprinted in the textures, colours, moods and grain of Robert Wilson's superb studies. As the commander of the Helmand Task Force I could not have asked more of a war artist. Indeed for those members of the British Army who have served in Helmand I hope the images represent and provide a lasting legacy of the extraordinary experience you undertook.

WAR THROUGH A LENS
MARK HOLBORN

The limits of the known or conquered world were once distant views across oceans and deserts. The skyline was the frontier. Pictures of the far-off worlds of Egypt, India and China reached nineteenth-century homes to be admired in albums of richly toned prints opened on mahogany library tables. Photography was born in the century when the Empire was at its height. Just as explorers planted flags on remote soil to signify their conquest or possession, fragile photographic plates were carried the length of the Empire, transported over steep mountain passes and even, for the first time, brought back from the battlefield.

When the photographer Roger Fenton and his assistant Marcus Sparling joined the expedition to the Crimea in February 1855, war was in some regards a spectacle. Officers' wives were to join the party and picnics were held on the heights above the action. Cavalry moved with the panache and discipline of the parade ground. Uniforms were gorgeous. Fenton's photographs were later to be transformed into engravings, the popular illustrative medium.

Fenton's subjects were not heroic or even glamorous, though he observed the senior staff and witnessed a council of war between Lord Raglan, Omar Pasha and Marshal Pélissier. The Marshal did pose for him astride his white horse. The overriding impression from the photographs is of the ordinariness of camp life, of figures sat outside their campaign tents, of ordnance lying stacked in the chaos of the Balaklava harbour front, of desolate terrain scarred by artillery batteries and of the tents in rows on the plateau before Sebastopol. The cannonball resting beneath the elegant boot of Lieutenant-General Sir Henry William Barnard in Fenton's portrait was enormous.

On April 23 Fenton ventured with his van drawn by two mules into a ravine that lay in the direct line of fire of three Russian batteries. He noted in his diary entry for that afternoon that in a lull in the firing he felt confident enough to set up his camera. When firing resumed he moved back a hundred yards and a further shot rolled to a halt at his feet. He recorded that he made two photographs in the space of an hour and a half before returning with a cannonball as a trophy. The two photographs have been the subject of recent debate. In one scene the main track is scattered with the cannonballs and in the other they lie mainly in a ditch to the side. The obvious inference is that Fenton arranged them to make a stronger picture. By this simple shifting of the evidence Fenton had created the first great photograph of war. Its power lies not in what it describes, but in what it implies. There are no human forms and no trail of blood. The picture plants in one's mind what the physical consequences might have been if one had advanced into such cannon fire. In its early years photography had been regarded as the medium of fact and truth. The camera obscura was even said to have reproduced reality itself. Despite the veracity of the medium, Fenton's photograph was a fiction. He returned to England with over three hundred negatives and the photographs were exhibited in London and Paris, but after the imaginary heat of battle depicted in historical painting, Fenton's evidence of war was sober.

Photographers with their large cameras and tripods came in Fenton's wake, following military action across the Empire. They recorded the debris after the battle, sometimes with great power and poignancy. In 1858 Felice Beato recorded the aftermath of the Indian Mutiny. He was at Lucknow after the siege and photographed the bones of the rebels in front of the pitted walls of the palace. Two years later Beato was with the Anglo-French invaders advancing to Peking, where they were to sack the Old Summer Palace, Yuan-ming Yuan. He photographed the Taku forts that lay in the path of the invaders after their walls had been scaled and the defenders killed. These were unsparing pictures of the dead. In the 1860s the American Civil War was fully chronicled by teams of photographers, most notably first under Matthew Brady and after 1863 by Alexander Gardner, who, in contrast to Brady, credited his photographers. Gardner's achievement was the publication in two volumes of his *Photographic Sketch Book of the War* in 1866. Each volume contained fifty albumen prints. One of the most frequently reproduced pictures was

that of the body of a dead sharpshooter at Gettysburg from 1863. In addition to images of the fallen, photographers could present the landscape of war. One of Brady's most memorable images is the silhouette of the blasted flour mills at Richmond, Virginia from 1865. There is an undeniable aesthetic to the photograph that makes it all the more memorable. Just as the war cut a trail of human devastation that was to mark America for generations, its destructive power left ruins that were stark, mysterious and attractive to the photographer.

Photojournalism was born with the development of the small hand-held camera. The rise of the photographically illustrated magazines in interwar Germany coincided with the invention of the Leica. The challenge for the modern photographer was to get close. Proximity was a virtue. Robert Capa's photograph of the Loyalist soldier at the moment of his death near Cerro Muriano on the Cordova front in September 1936 brought the viewer as close as an outstretched arm. The early cameras had been dependent on long, loosely estimated exposures. The hand-held camera dealt in fractions of a second — in the actual second of another's death. Capa epitomised the modern combat photographer and his example was followed by those who came after him — Eugene Smith, Larry Burrows and Don McCullin, to name but a few. During the Vietnam War colour film added a further dimension, which Burrows, in particular, used with great invention and skill. The photographic coverage of the war, coupled with the daily television reports, contributed greatly to the domestic rejection of US foreign policy. Photographs ultimately revealed the war to be untenable. The power of the photograph at a time of conflict was in effect acknowledged when McCullin, in every sense the most qualified photographer, was later refused permission to go to the Falklands.

By the time of the first Gulf War the magazine world that had once sent Burrows and McCullin on assignments had changed. The picture story was dying. Editorial priorities had shifted. *Life* magazine had folded as a weekly. Photographers too had changed. The publication in 1983 of *Telex Iran,* a photographic account of the Iranian revolution by Gilles Peress, coupled his coverage of events with his own communications from Tehran, so creating a commentary on the process of reporting as on the subjects of his pictures. The following year Sophie Ristelhueber documented the shell-scarred city of Beirut. In her book *Beirut* (1983) there is not a single human figure save for the outline of a bullet-ridden sculpture on the cover. To see the city seemingly devoid of inhabitants is chilling. The absence of human figures only underscores the human cost. Whereas in Fenton's day the photographic language was metaphorical by necessity, here the imagery had become metaphorical by choice. So strong were the images of the destruction of the city, and so great was the loss for its inhabitants, that a further photographic project with a number of celebrated photographers including Josef Koudelka and Robert Frank was launched in the ruins of Beirut in 1991. It should be noted that McCullin was working in the midst of the Lebanese Civil War. Some of his most terrifying pictures were made in Beirut at the height of the fighting in 1976 and 1982 and were published extensively in magazines before appearing in books. But as Brady had demonstrated at Richmond, ruins are photogenic. Cecil Beaton said as much in the rubble of the Blitz.

Sophie Ristelhueber's *Aftermath* (1992), her book about Kuwait in 1991, opened with a view of discarded artillery cases in the sand, an echo of Fenton's cannonball motif. With the exception of a few similar images of debris, the book shows a ravaged landscape seen from above. Her views are almost entirely horizonless. In contrast to the nineteenth-century view from the fixed point above a tripod, her view was from a point in motion looking down on the patterns of tracks in the sand. The imagery was as abstract as those sequences frequently shown on television at the time in which the target is caught in the cross-wires before the pilot pushes the button. A puff of smoke then appears on the screen. As war becomes increasingly abstract, detachment from the consequences of action only deepens.

The renewed war in Afghanistan further reinforces a sense of the cyclical nature of history. The physical demands of the terrain are as great in the twenty-first century as they were in the nineteenth. Afghanistan existed on the fringes of the Empire as tribally controlled badlands. The geography is unaltered. From the west you enter across the deserts of Iran. From Peshawar to the east you cross the Khyber Pass to Jalalabad and on to Kabul, set on a great plain beneath surrounding mountains. To the north lie the high valleys and remote tracks through the Hindu Kush where pilgrims once wandered on their way to Bamiyan or merchants headed for the traffic on the Silk Route. To the south is Kandahar and the deserts beyond. Helmand is in the beyond. The British garrison in Kabul was methodically slaughtered as it struggled unsuccessfully back along the road to Jalalabad in 1842. Afghanistan offers perfect terrains for an ambush. The Canadian artist, Jeff Wall, working on an enormous lightbox panel, produced a hallucinatory vision of the aftermath of the ambush in an epic tableau called *Dead Troops Talk (a vision after an ambush of a Red Army patrol, near Moqor, Afghanistan, winter 1986)*, (1992). The power of this photographic reinvention of an historical event was in no way diminished by its artifice.

In 2002 the Imperial War Museum commissioned Paul Seawright to photograph in Afghanistan. He too found discarded shell cases in a dusty, almost monochrome ravine that seems to explicitly refer back to Fenton's valley. He made markedly unspectacular pictures of the landscape. In his brief survey of the country in the wake of war, he was helped by several organisations, including a landmine action group. The implicit danger in Seawright's landscapes was in what lay beneath their surfaces. What was concealed was every bit as significant as what was revealed. Marina Warner, the chairman of the museum's commissioning board, noted that 'the impressive body of work shown here reflects — and helps us reflect — on matters beyond appearance'. This was photography of implication as much as it was photographic description.

Robert Wilson went to Helmand at the invitation of the commander of the British 52 Brigade who were about to complete a six-month tour of duty. He was invited as an artist, as distinct from a photojournalist who is assigned to cover a war. His background was that of a commercial photographer and the formality of the large camera and tripod were part of his customary mode of operation. He arrived with a Canon, the standard camera used on foreign assignments, and a Hasselblad with a Phase One back that could hold the largest possible digital files. This equipment could be used to make photographs on the scale of a billboard. It offers extraordinary detail and indeed in the details of his pictures lie their revelations.

He photographed the daily round of life behind the perimeter walls of the bases. As with Fenton in the Crimea there is a similar sense of the mundane. Meals are prepared, some Gurhkas play table tennis, a jigsaw puzzle is assembled. The ordnance is stored in preparation. The single most distinguishing element is the computer presence. This is a laptop war.

The view of the distant horizon observed by weary men crossing inhospitable lands has been replaced by the satellite view from above. The world has now been mapped from space. This is the time of the robotic probe and the drone — artefacts of the digital age — guided by a man with a computer. To work to the limits of possible information provided on a digital file is a logical response. Here we see a view of a war in motion, yet we see no bodies, save one in a flag-draped coffin. The visual language is that of a symbolism as loaded in implication as those cannonballs in Fenton's ravine a century and a half ago.

At the centre of this work stands a group of portraits, Robert Wilson's greatest accomplishment. With all the virtuosity at his fingertips and the equipment at his disposal he has answered with a kind of truth that redeems human values over the abstractions of the machinery of war and over the rhetoric of politicians who dispatch the armies. One of his subjects was nervous before the camera — there was incoming fire punctuating the day and to pose for a photograph was leaving him vulnerable. His subjects are characterised by signs of vulnerability, as they are by their resilience or by their sense of command. The most impressive picture shows us men returning after three weeks on patrol. Their hair is matted, their skin burnt. Wilson pointed his camera, not up from below to give that heroic shot so loved by propagandists, but level with his subjects, head on, straight into their exhausted eyes. Every line that marks their faces is exposed, making them both tender and monumental.

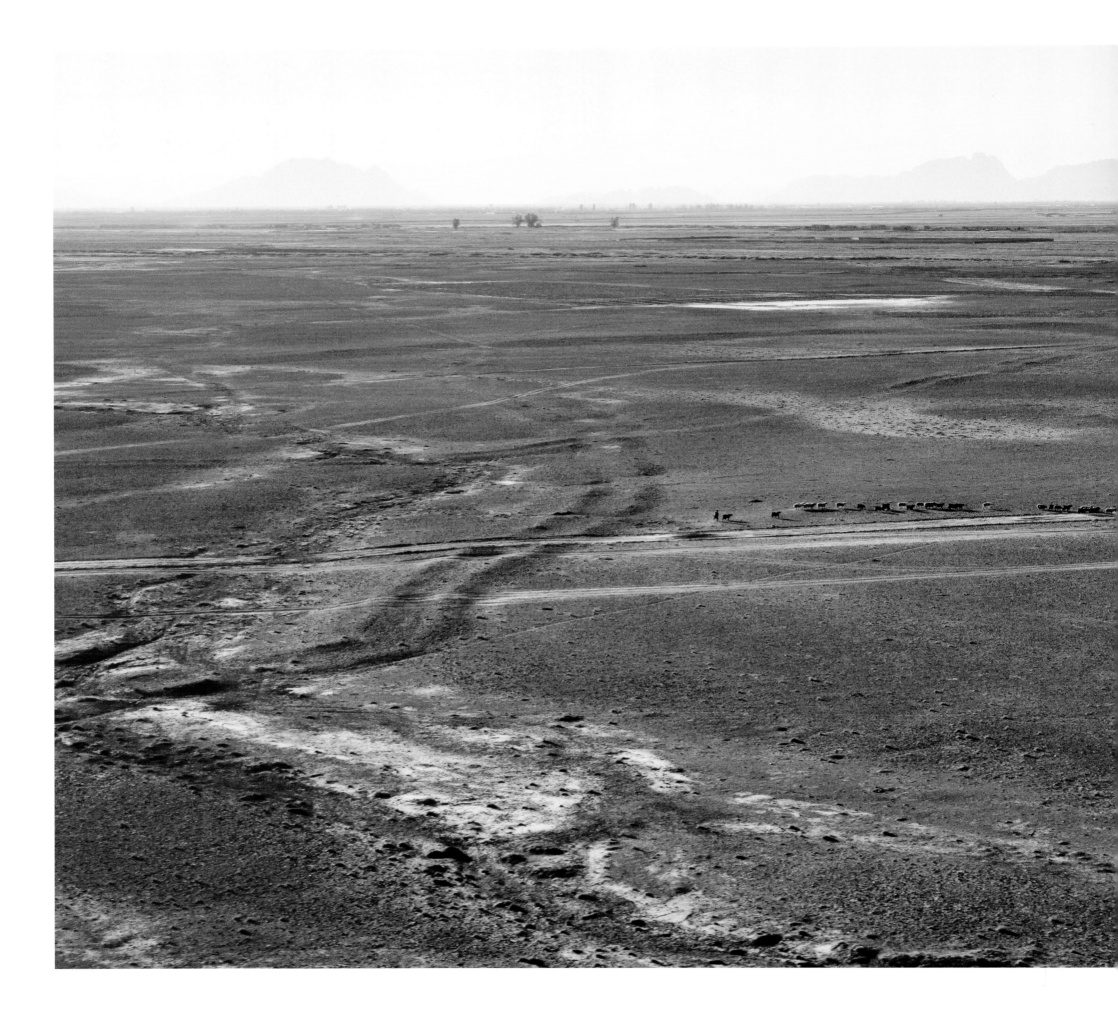

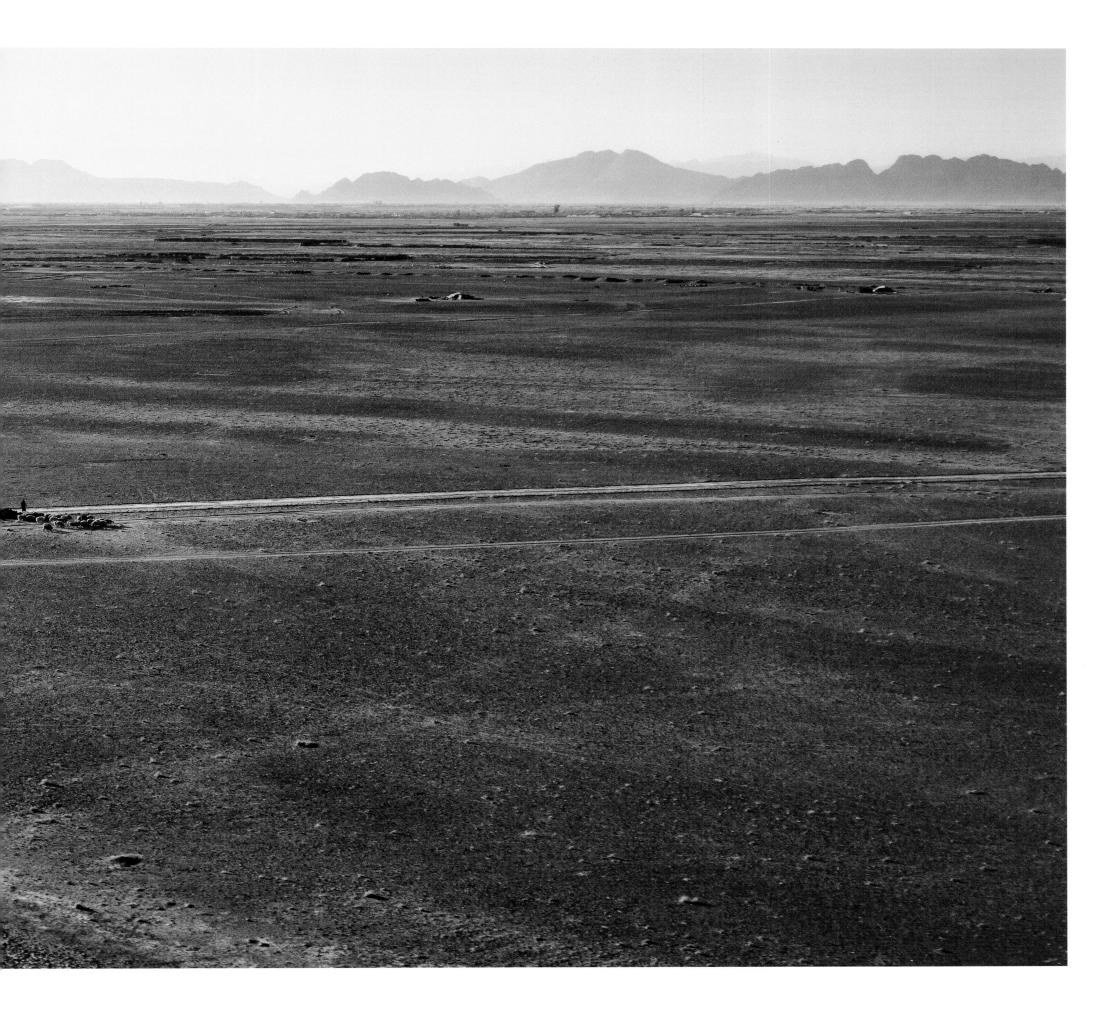

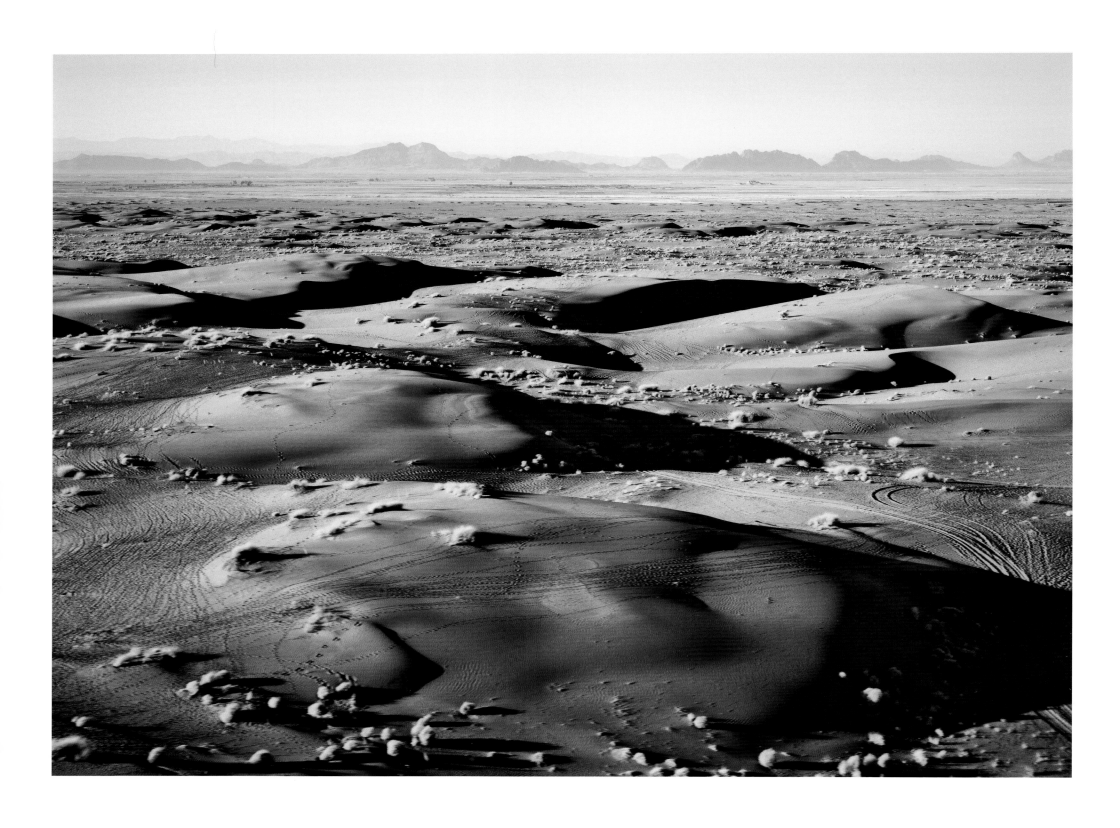

Flight to Kandahar

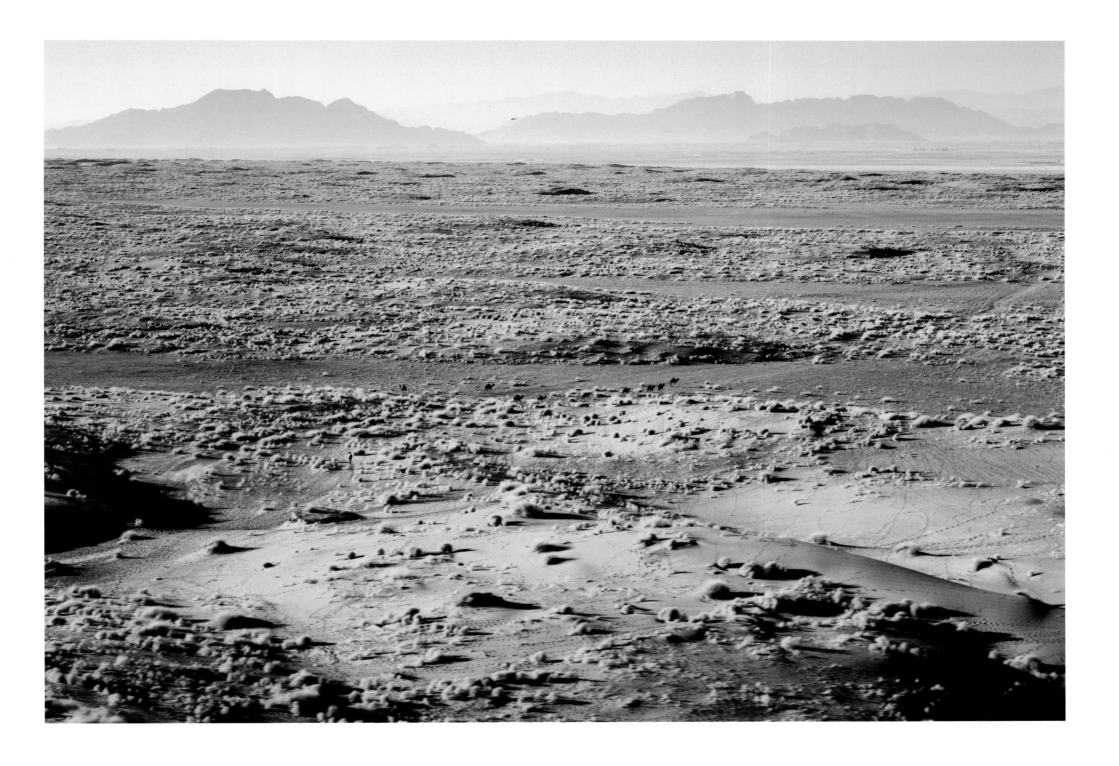

Flight to Kandahar

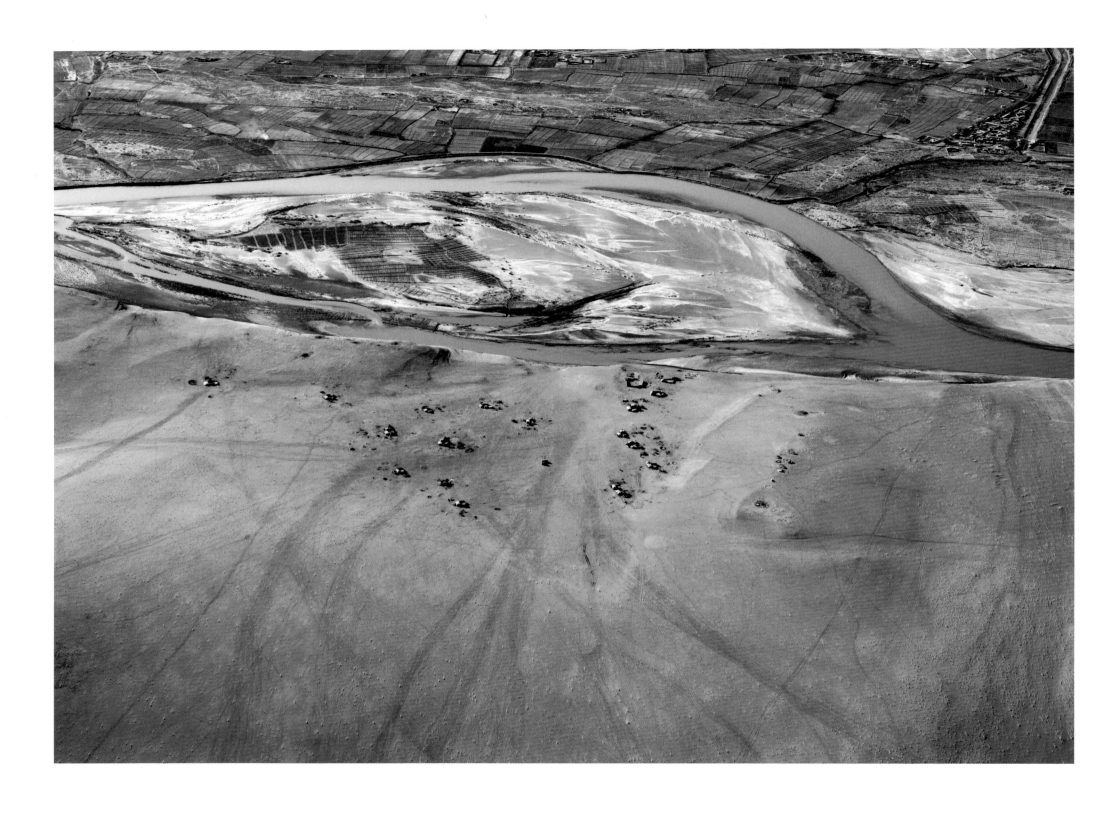

Flight to Garmsir

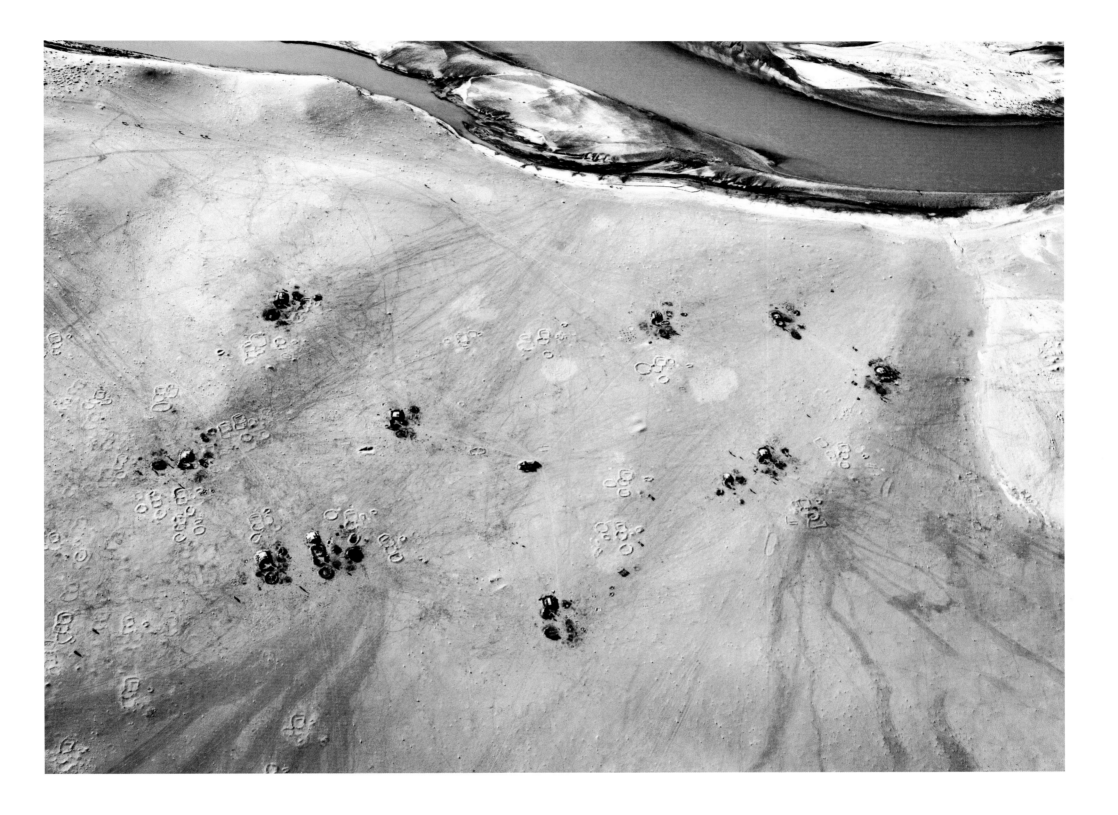

Flight to Garmsir

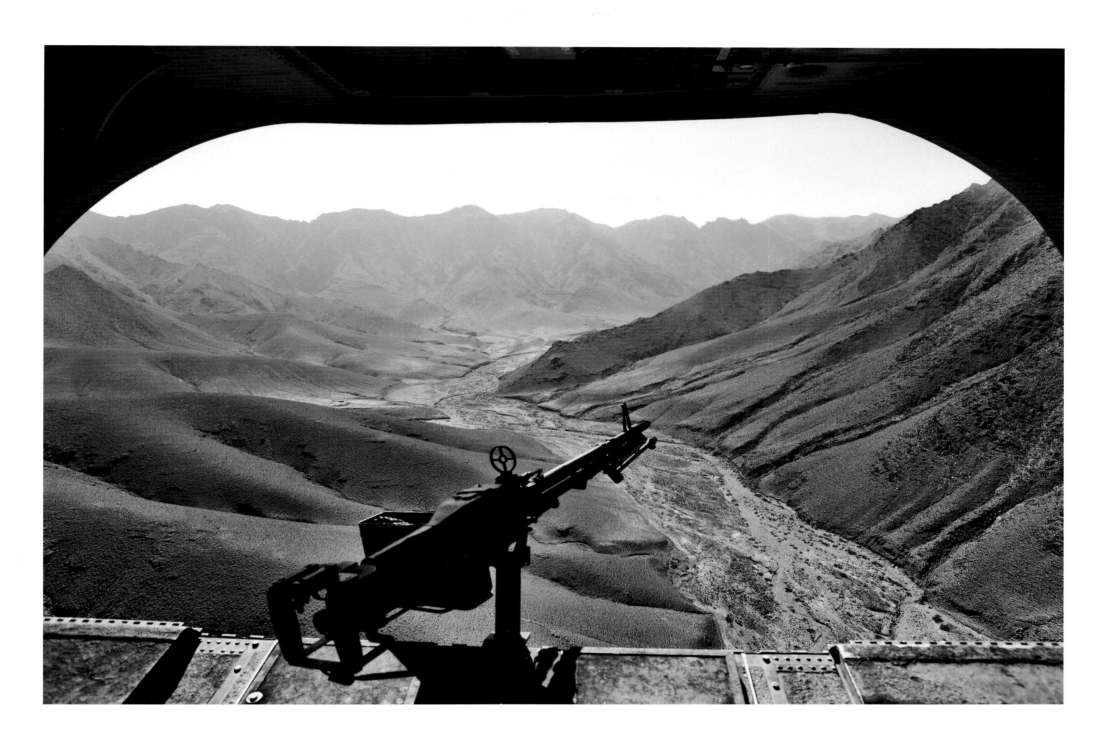

Flight to Kajaki

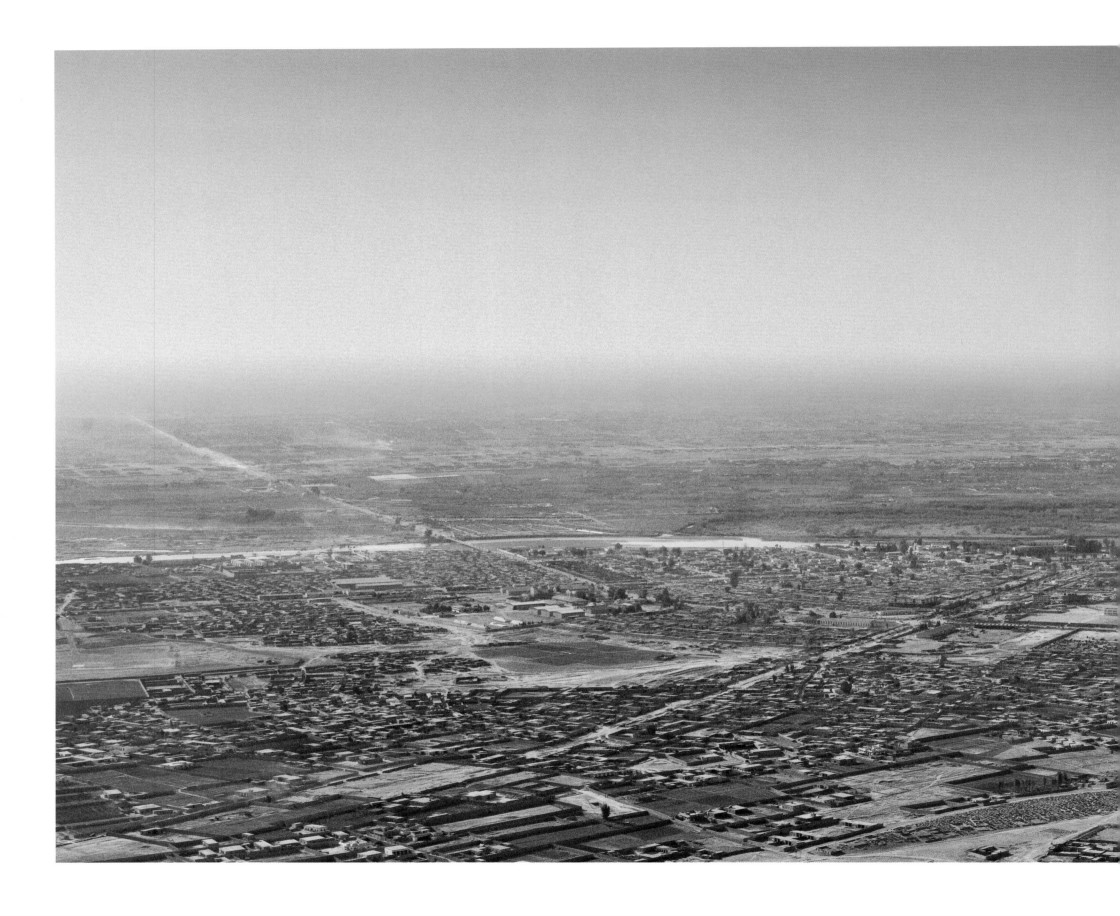

Lashkar Gah, provincial capital of Helmand

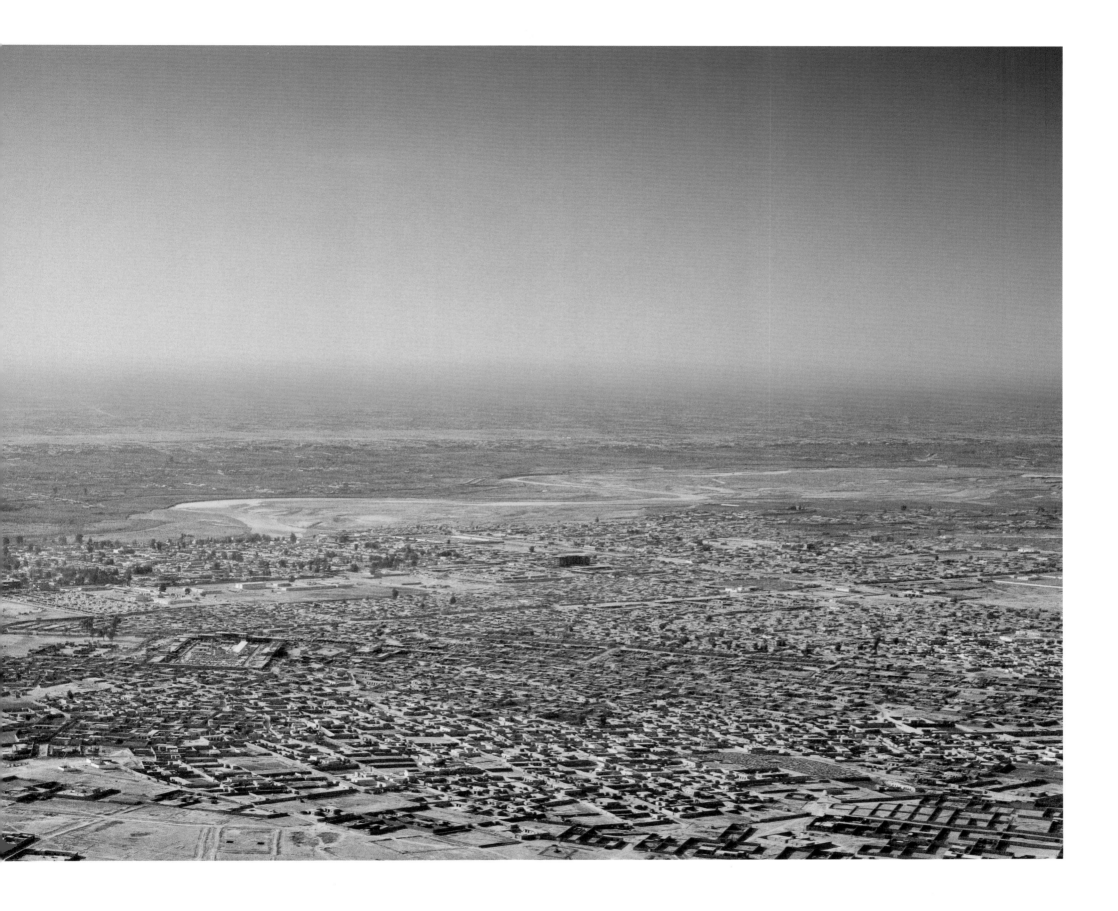

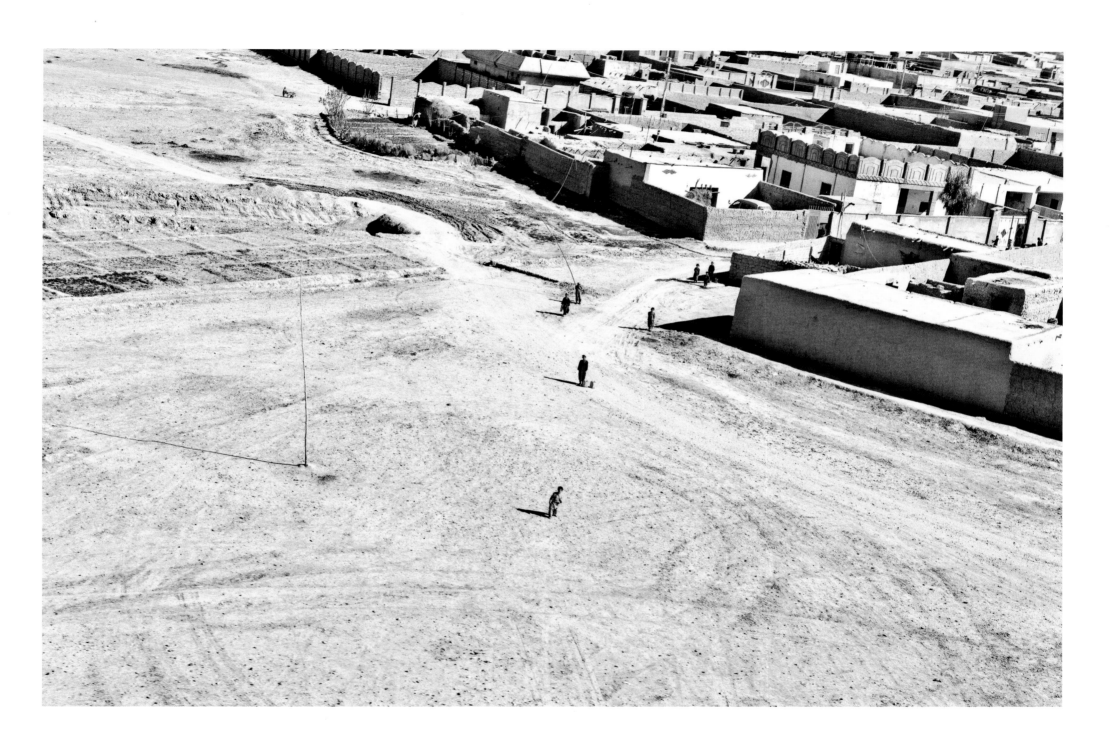

Lashkar Gah

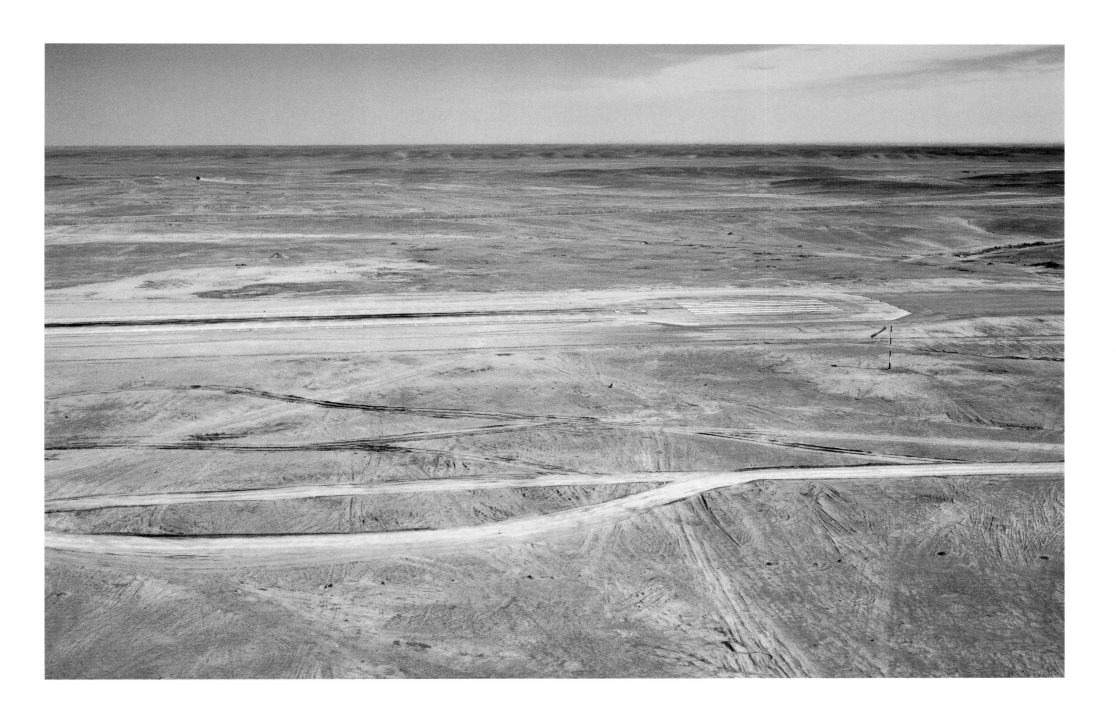

Camp Bastion

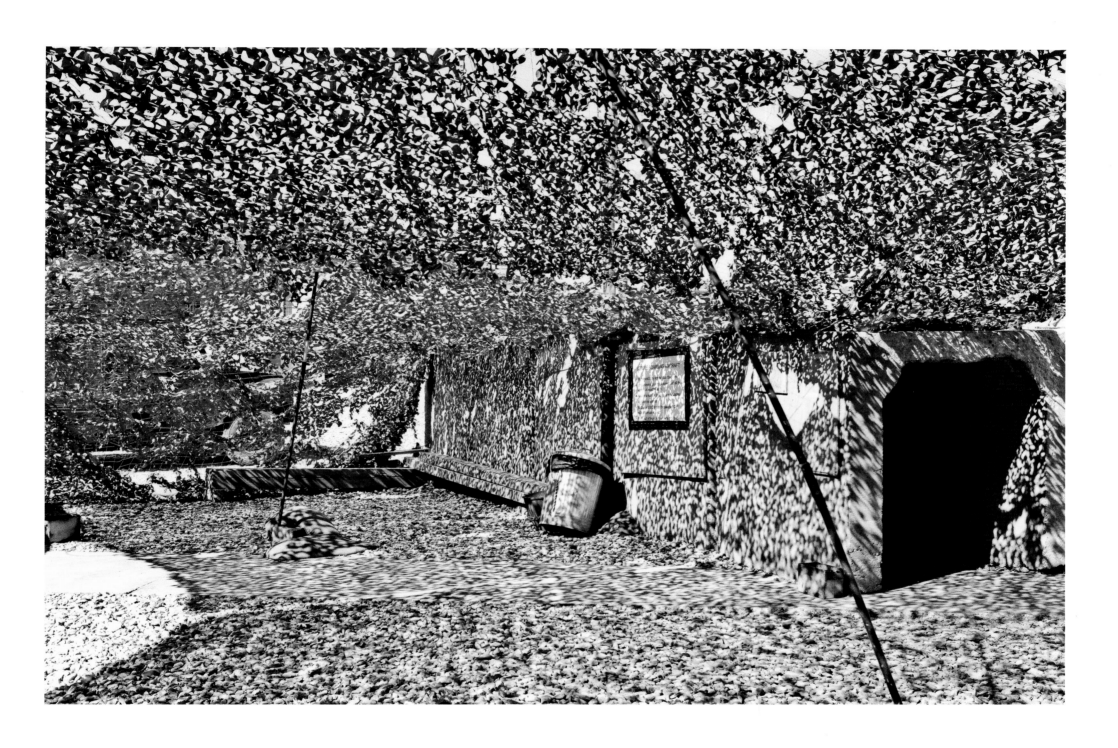

Flight waiting room, Lashkar Gah

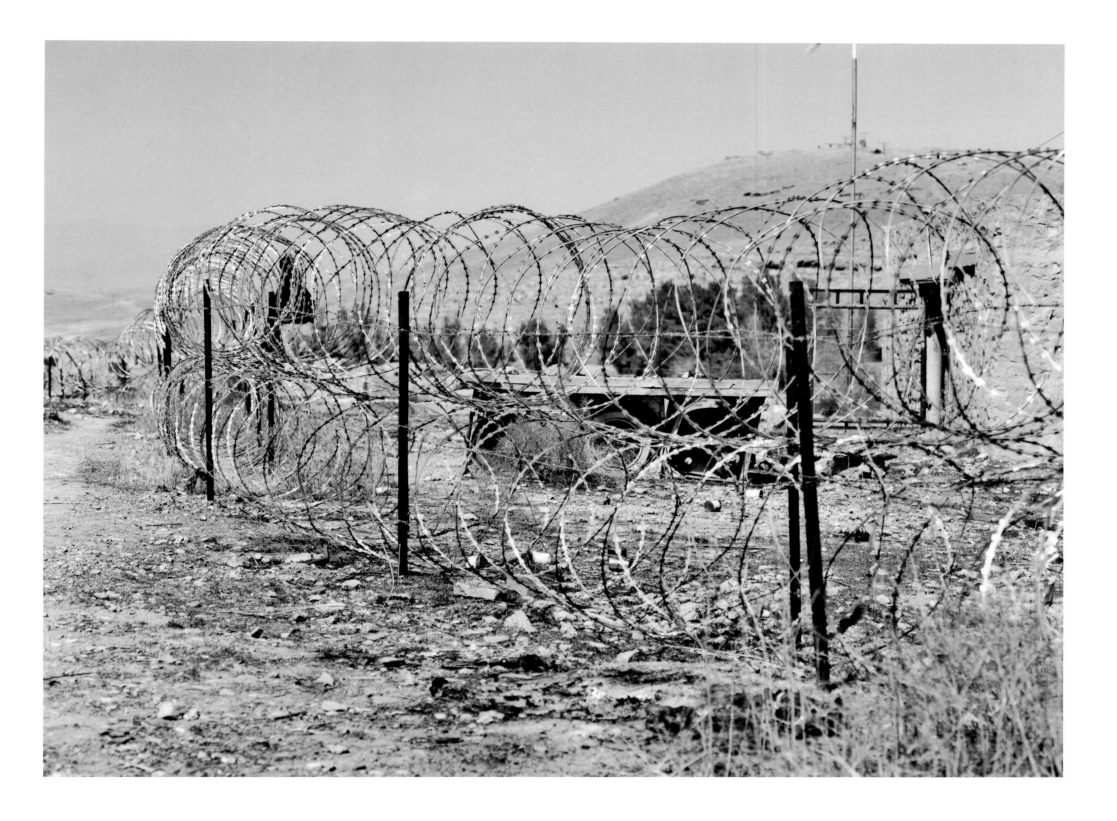

Kajaki

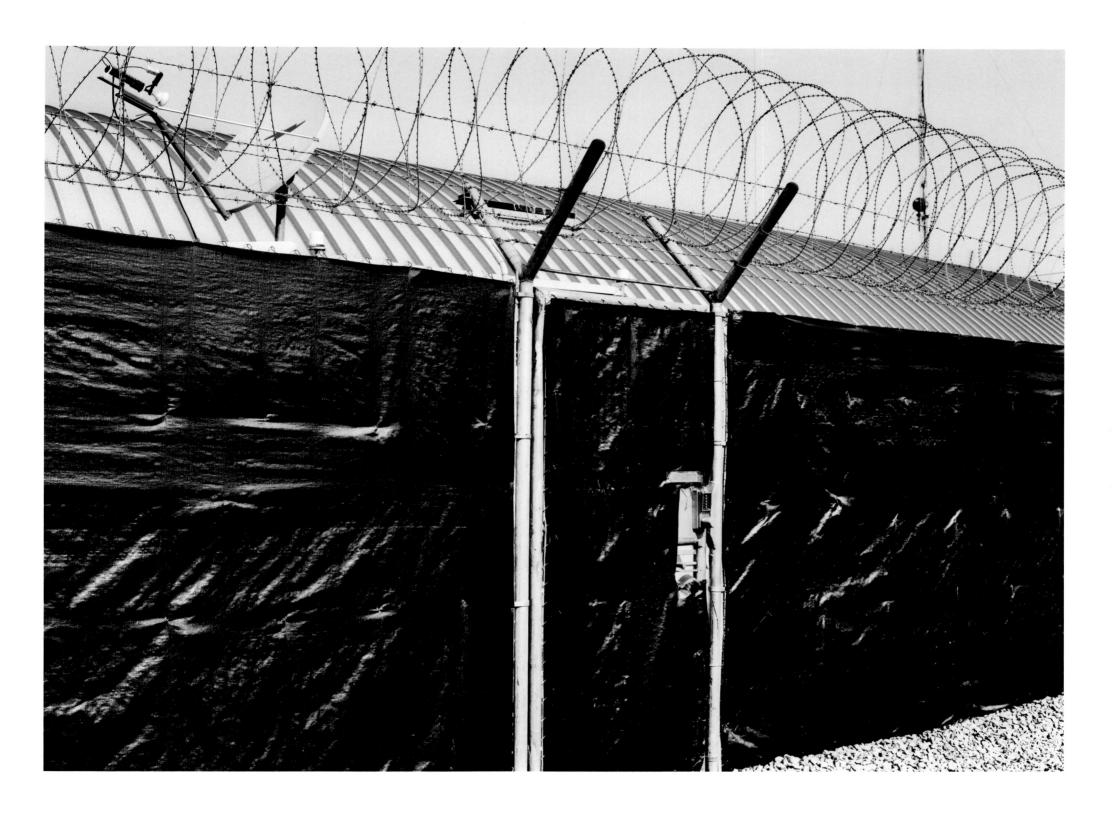

Door to Special Forces compound, Kandahar

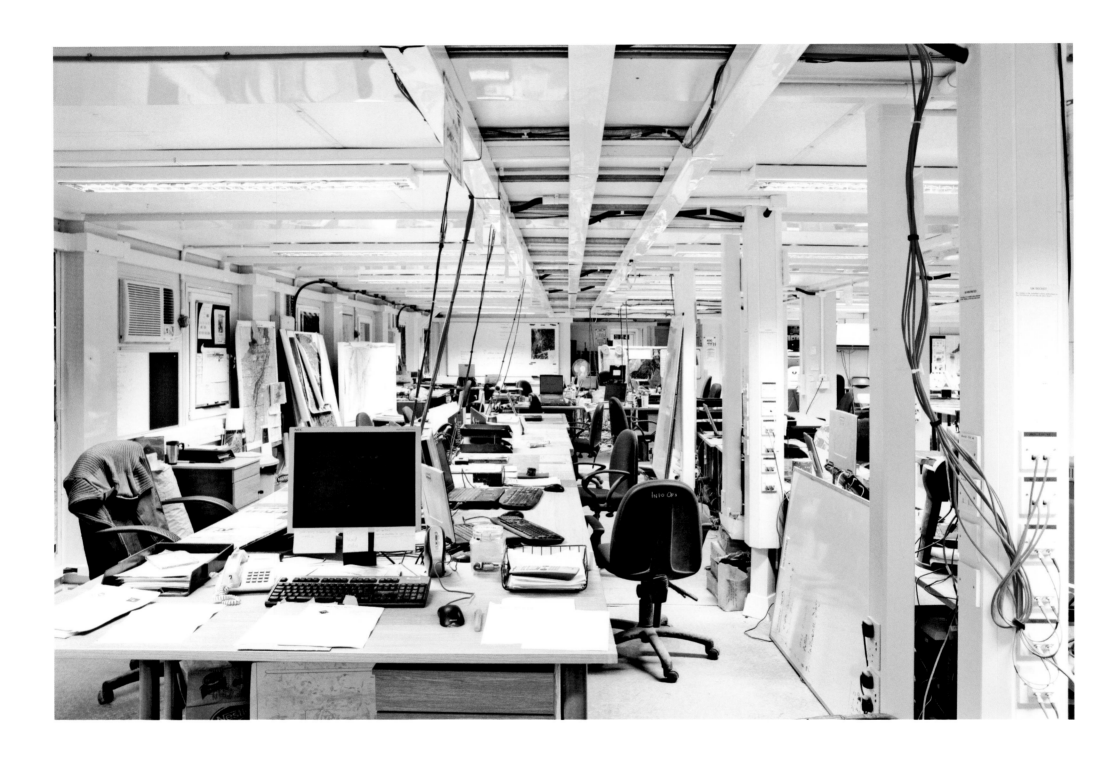

Lashkar Gah

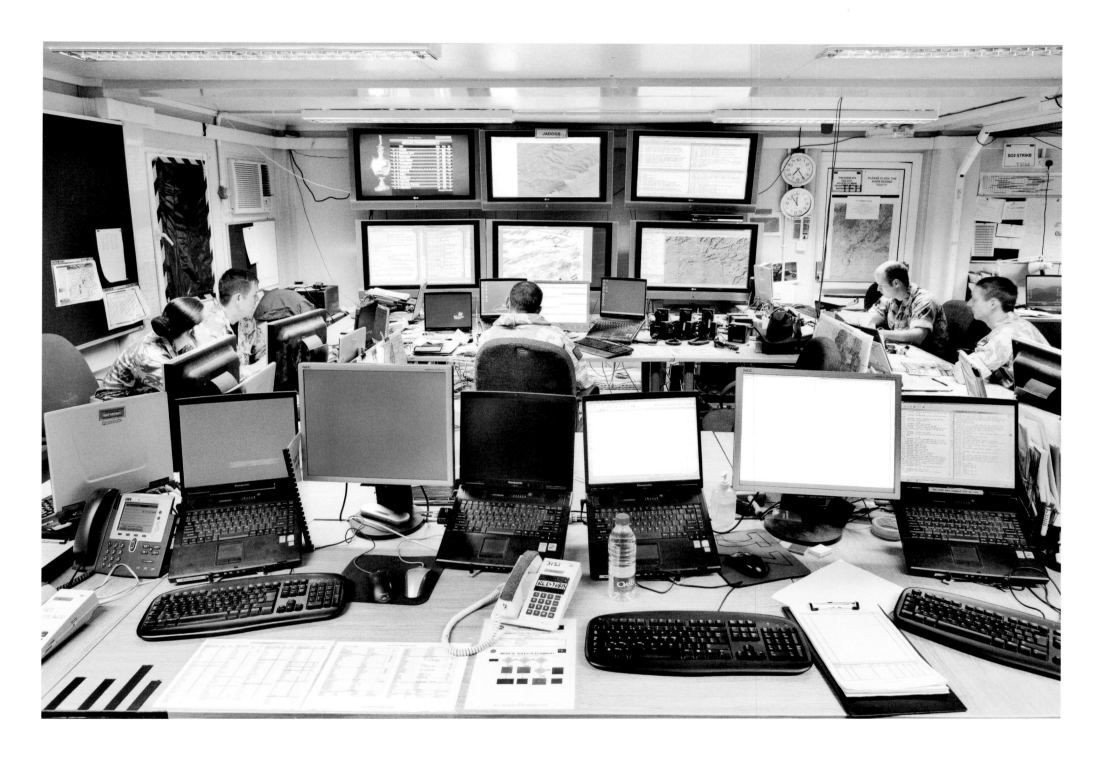

Lashkar Gah

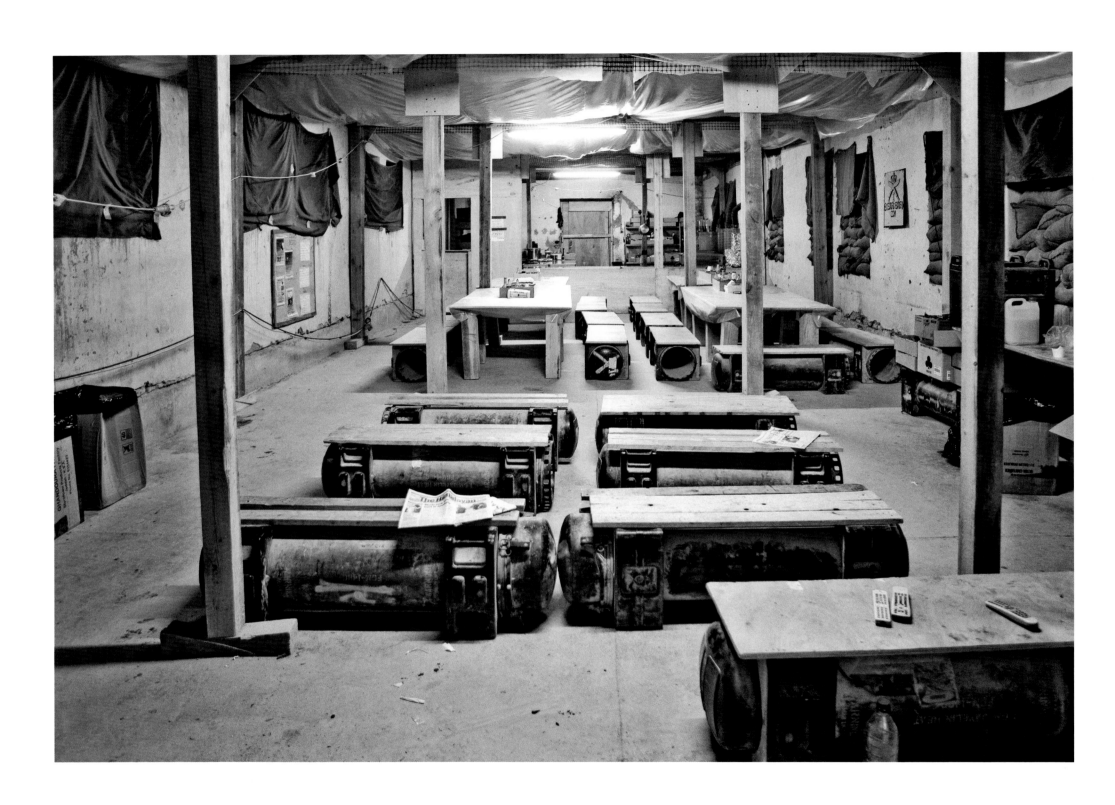

'Two Million Dollar Dining Room', FOB Delhi, Garmsir

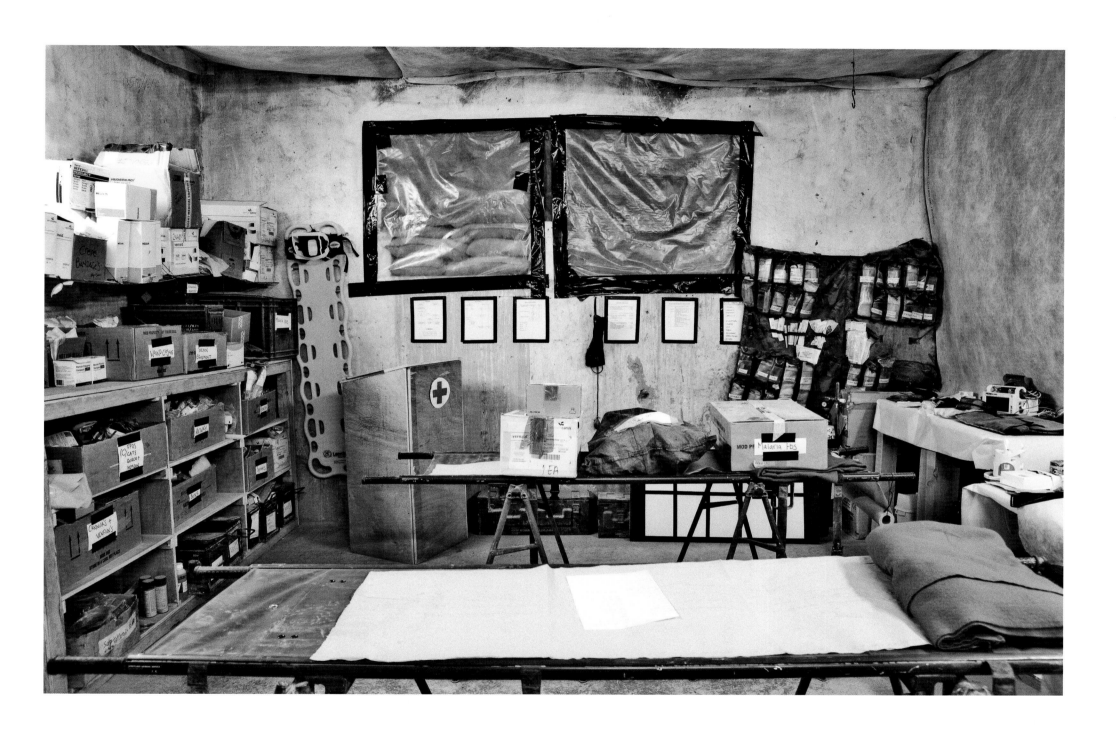

Medical Room, FOB Delhi, Garmsir

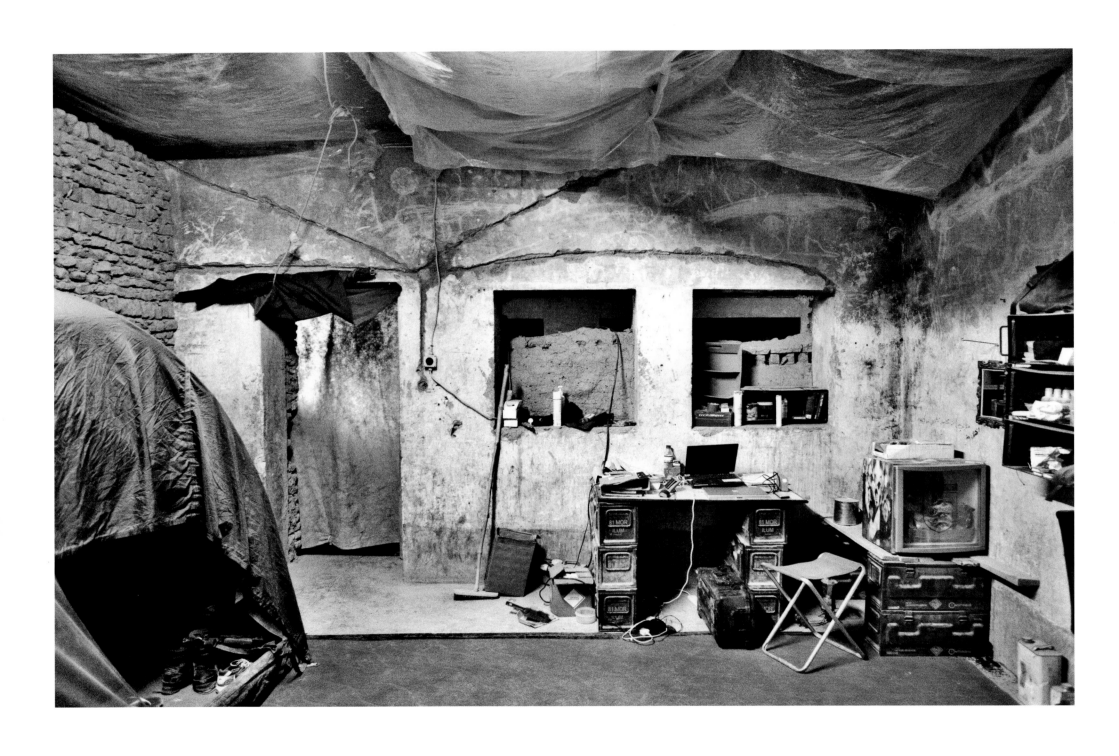

Officer's room, FOB Delhi, Garmsir

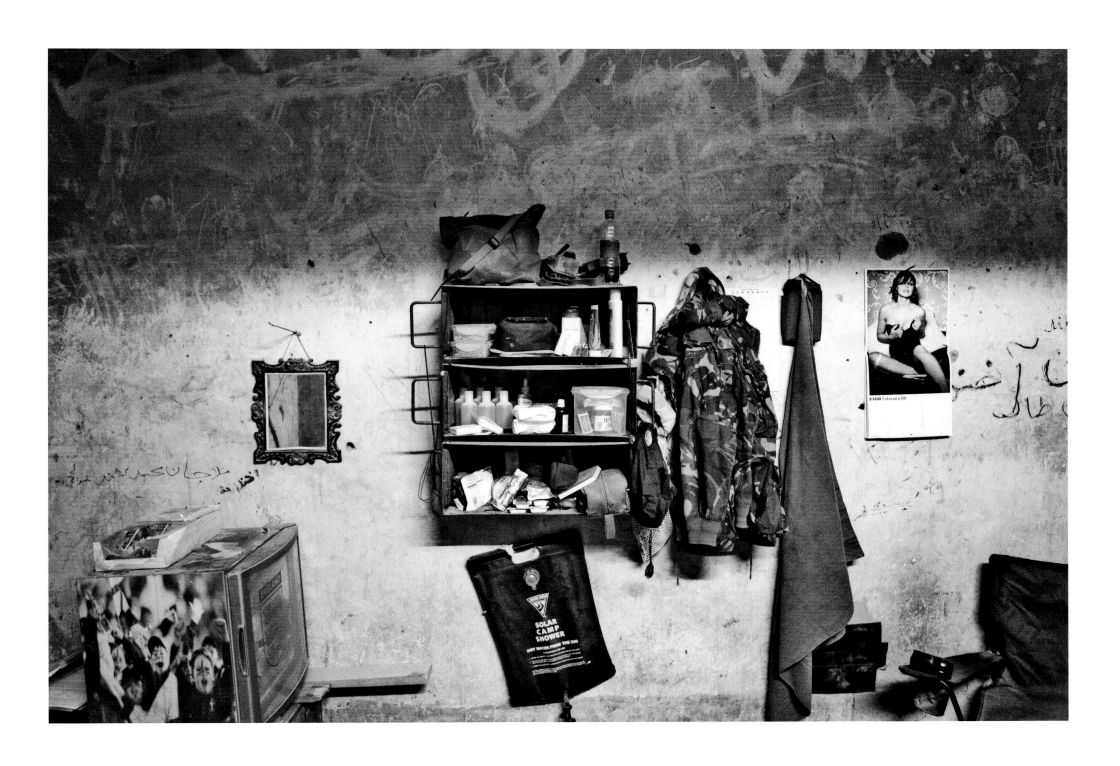

Officer's room, FOB Delhi, Garmsir

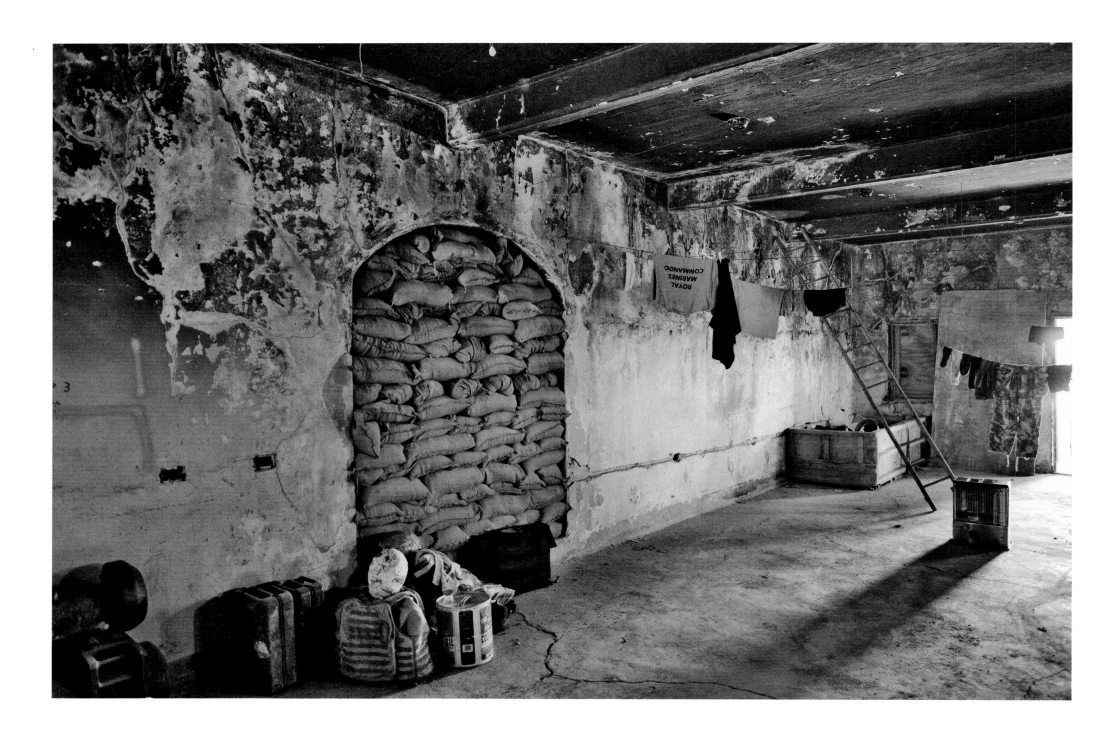

Kajaki

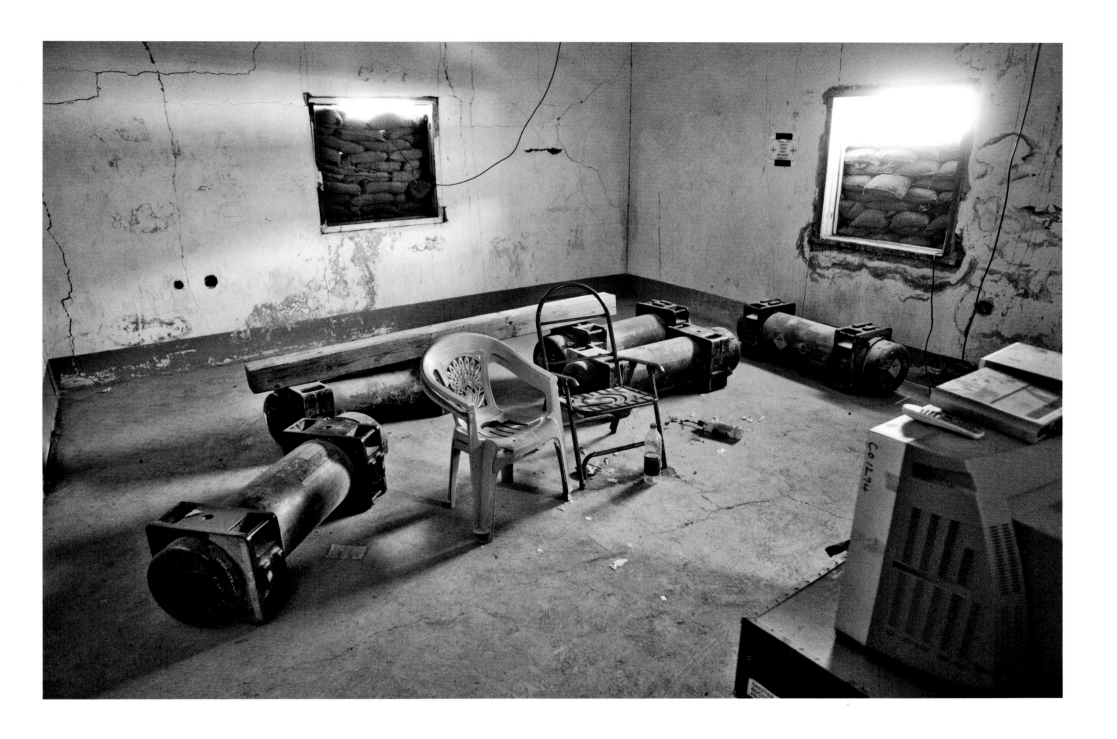

TV Room, Kajaki

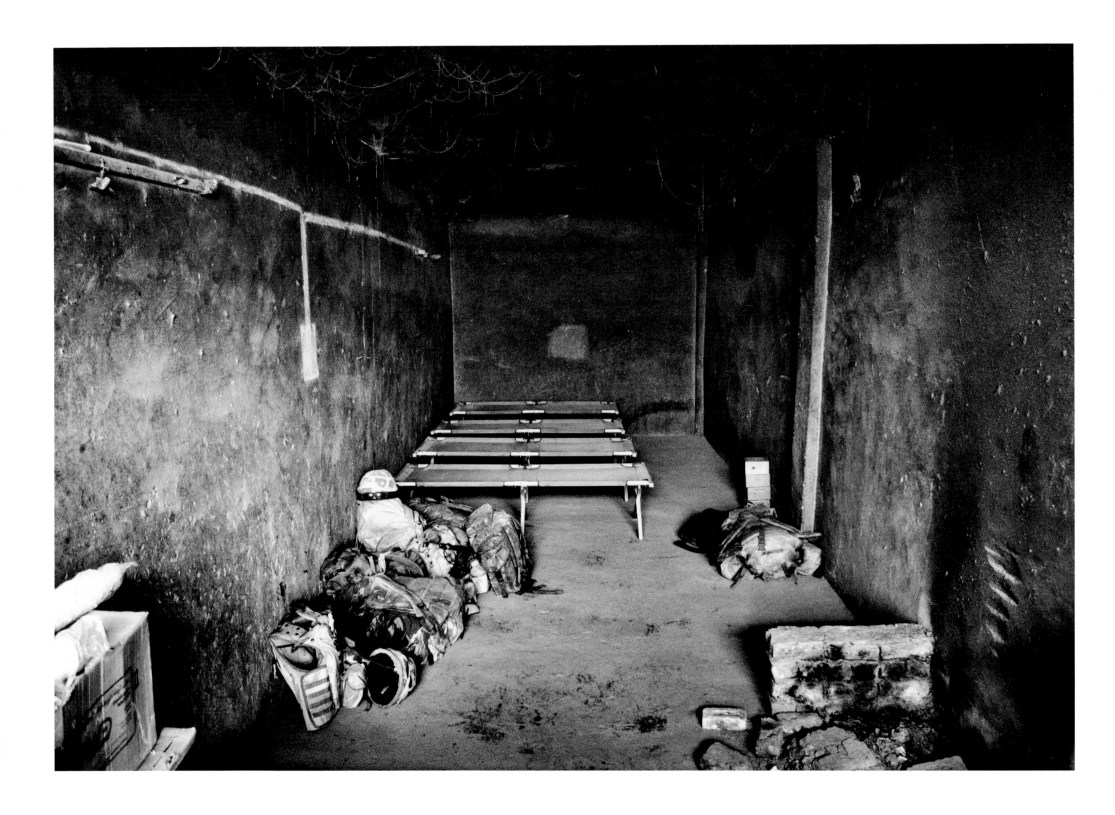

Musa Kala

Roof of Operations Room, FOB Delhi, Garmsir

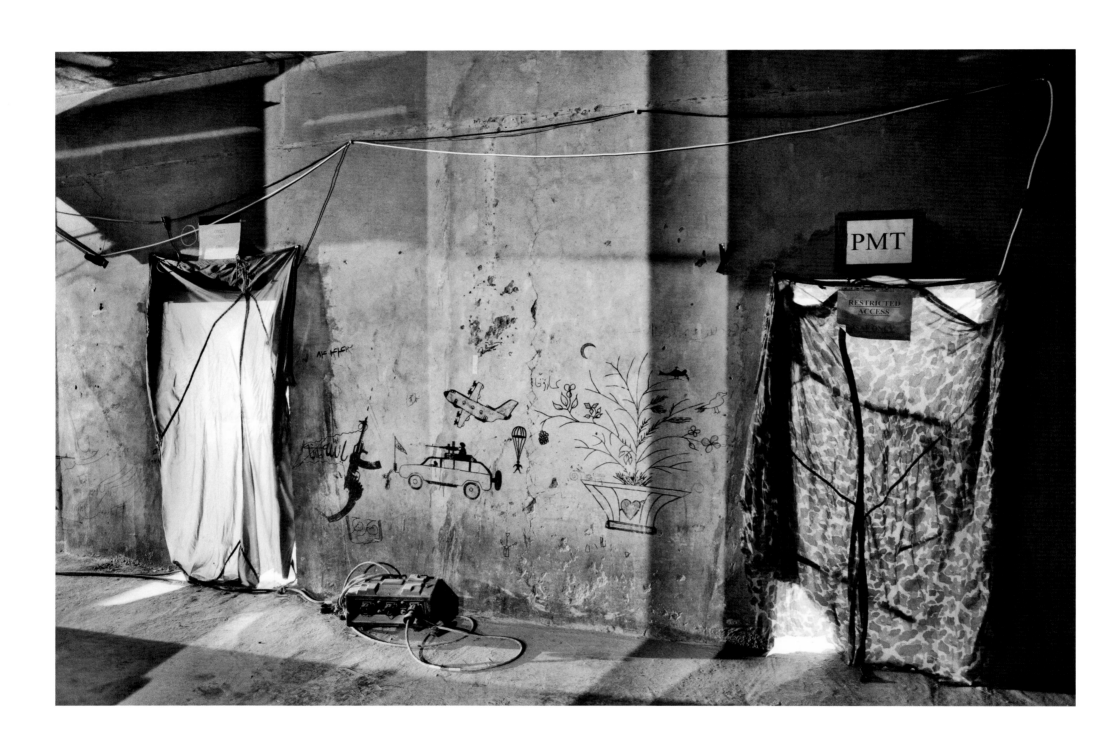

Operations Rooms, Musa Kala

Sleeping quarters, Musa Kala

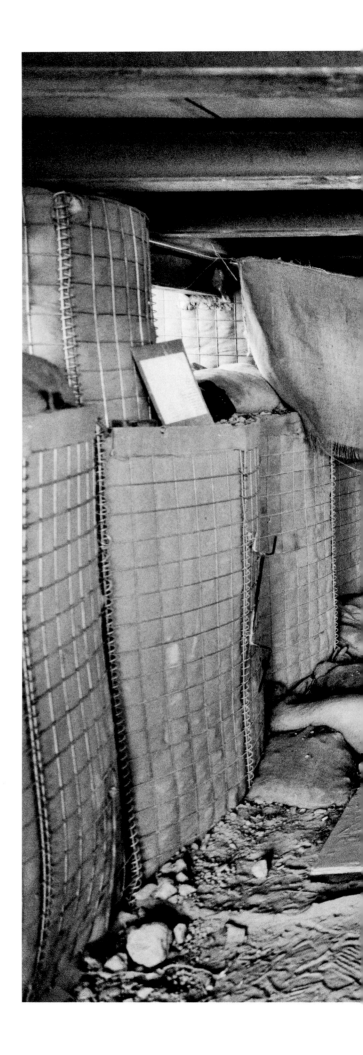

Checkpoint Balaklava, Garmsir

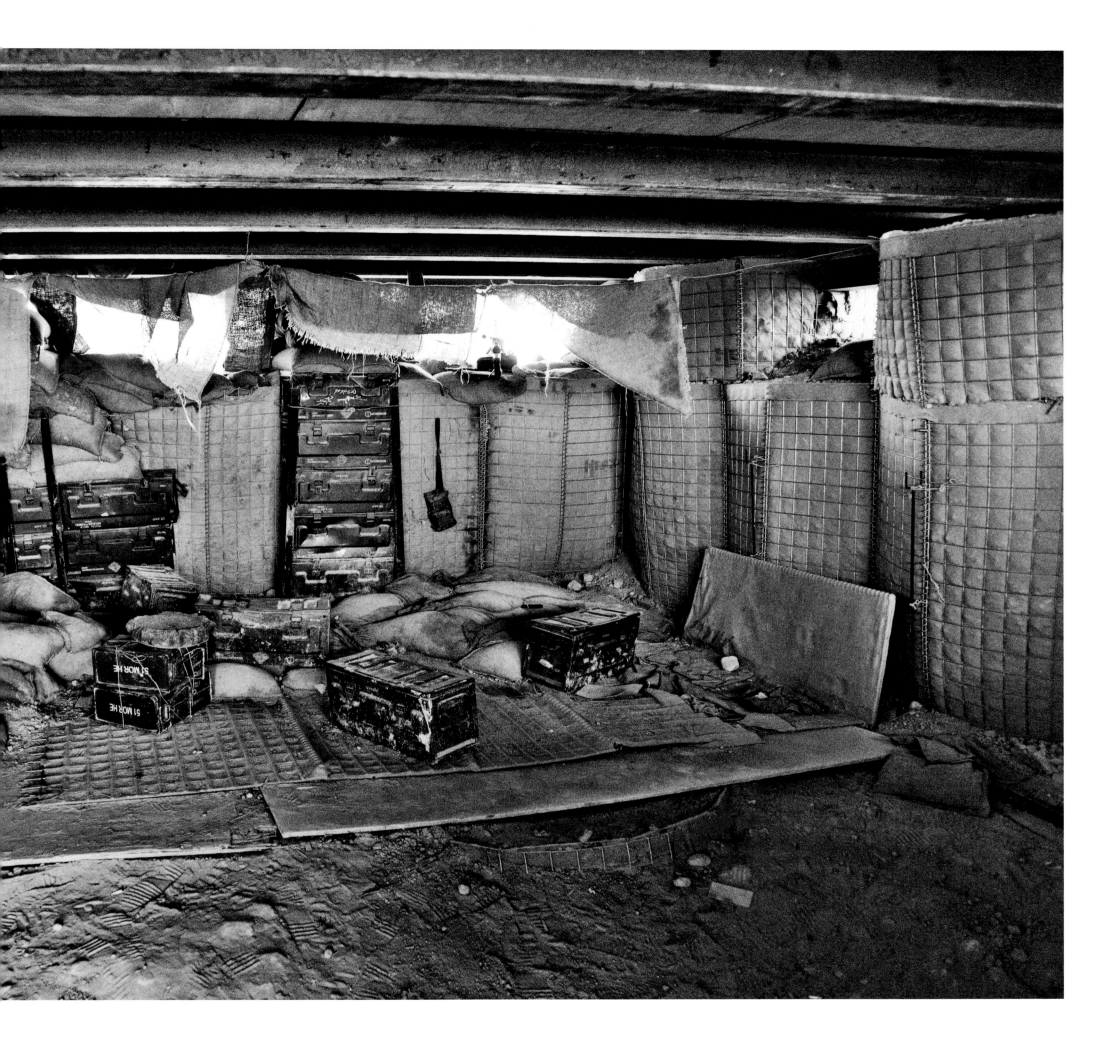

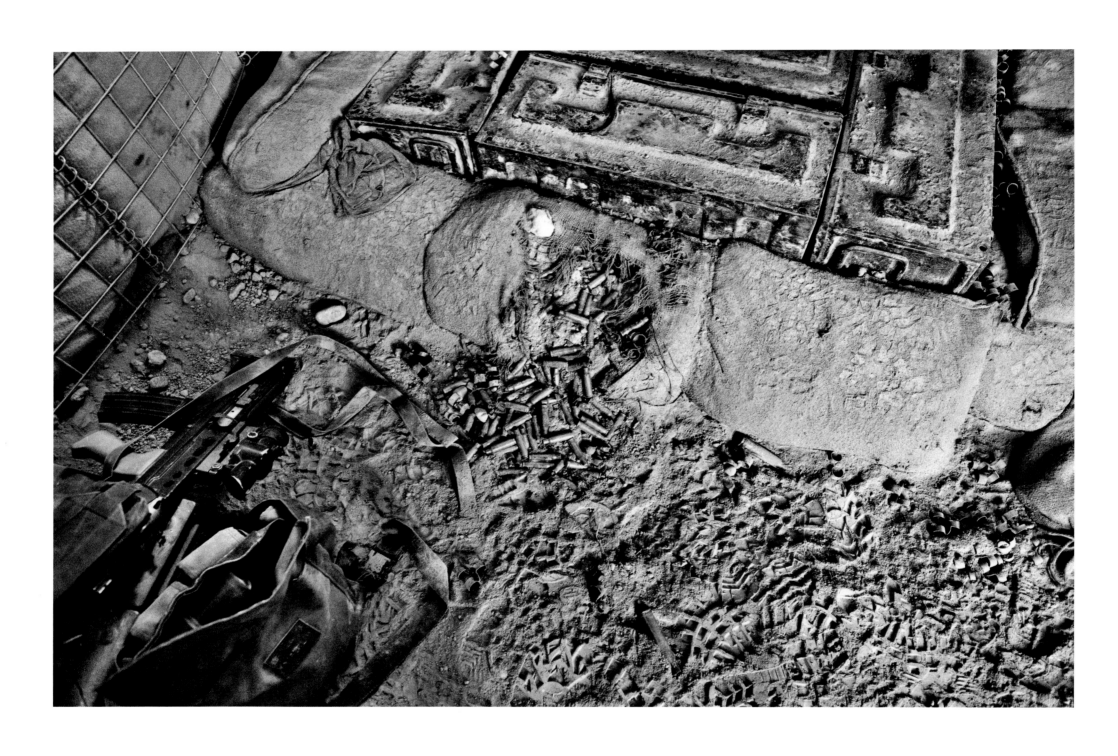

Checkpoint Balaklava, Garmsir

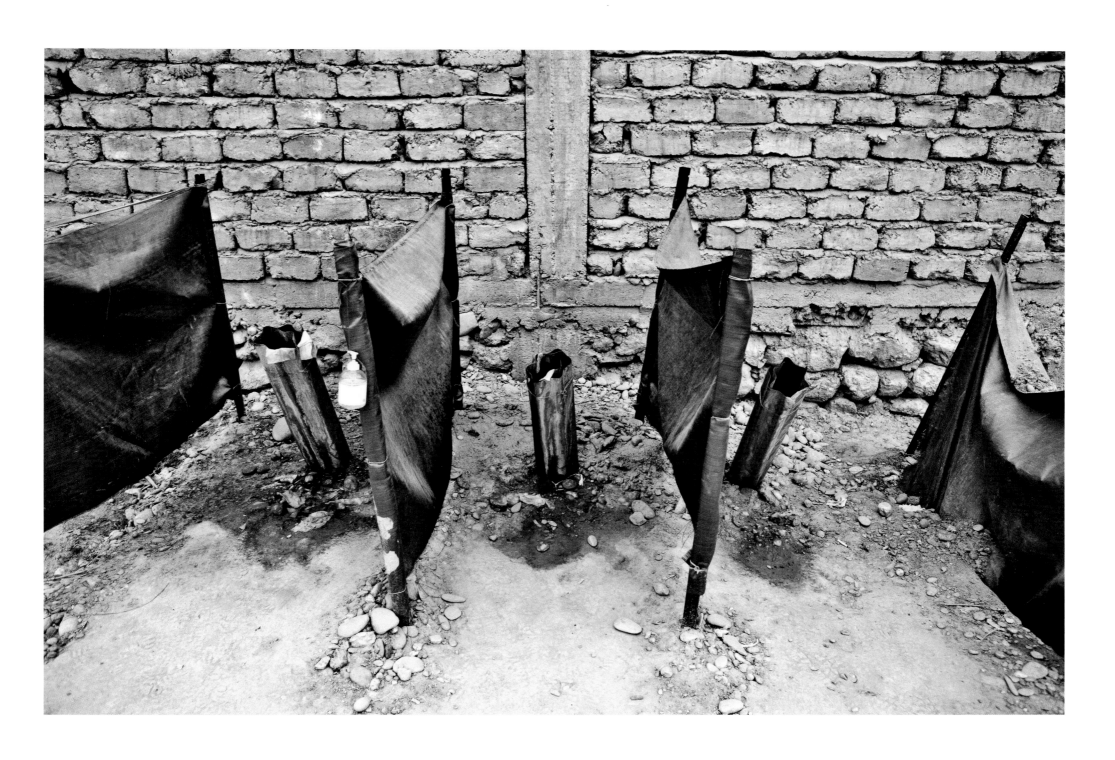

Urinals, Musa Kala

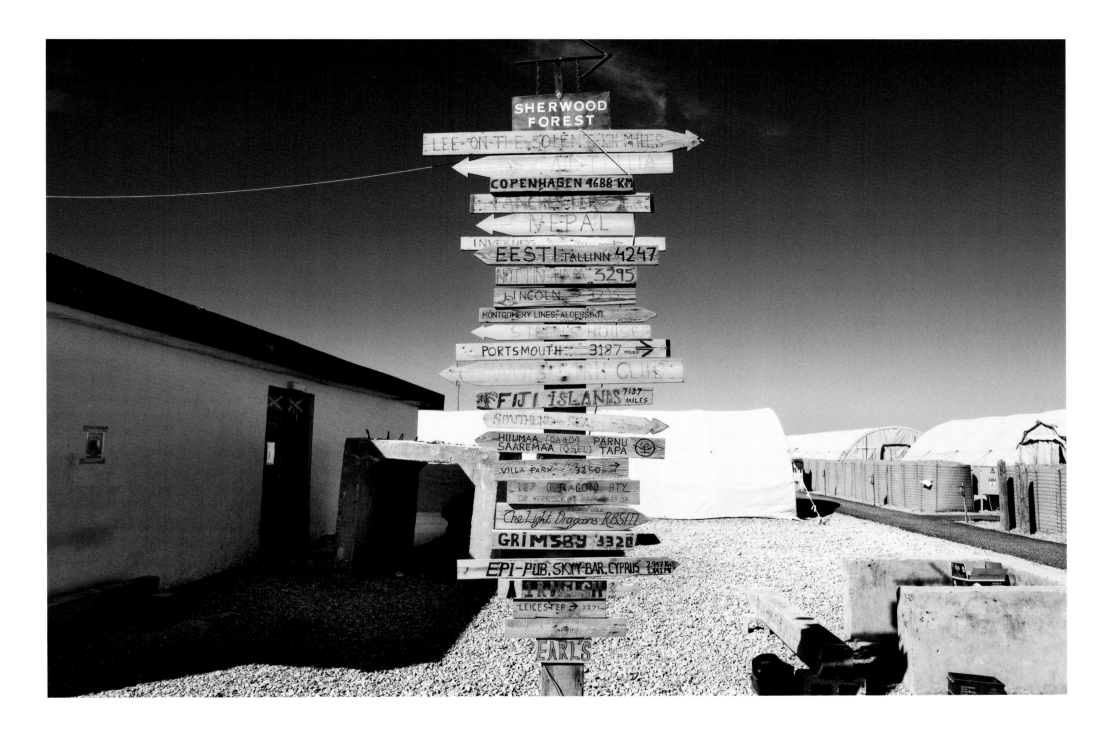

Lashkar Gah

JTAC Hill, Garmsir

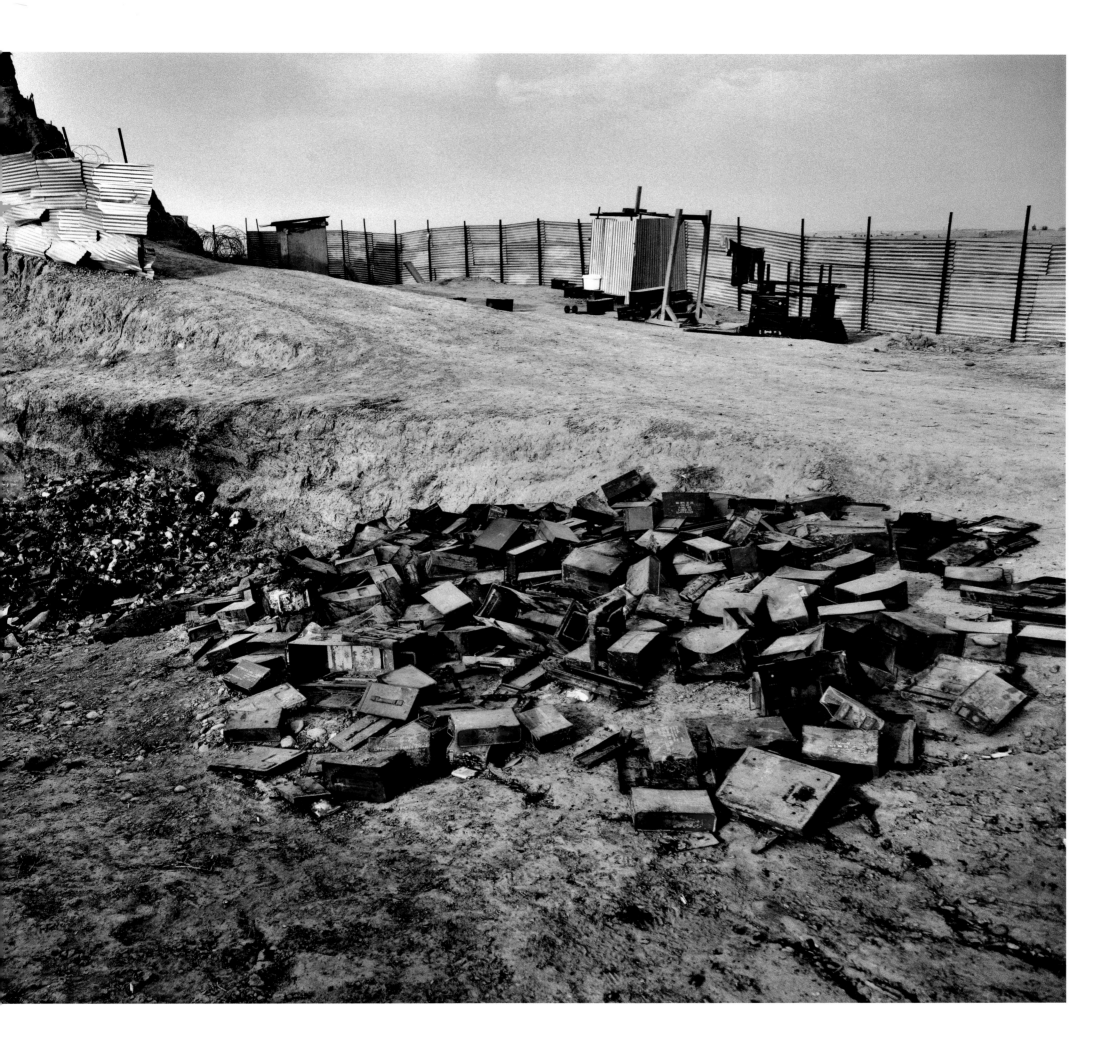

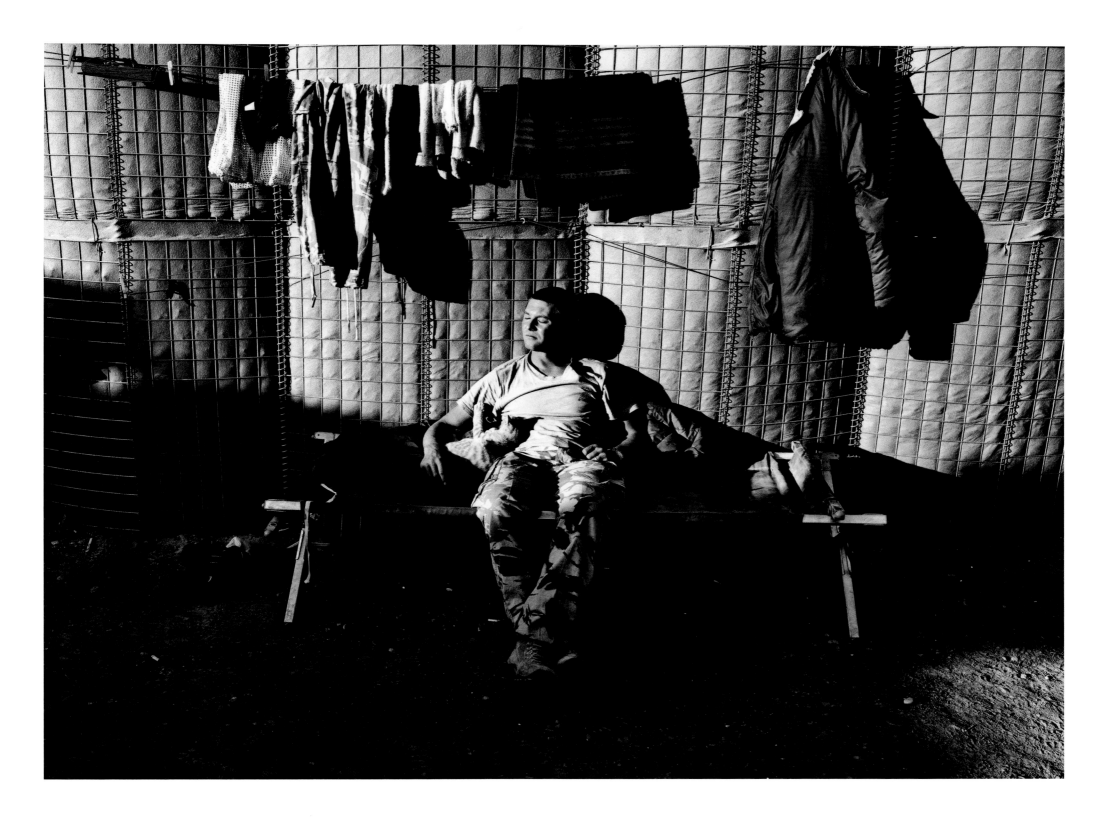

FOB Delhi, Garmsir

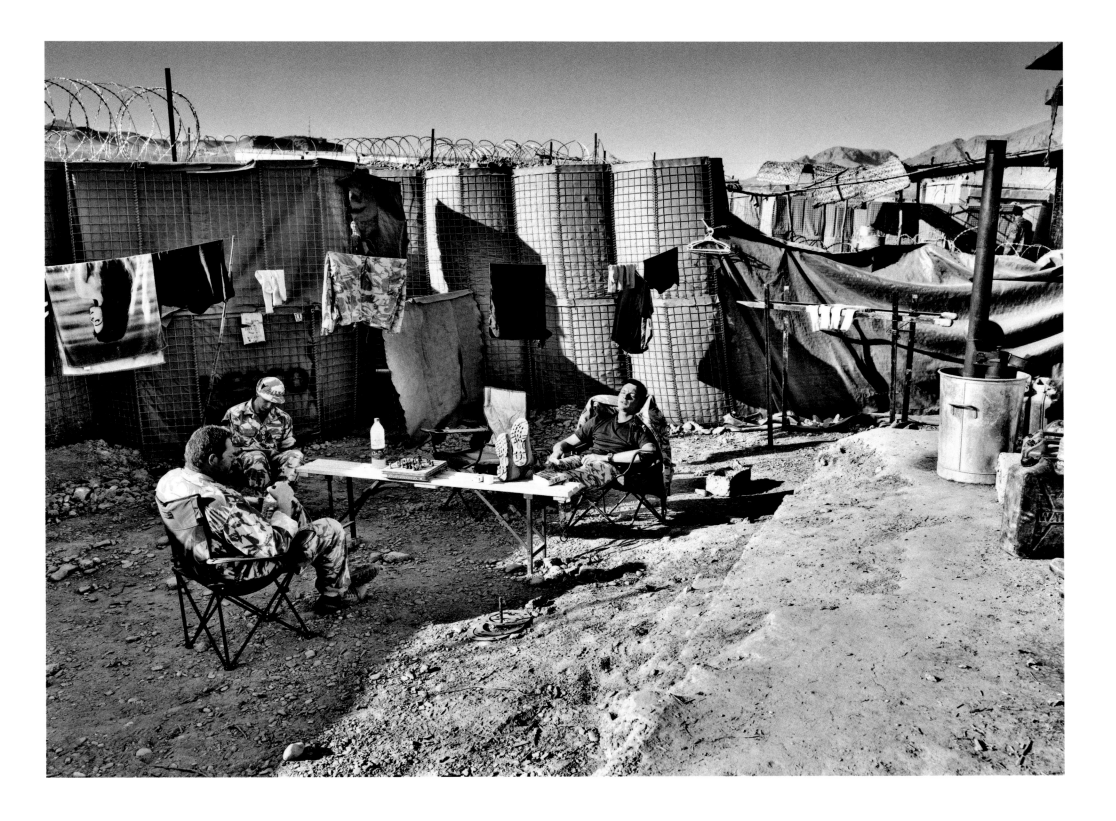

Musa Kala

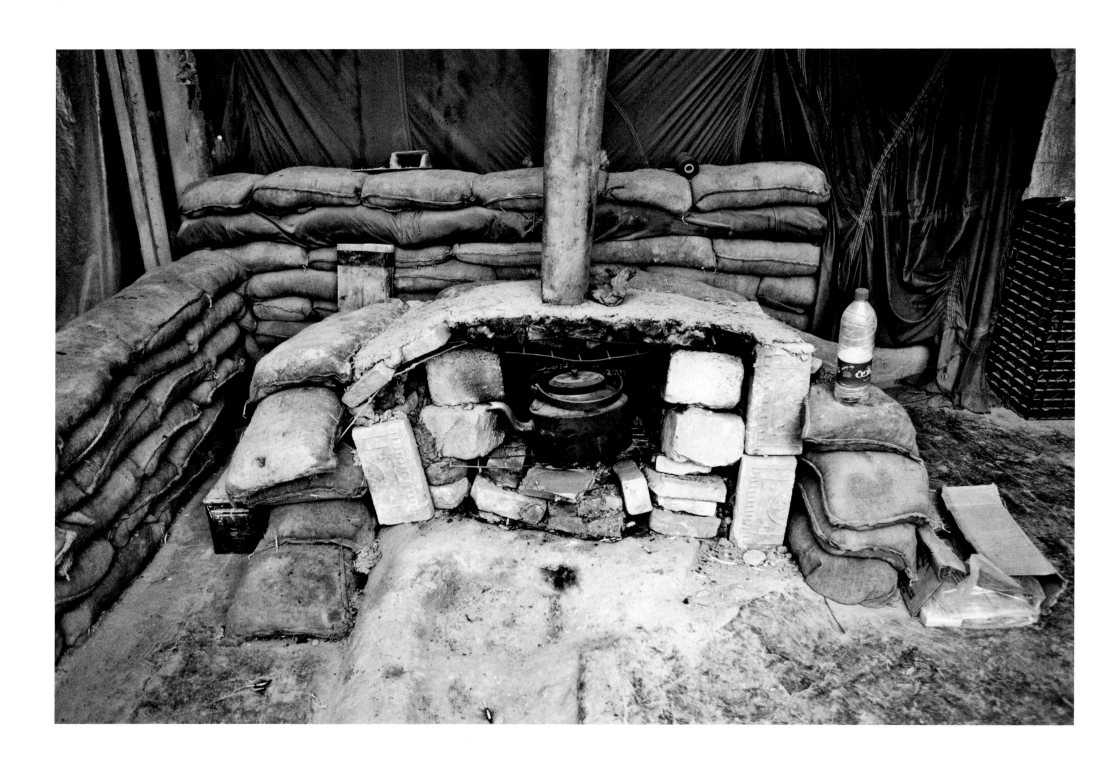

Musa Kala

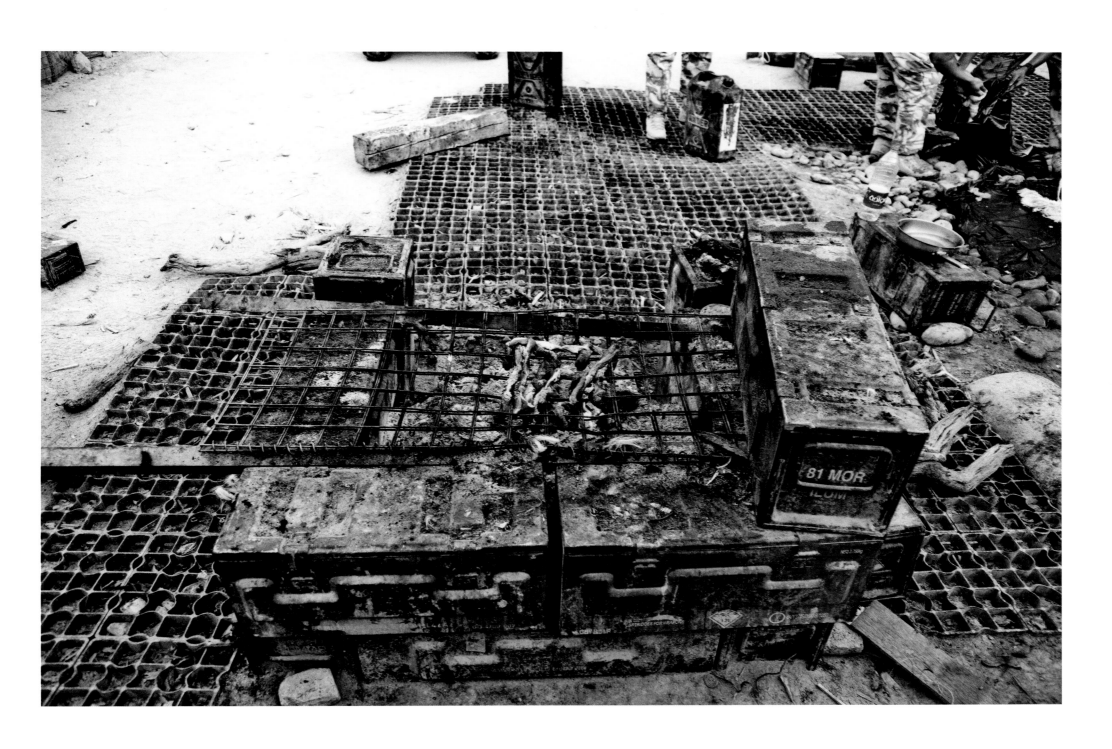

Goat curry, FOB Delhi, Garmsir

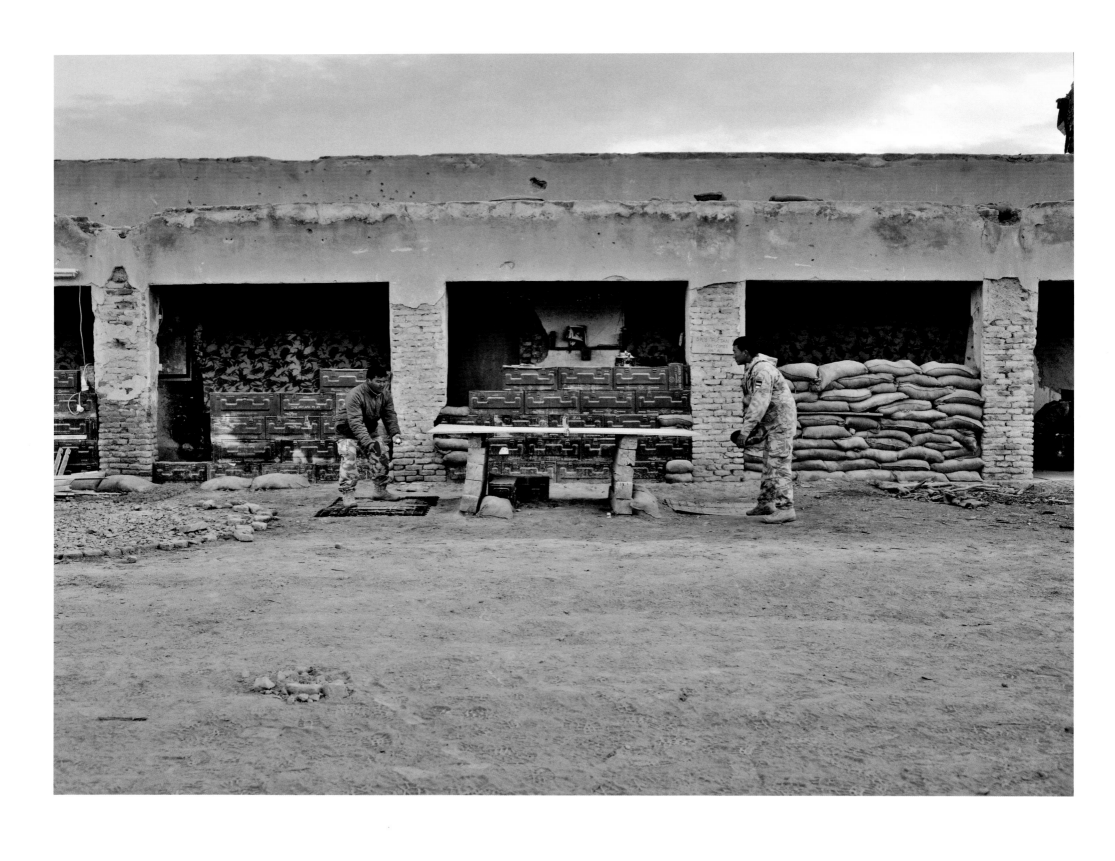

FOB Delhi, Garmsir

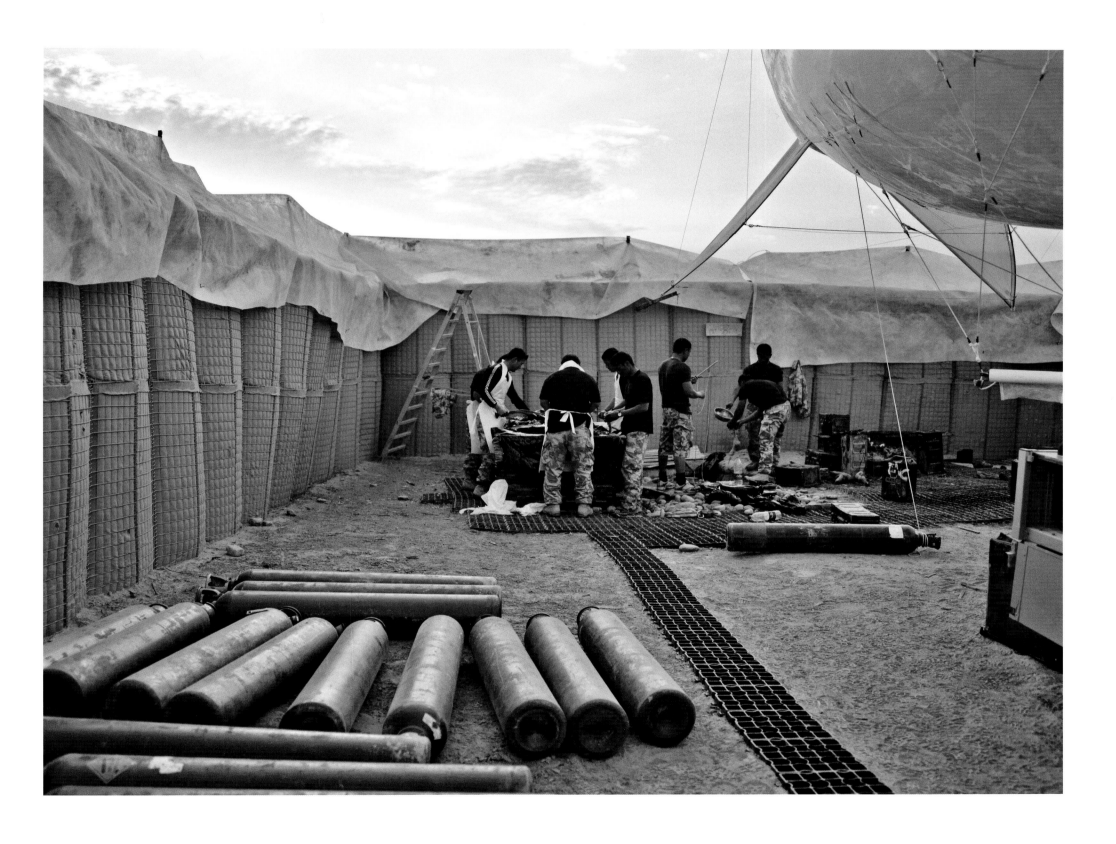

FOB Delhi, Garmsir

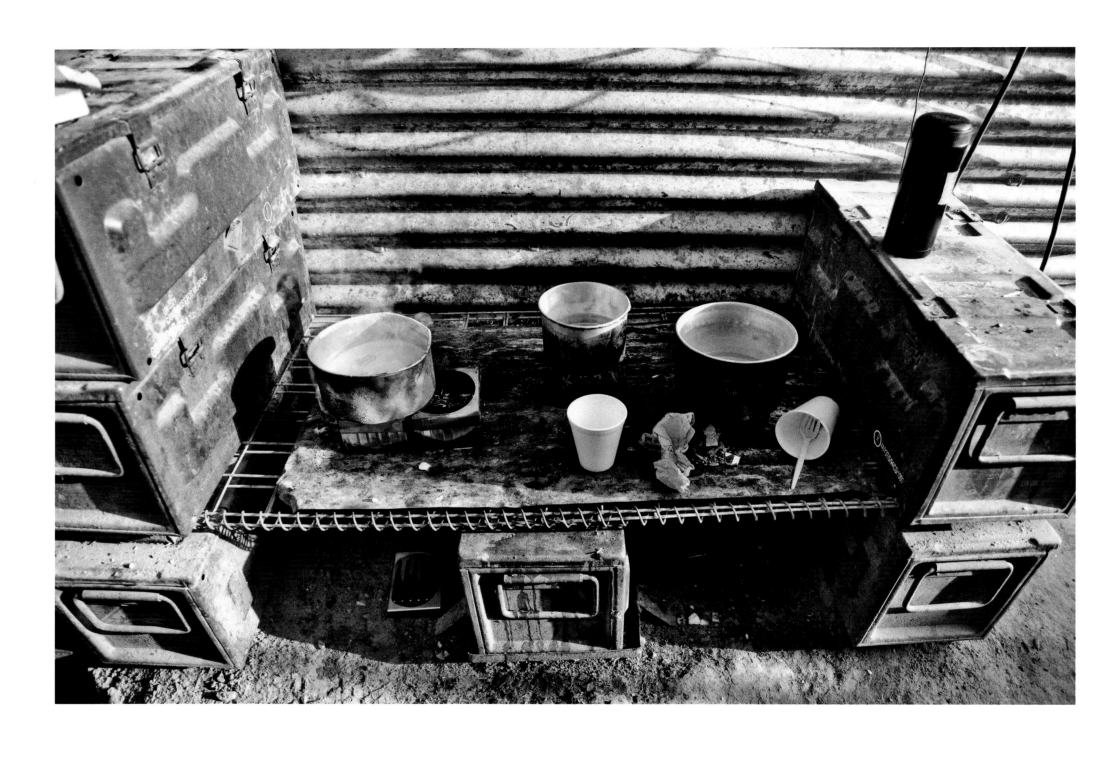

JTAC Hill, Garmsir

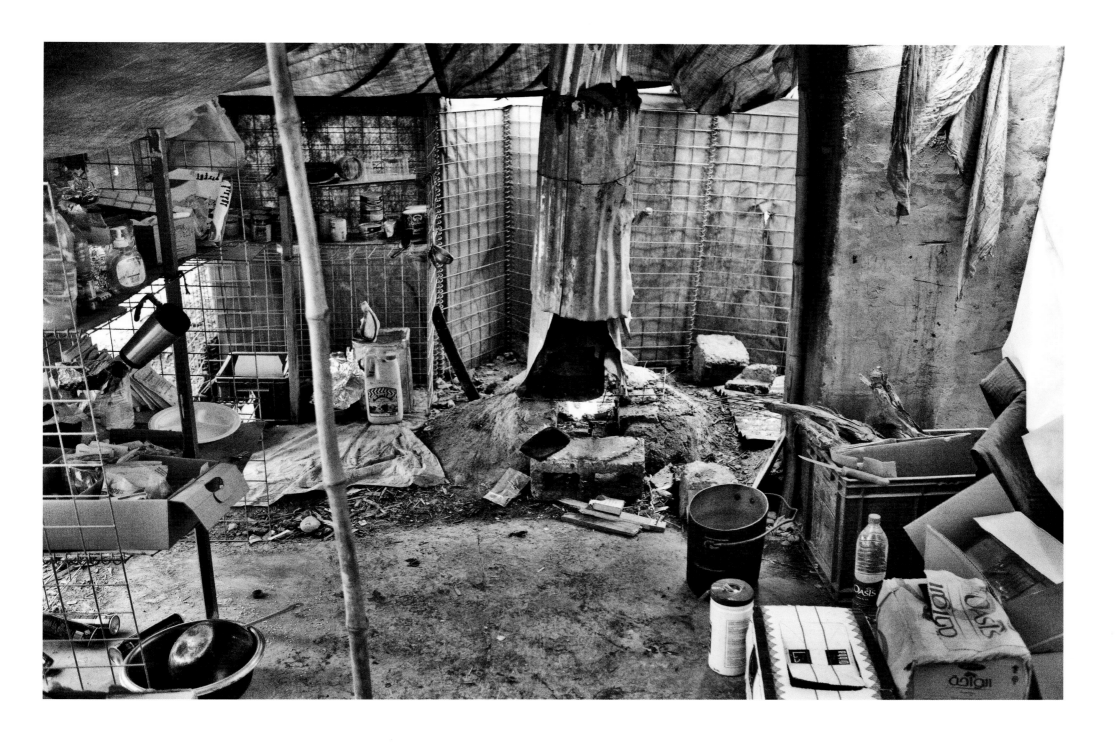

Musa Kala

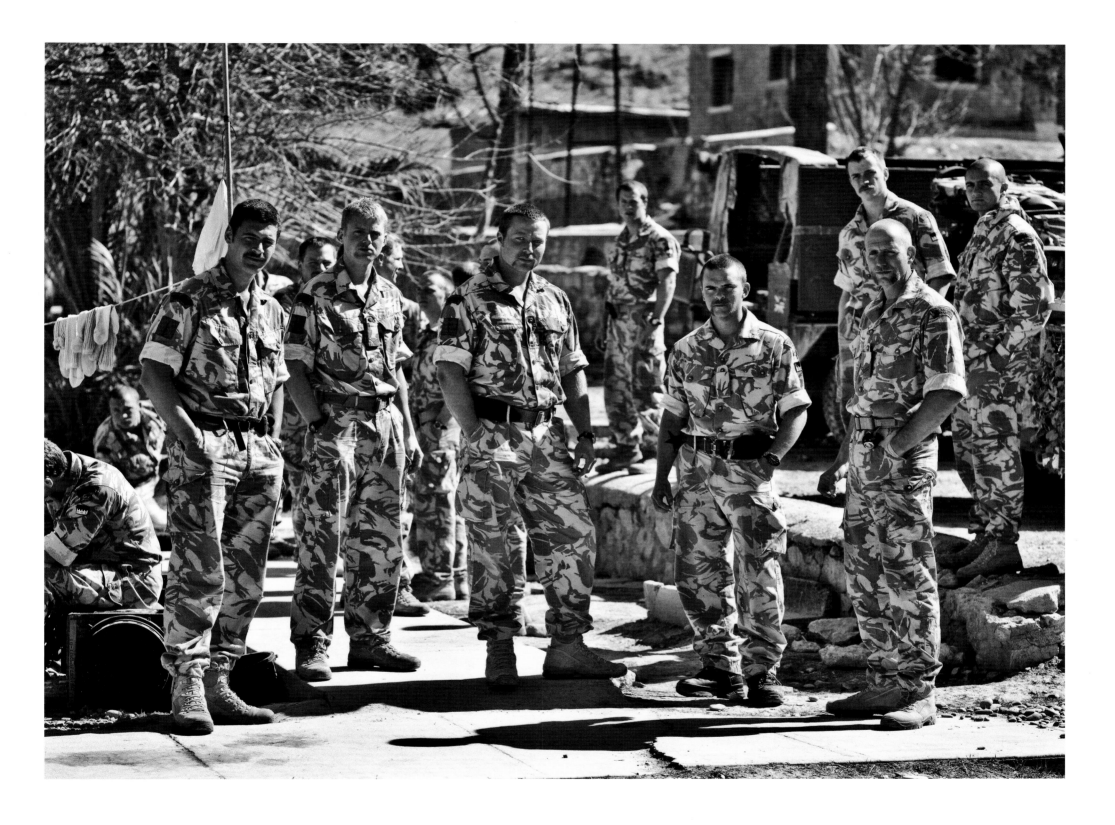

Kajaki

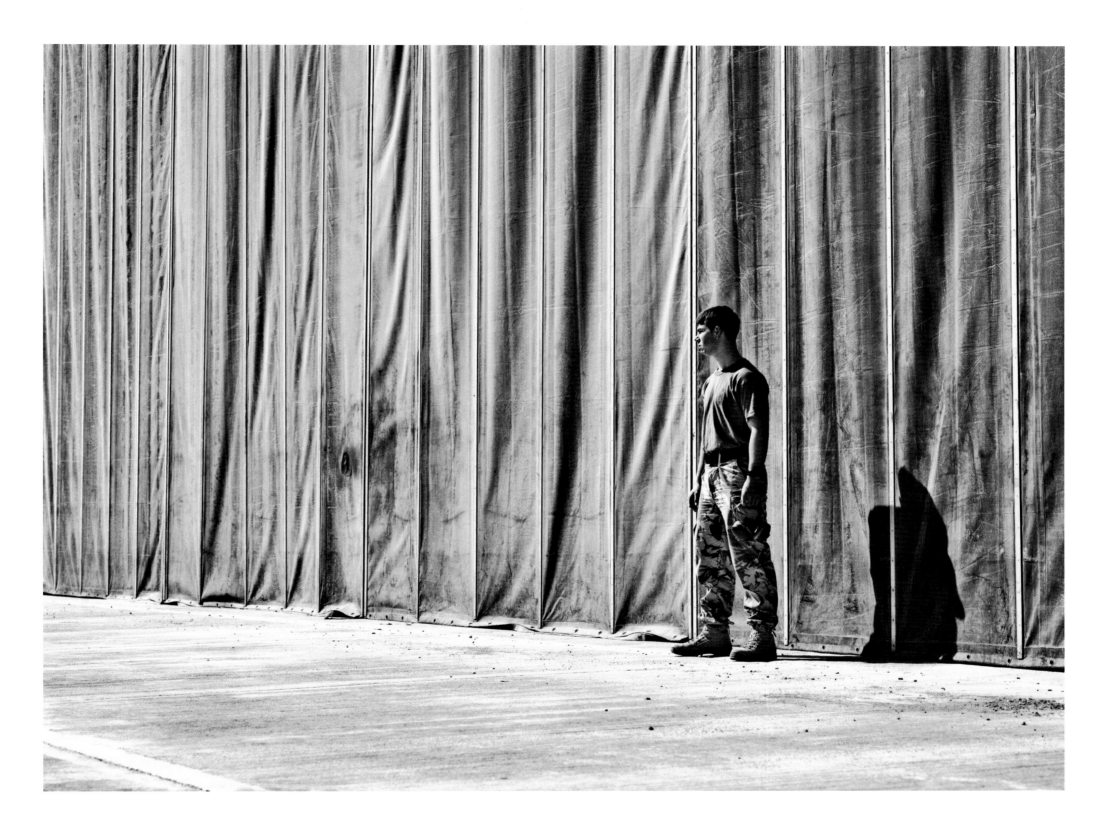

Camp Bastion

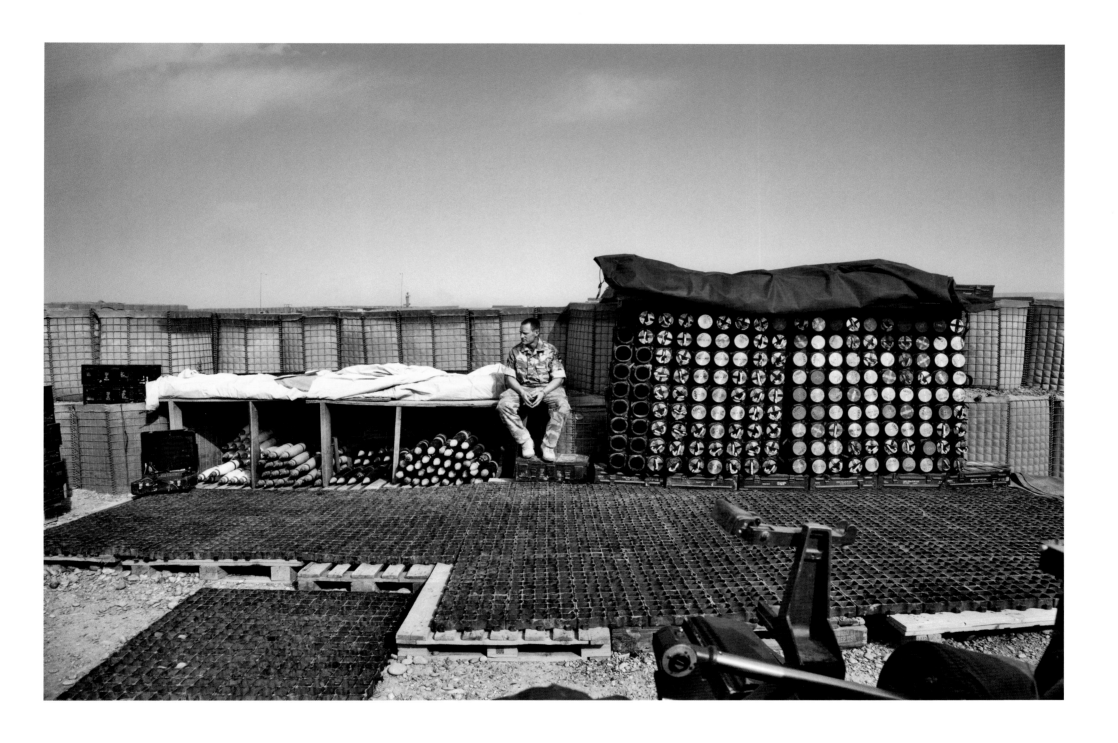

FOB Dwyer, Garmsir

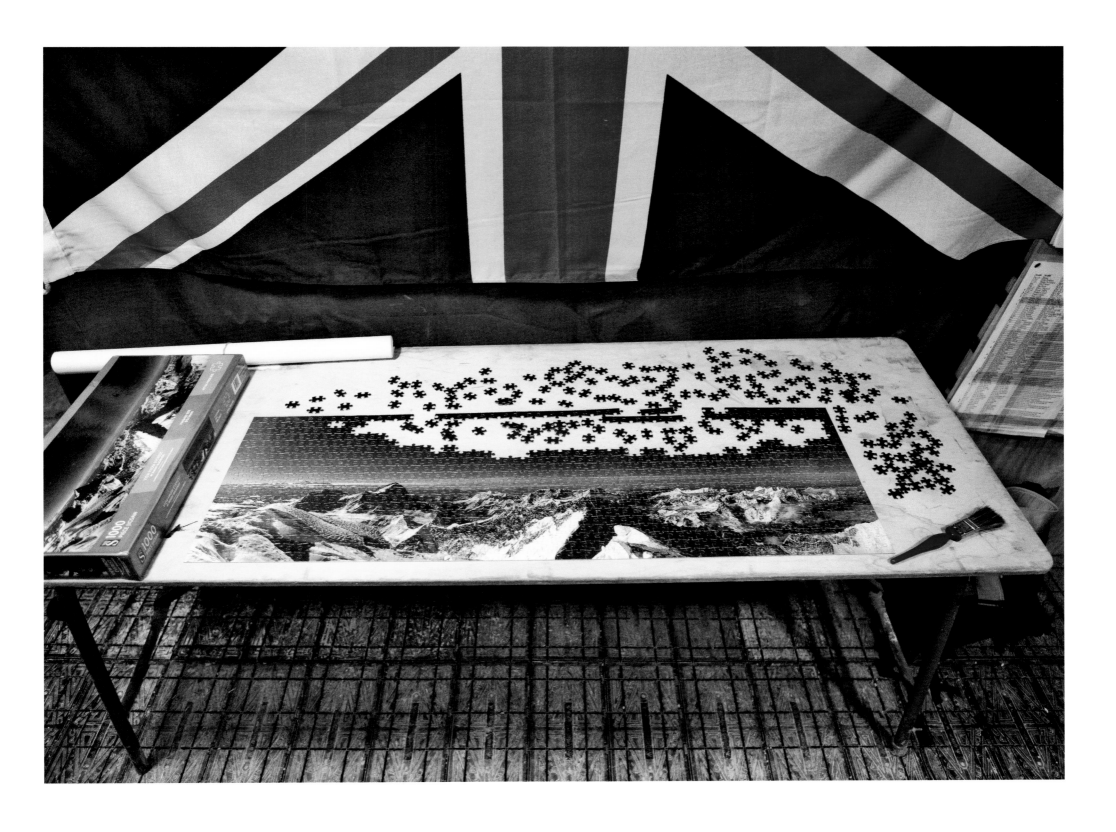

Camp Bastion

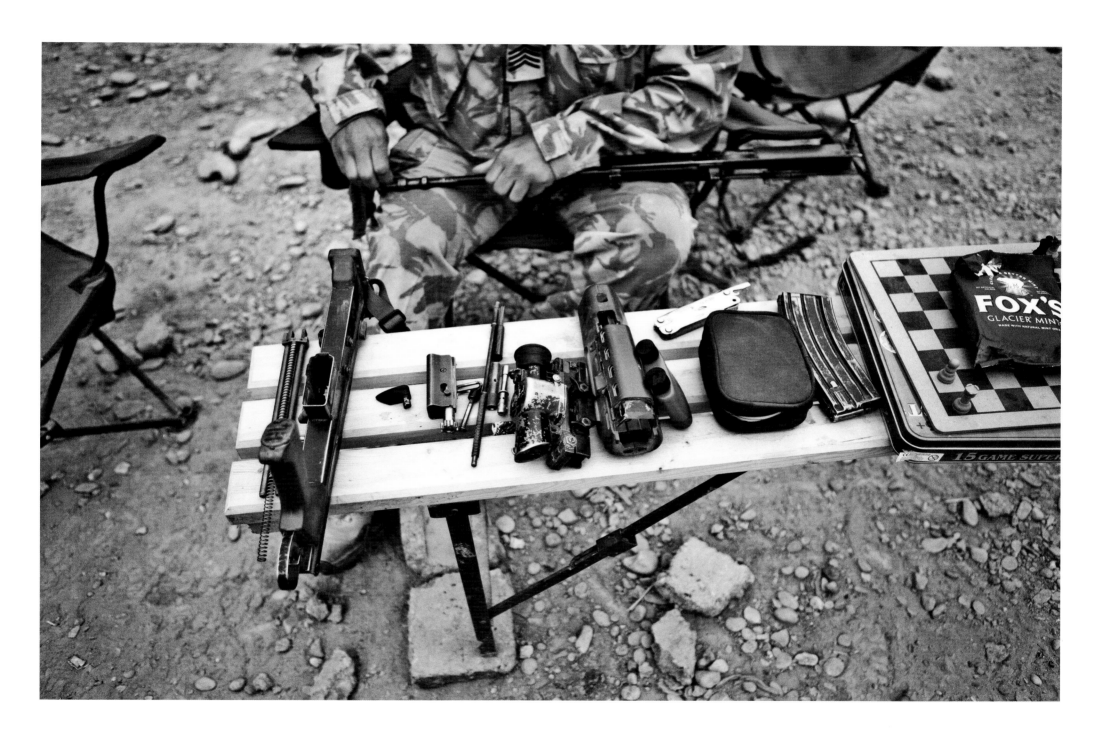

Musa Kala

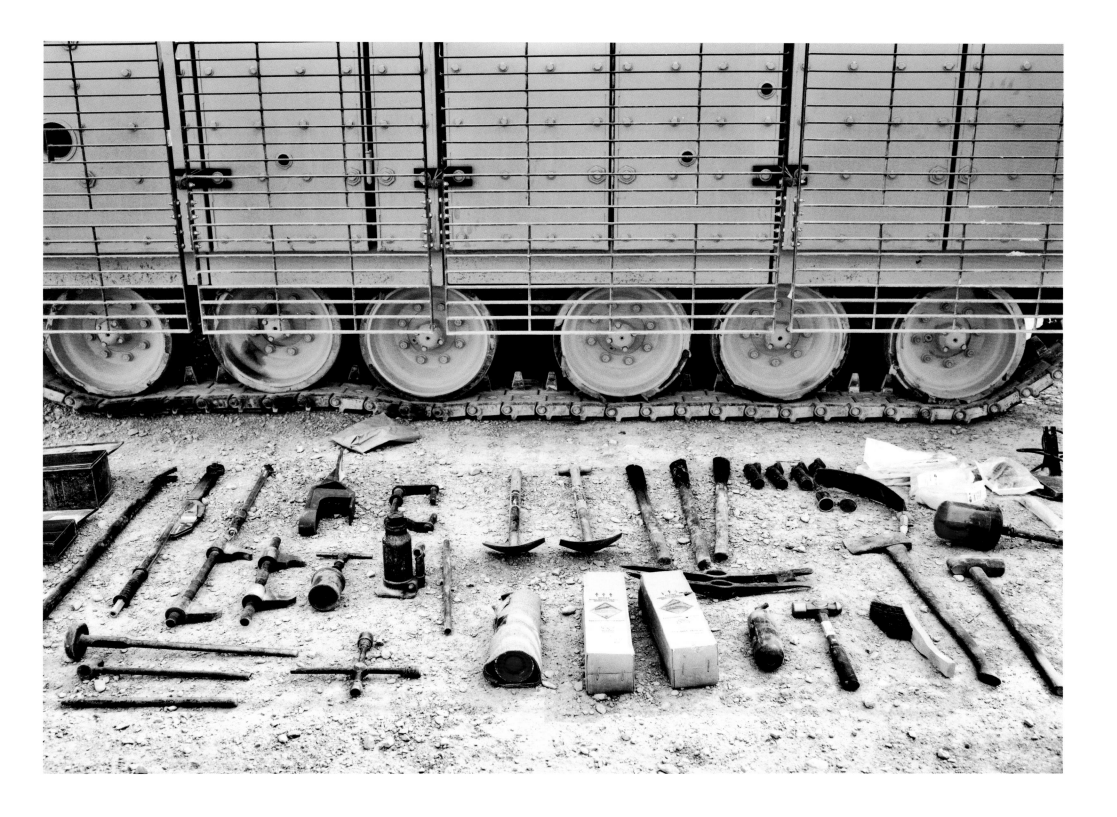

Camp Bastion

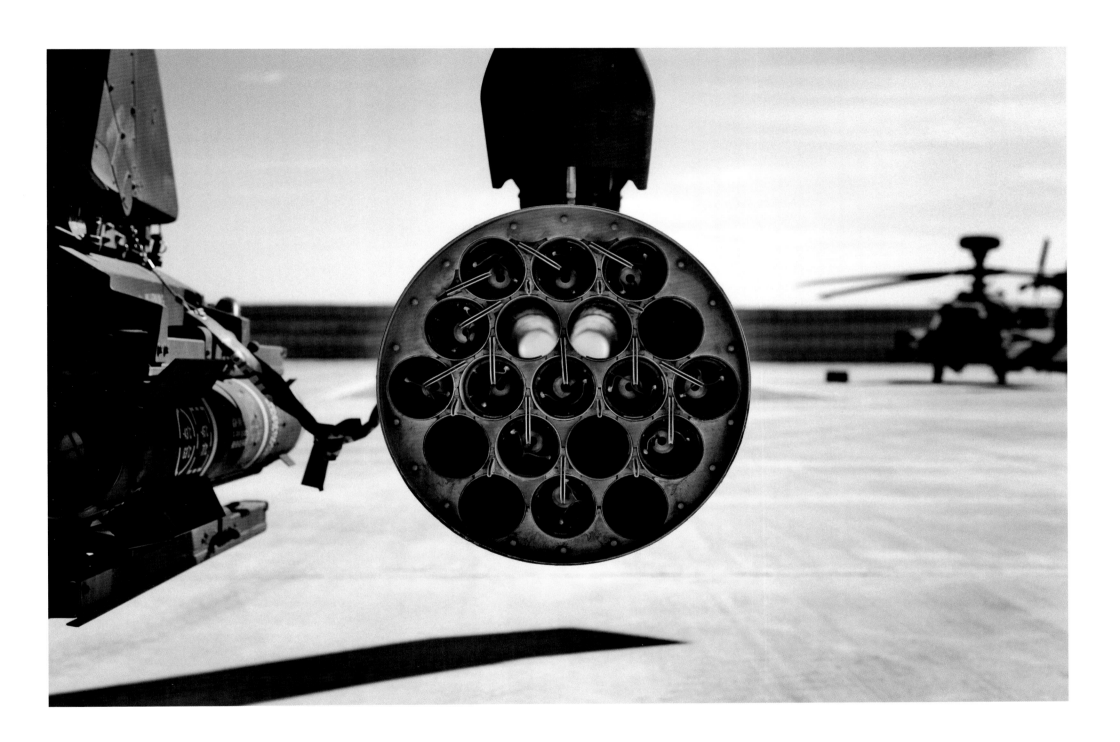

Rocket pod on the side of an AH-64 Apache attack helicopter, Camp Bastion

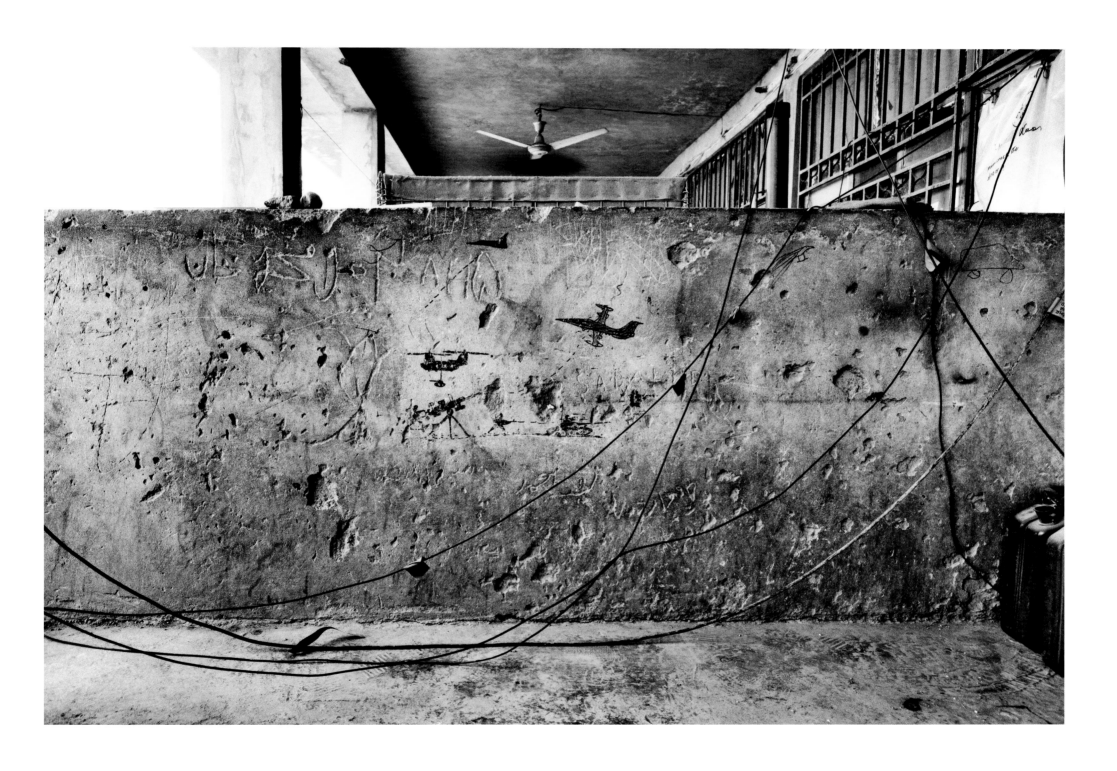

Taliban graffiti, Musa Kala

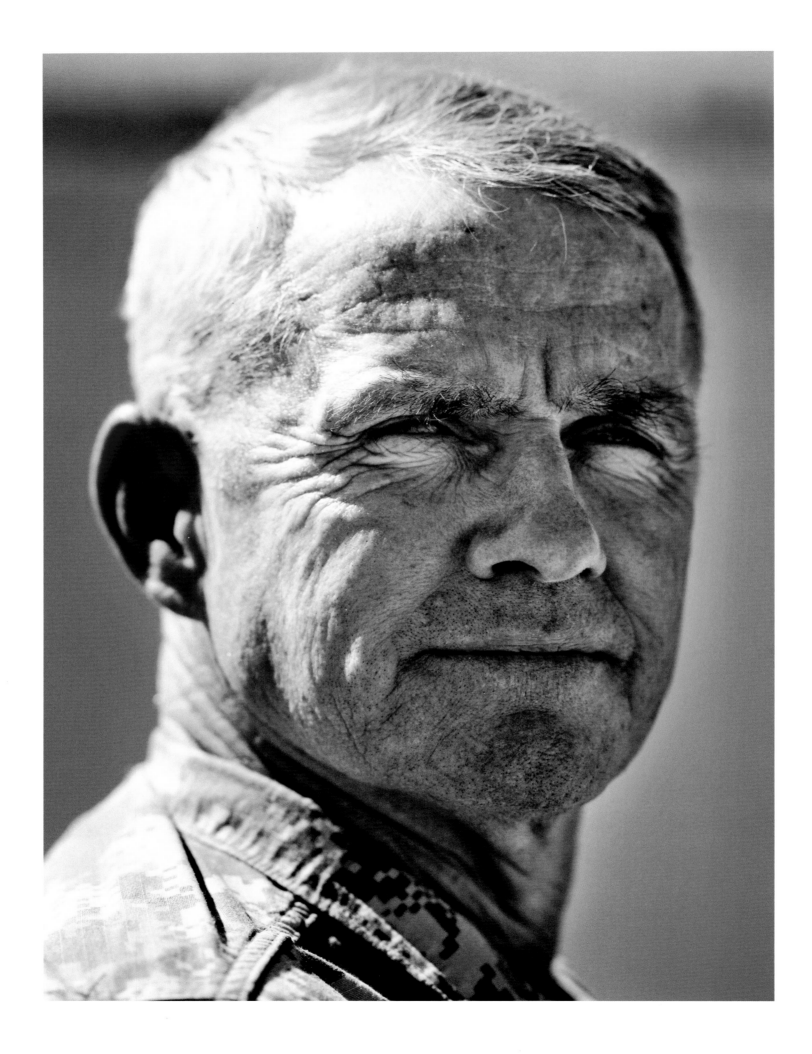

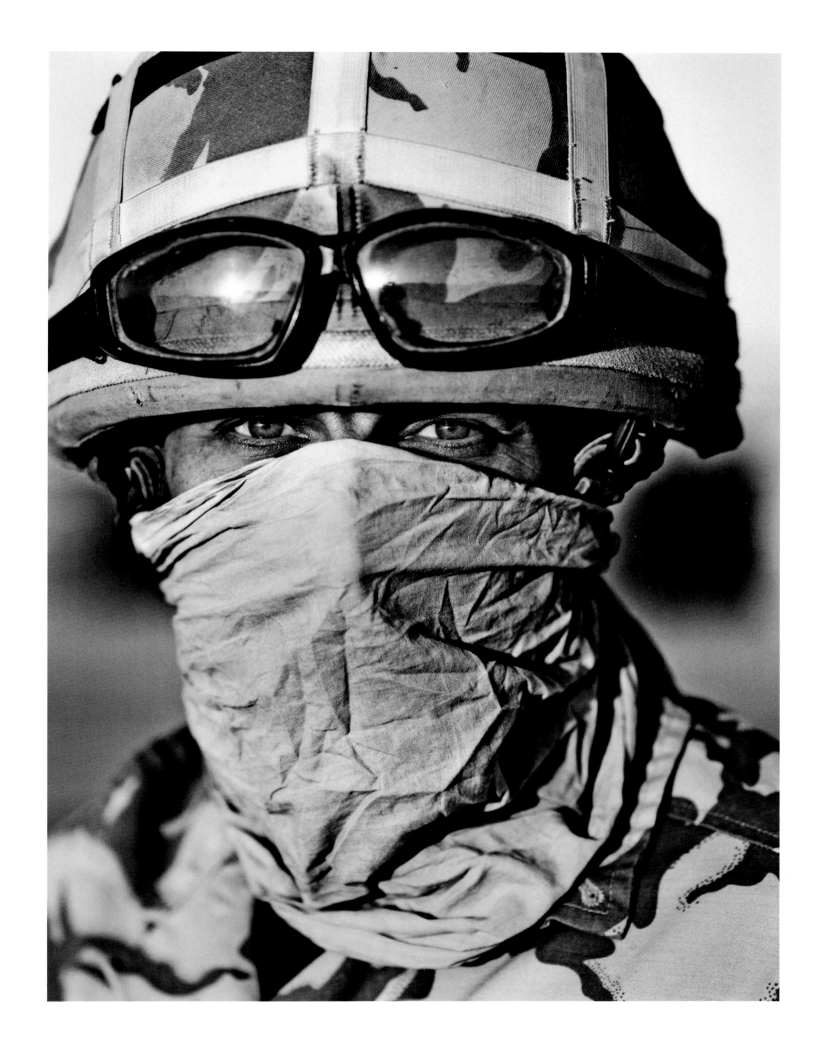

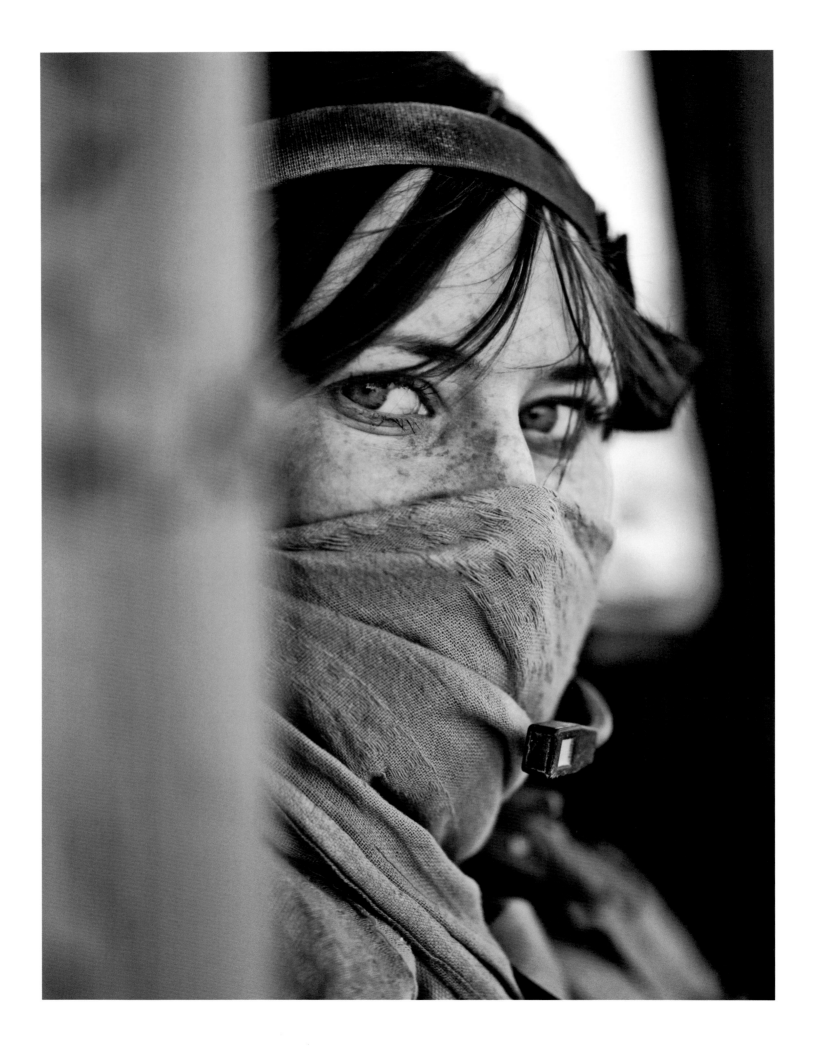

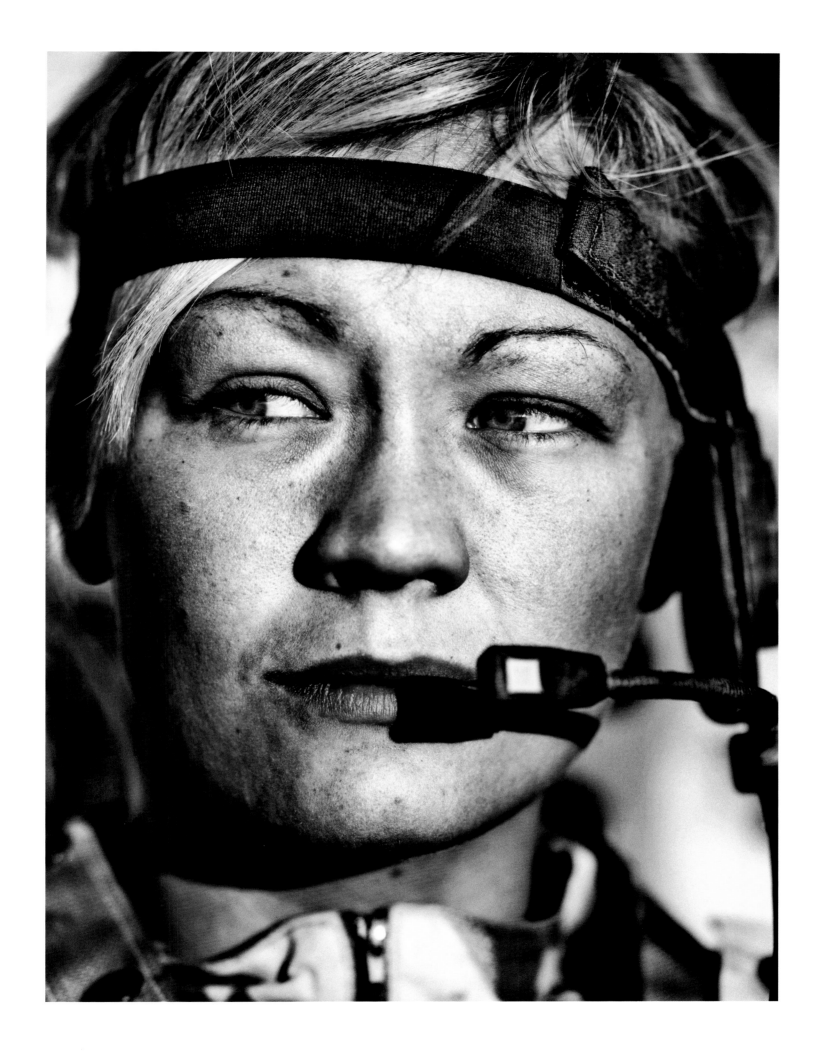

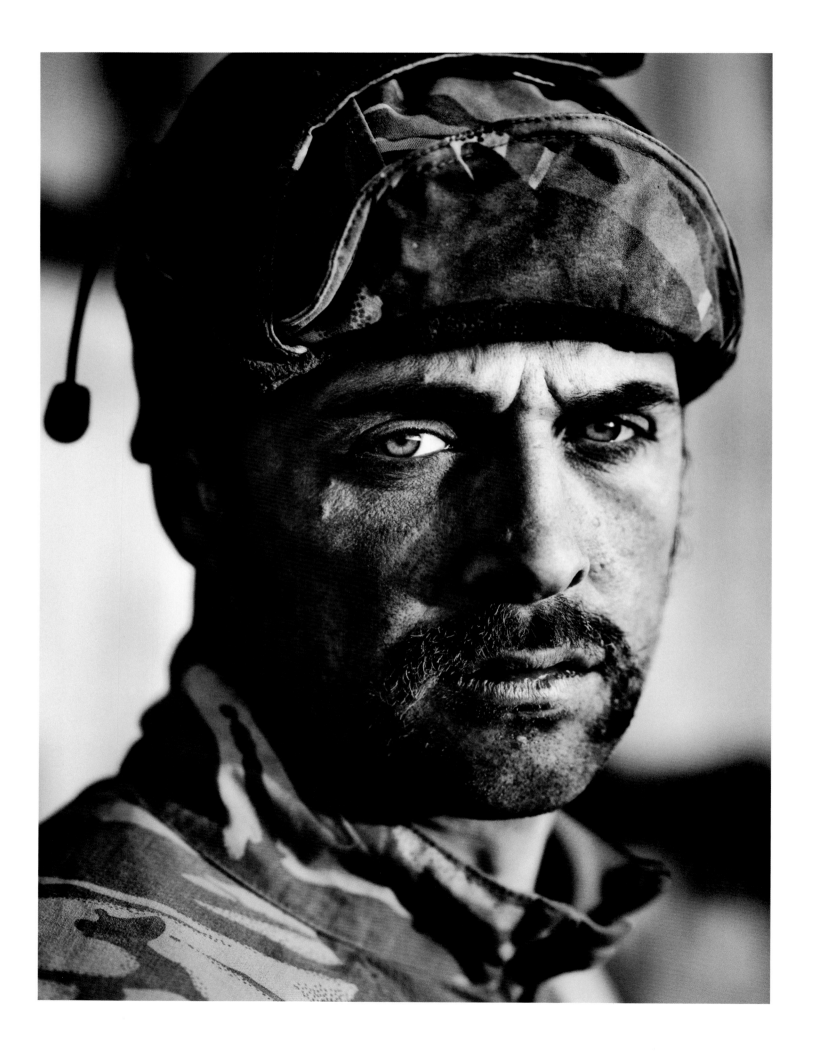

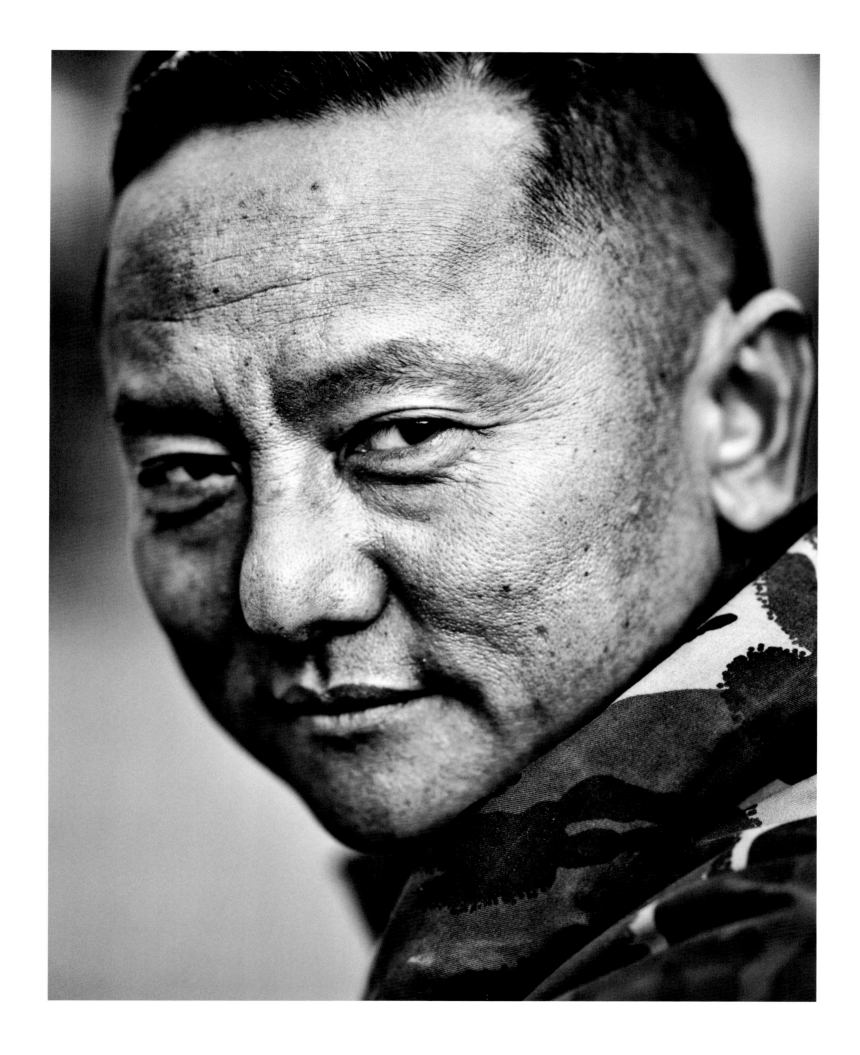

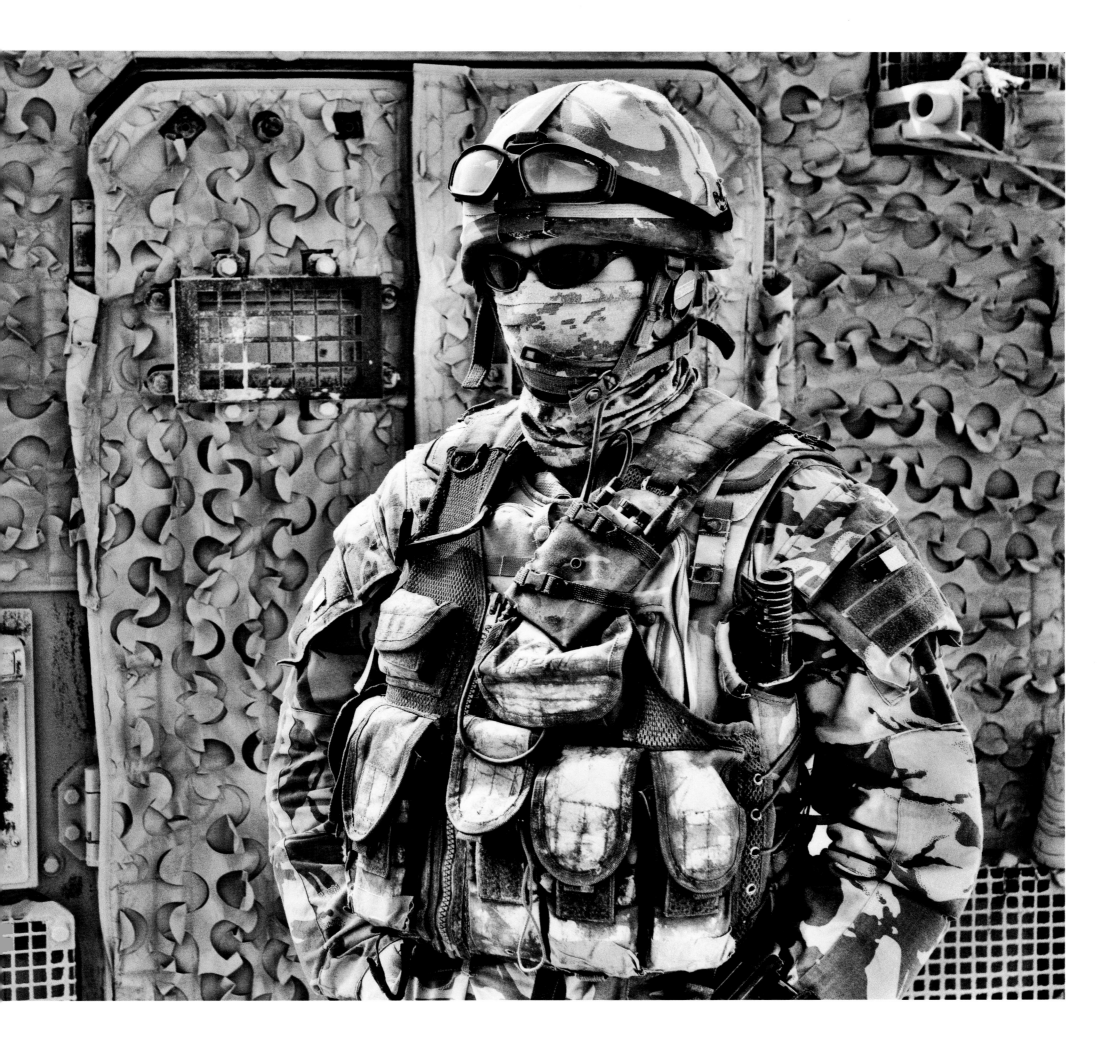

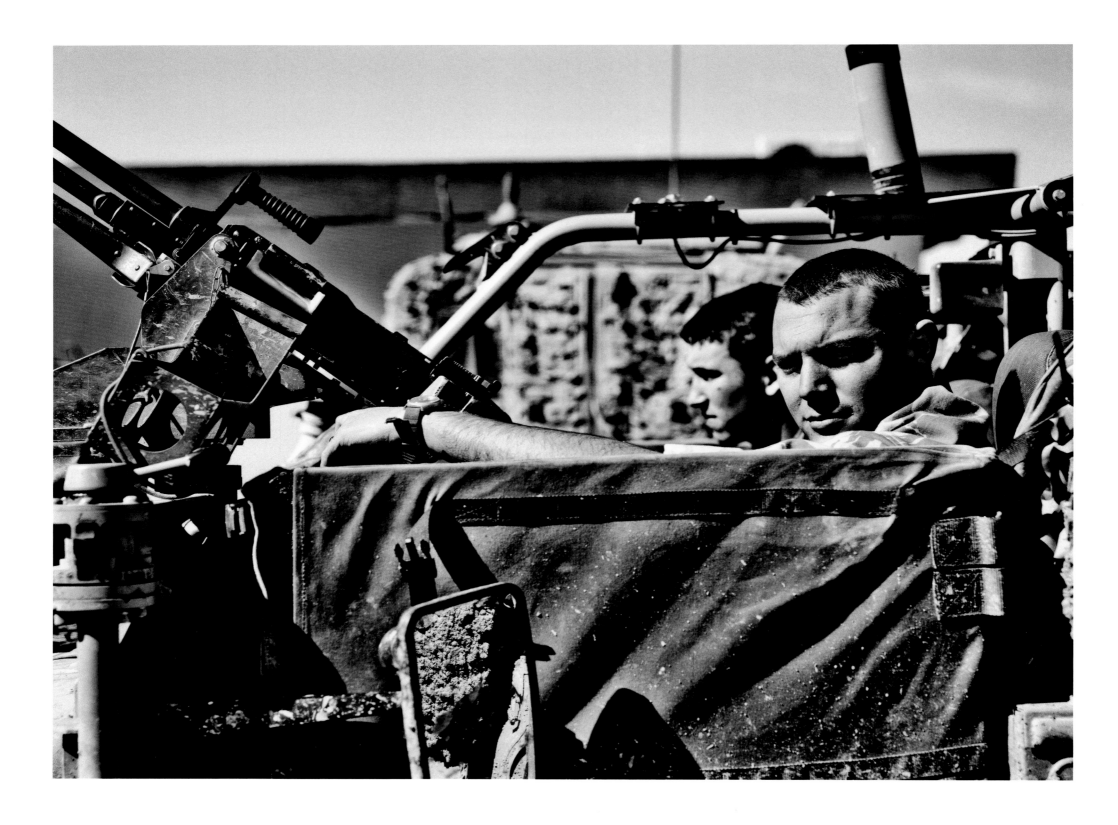

Lashkar Gah

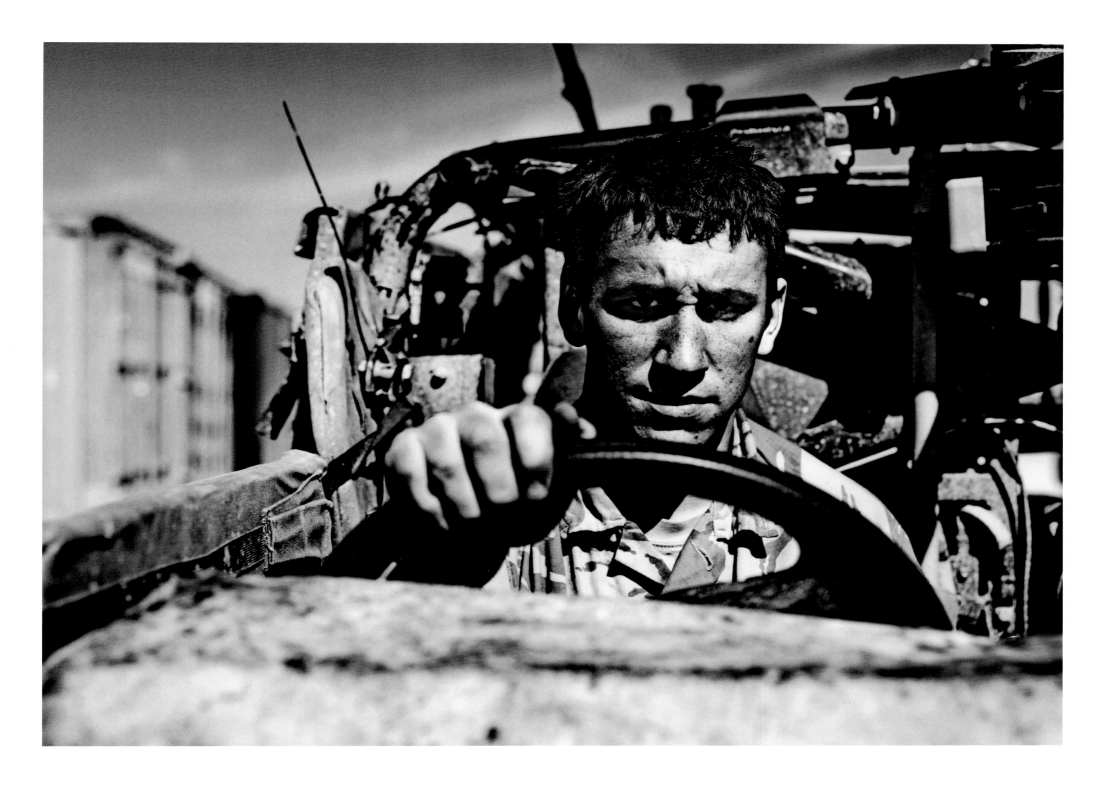

Lashka Gah

Journey from Musa Kala to FOB Edinburgh

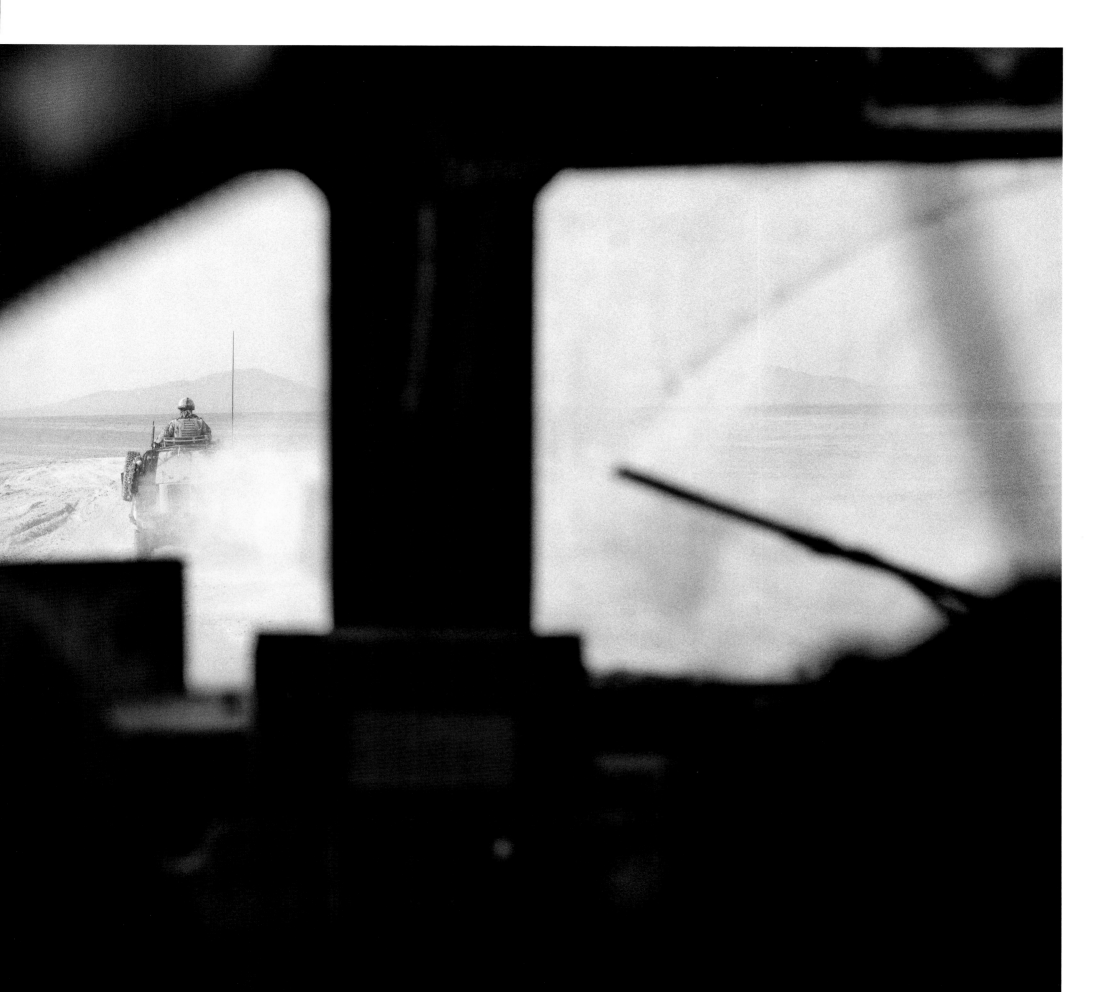

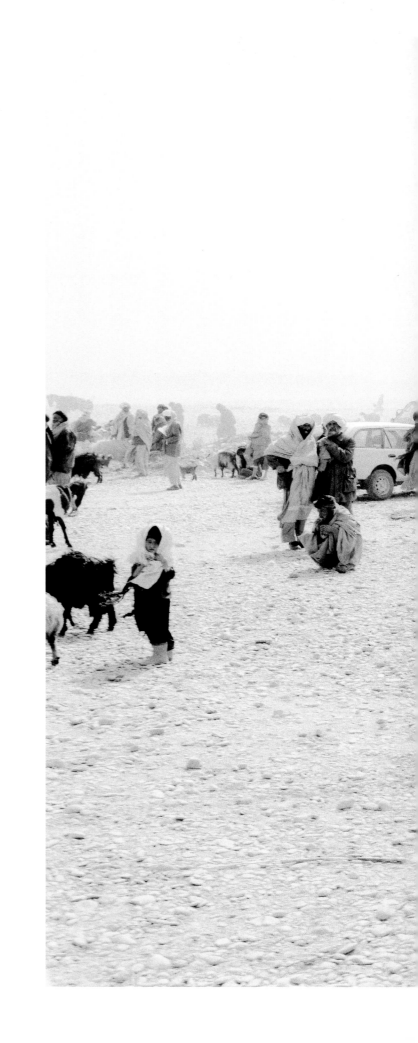

Marketplace/bazaar, Musa Kala

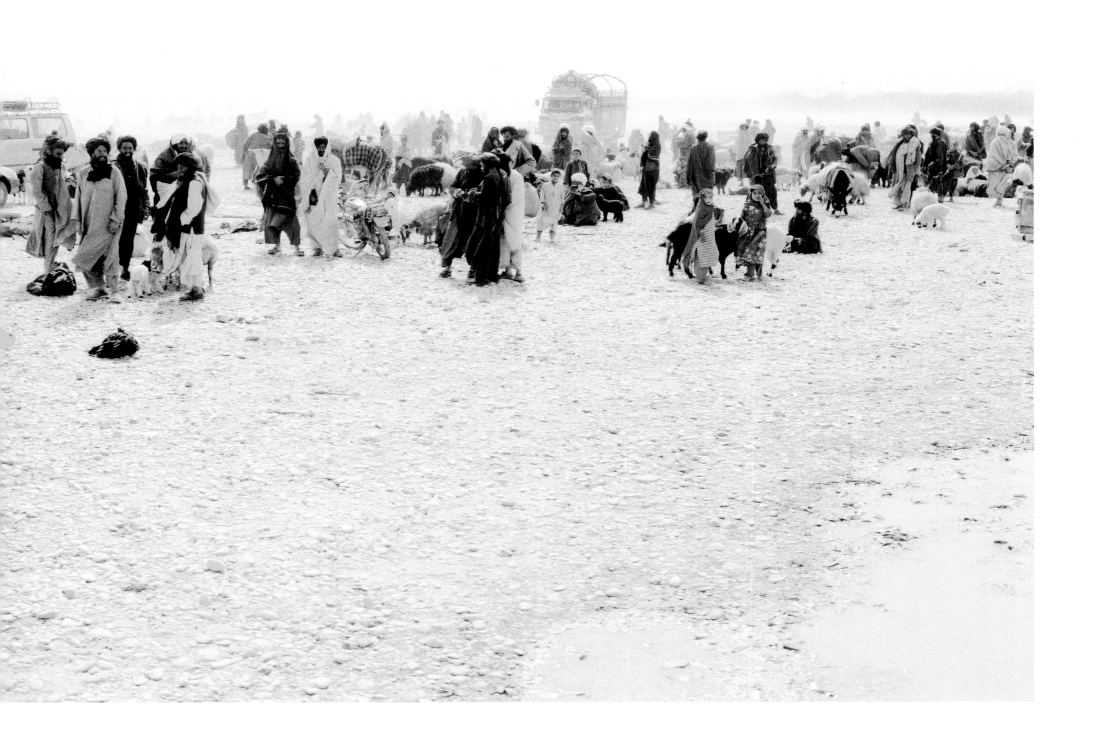

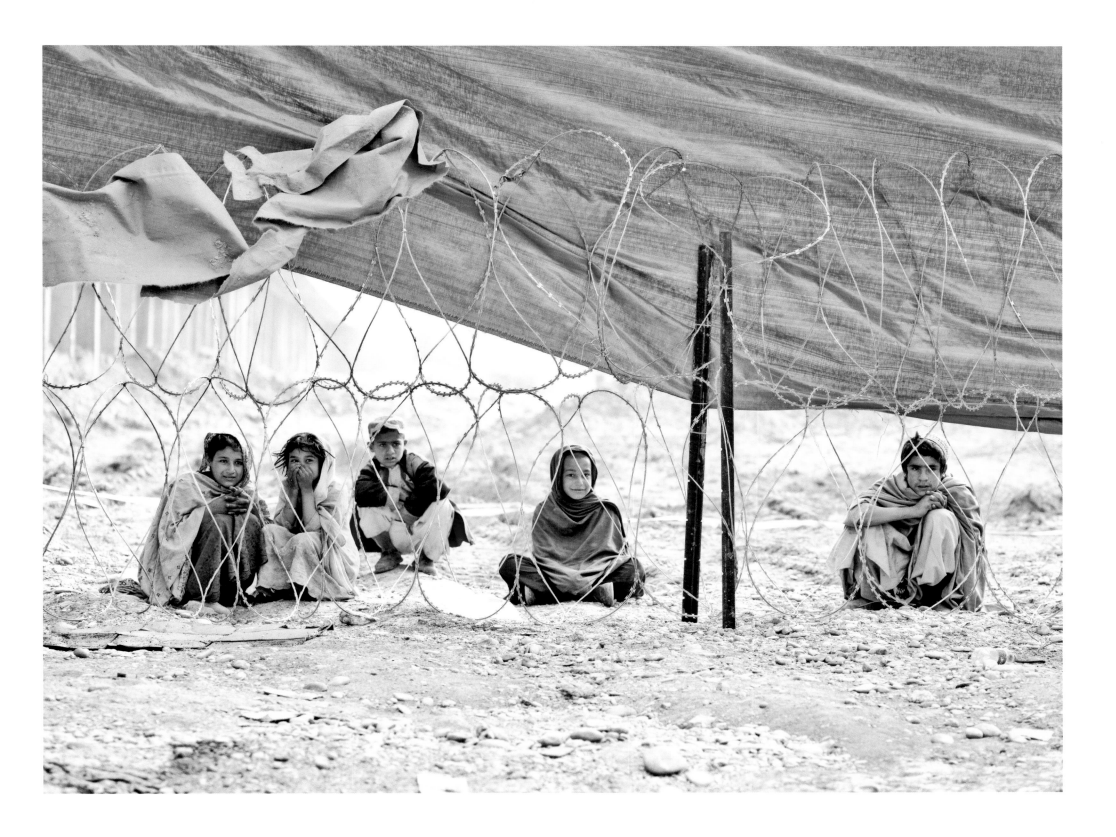

Aid point, Musa Kala

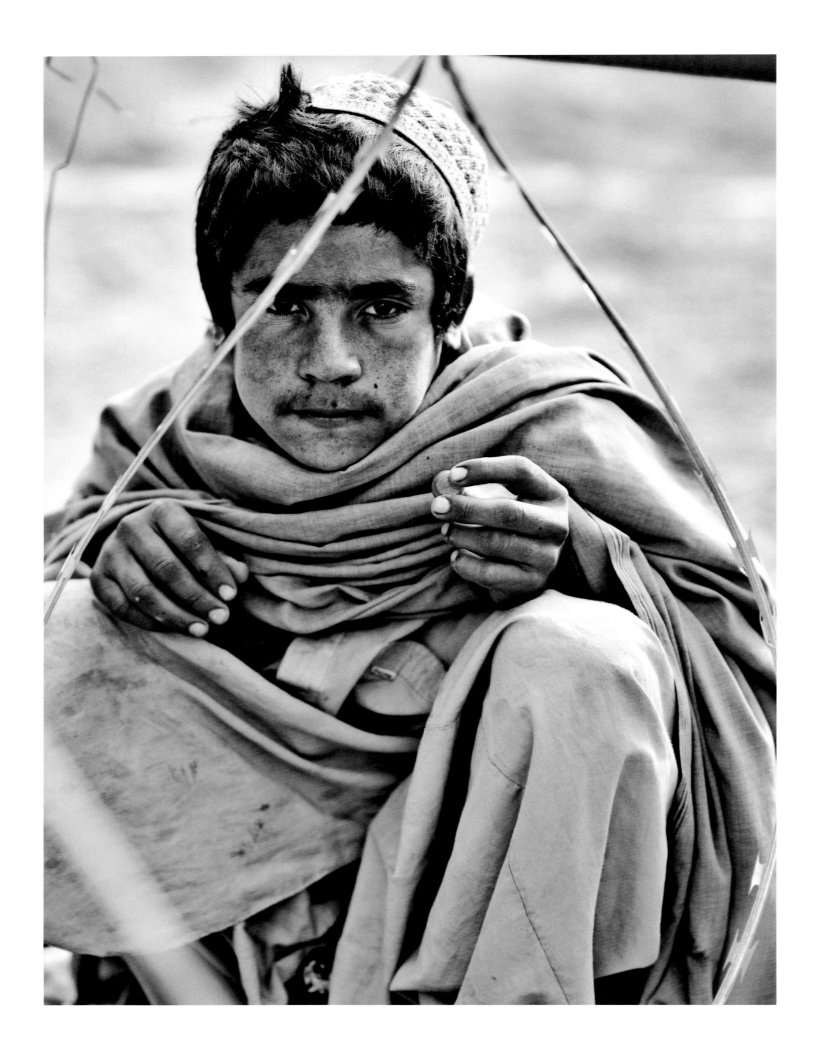

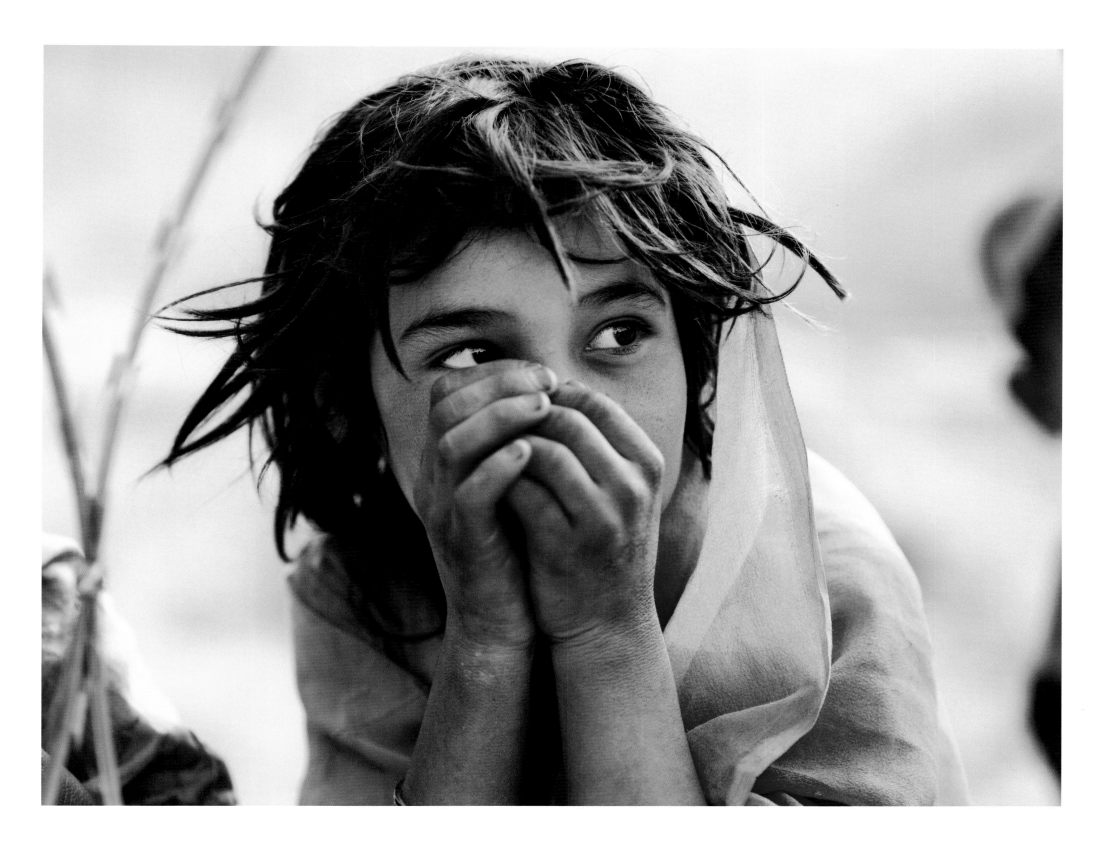

Aid point, Musa Kala

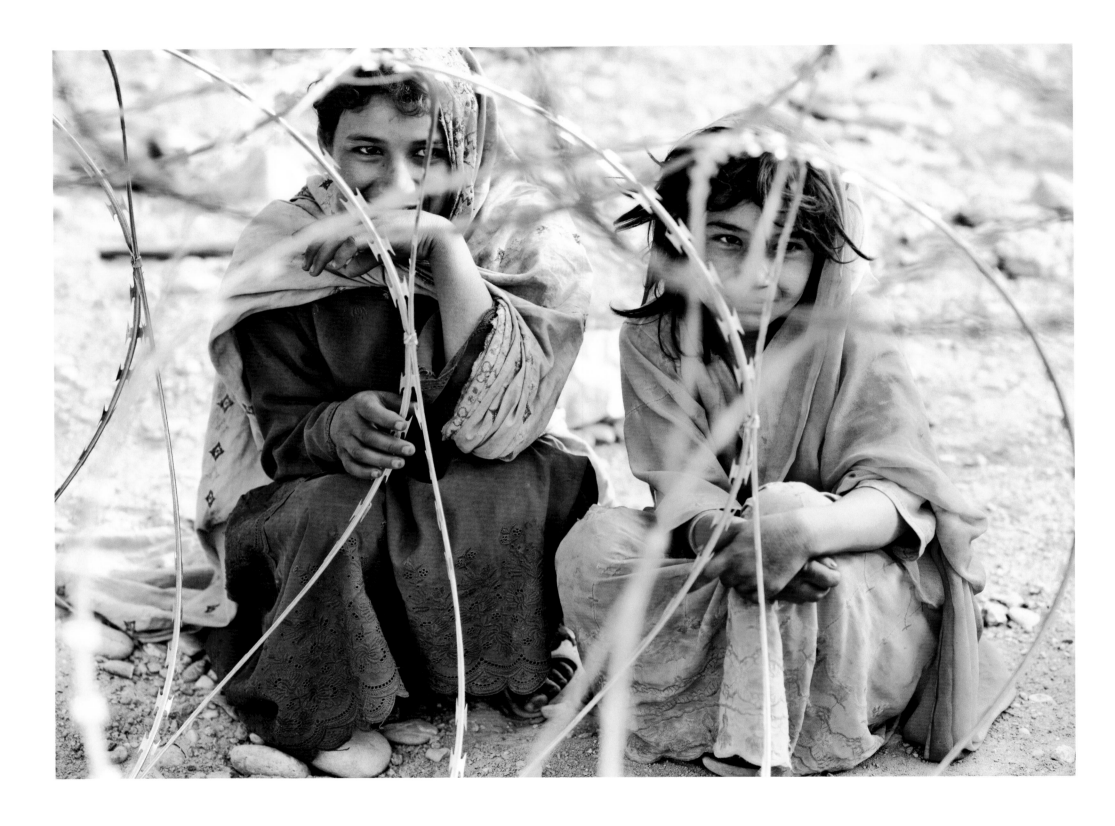

Aid point, Musa Kala

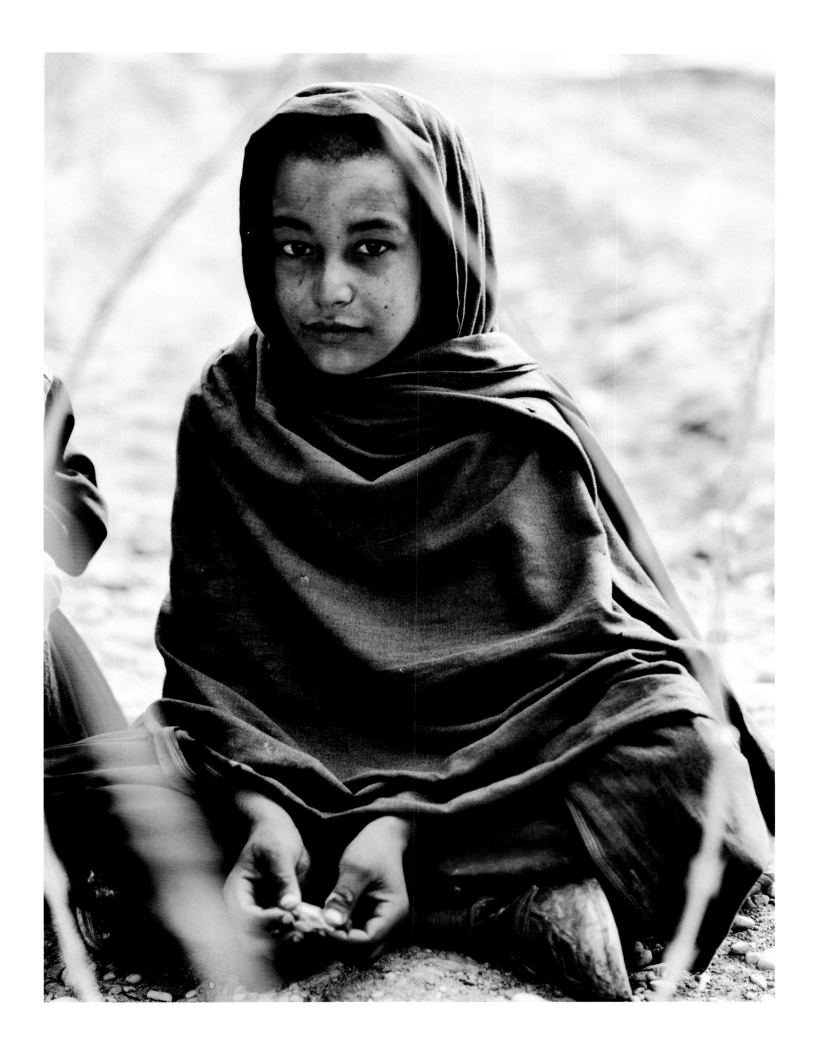

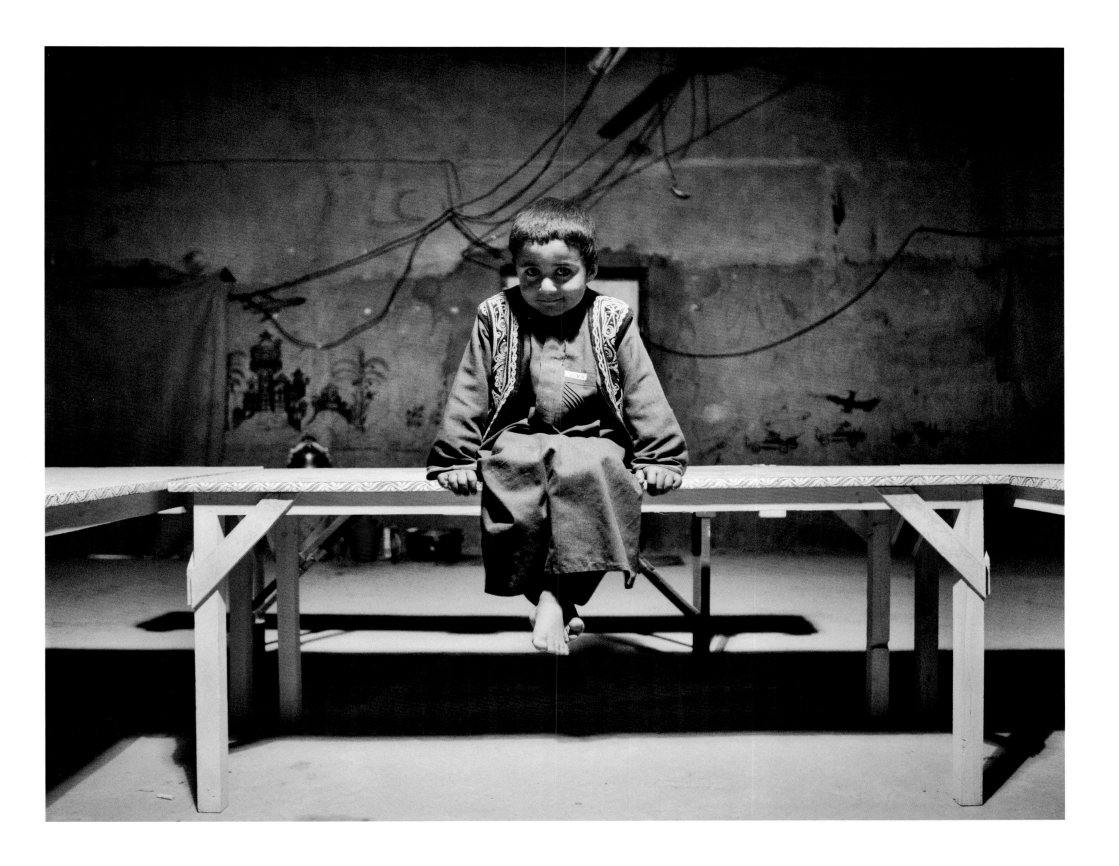

Abdul Halik (son of Mullah Salaam), Musa Kala

Former Taliban warlord, Mullah Abdul Salaam, Governor of Musa Kala District

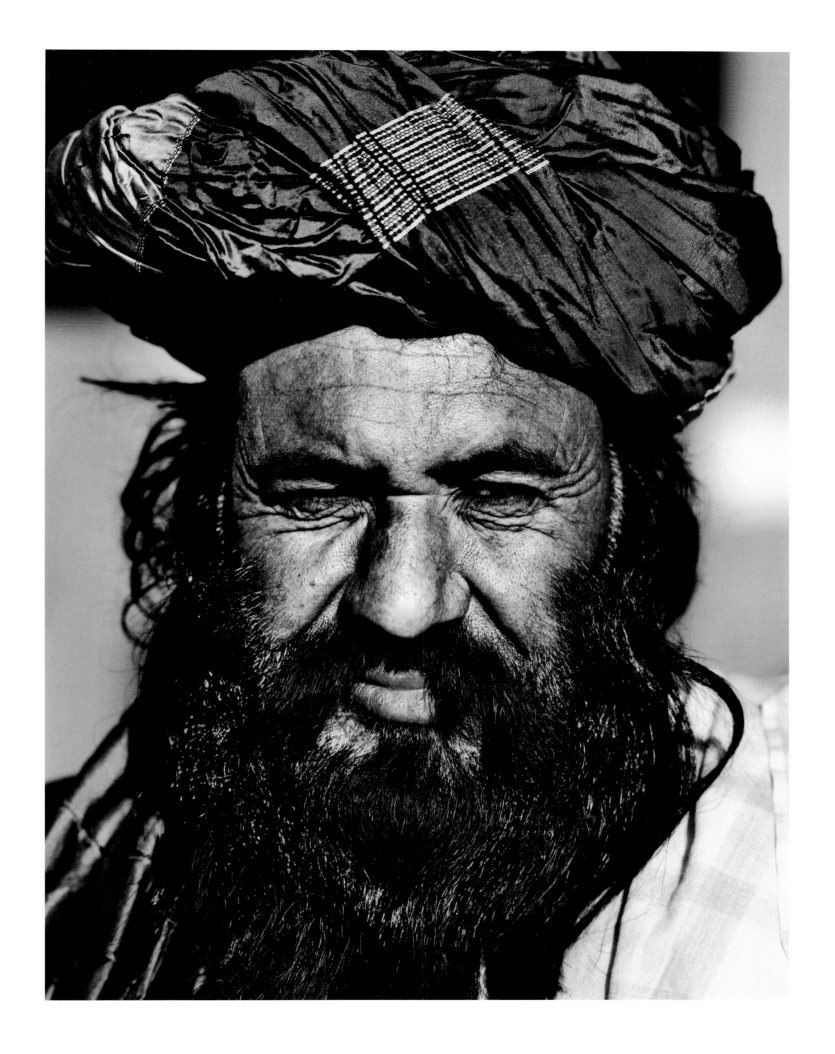

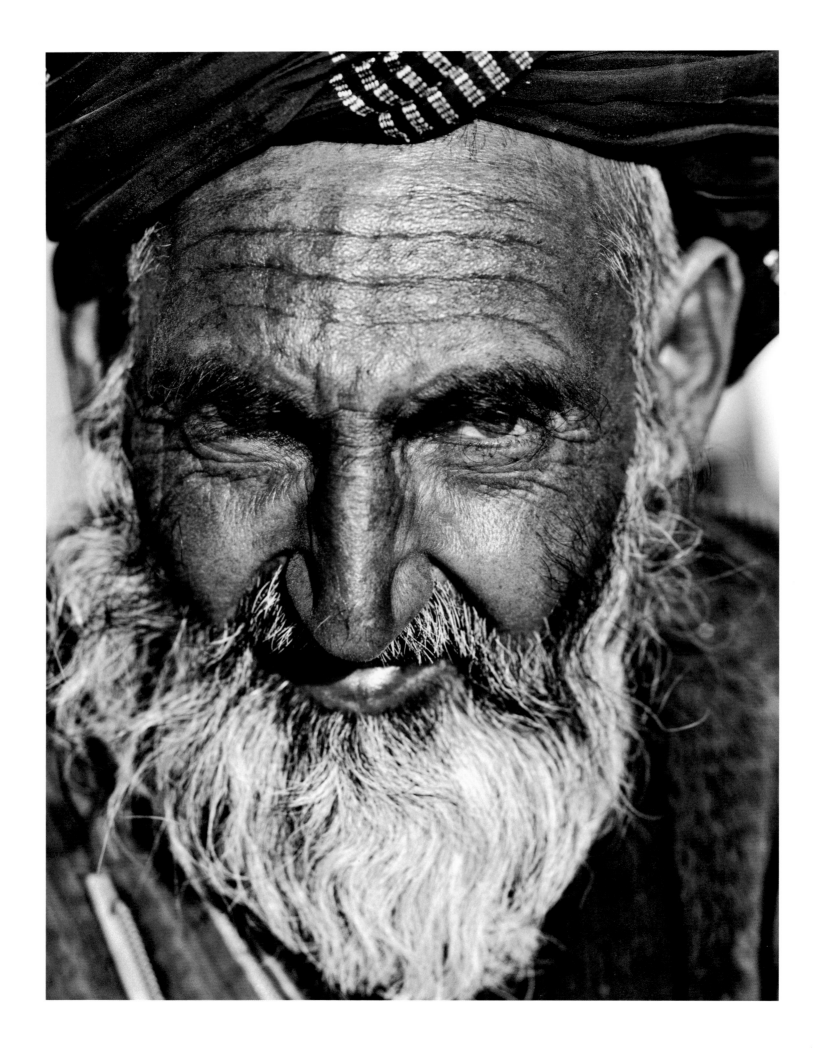

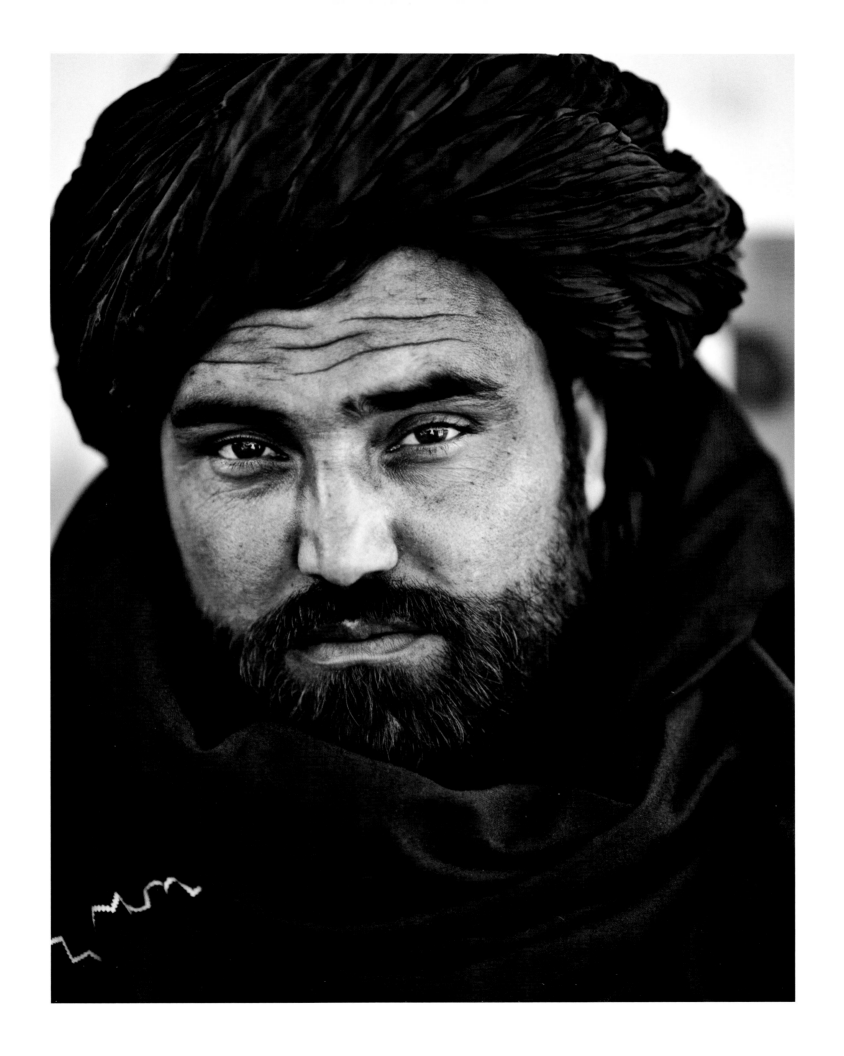

Pages 106 & 107: Lashkar Gah

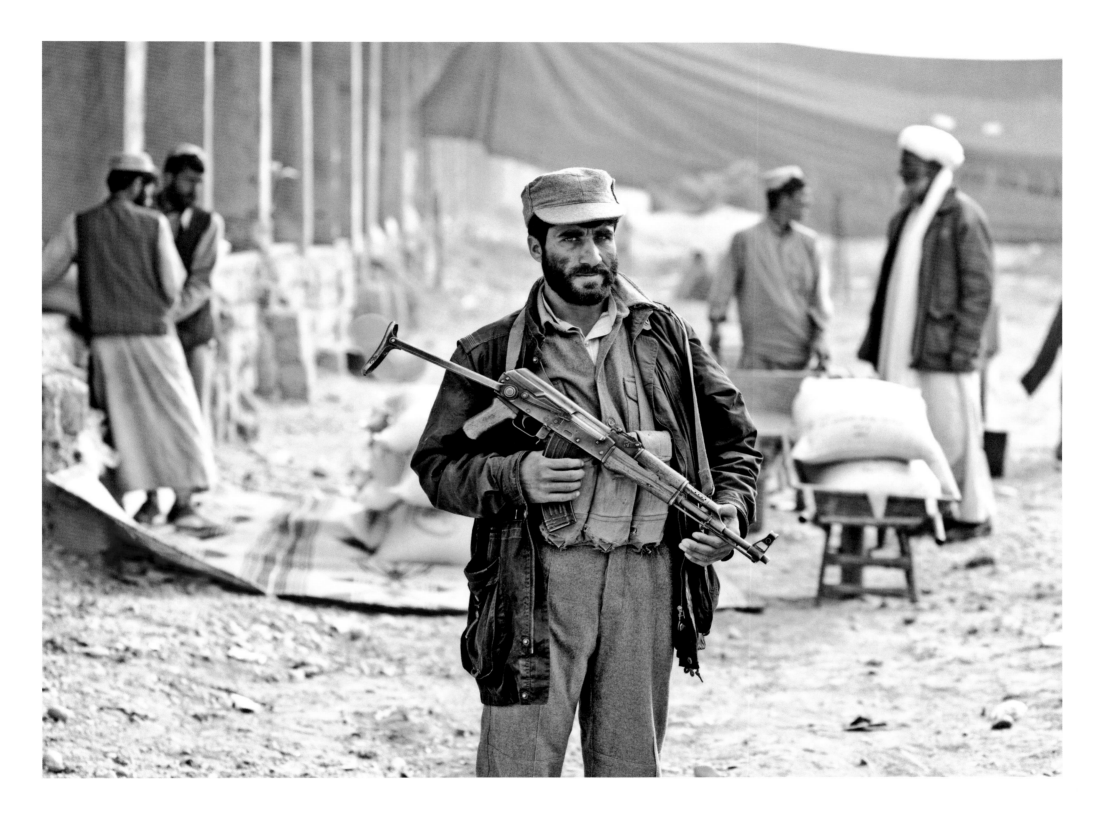

Aid point, Musa Kala

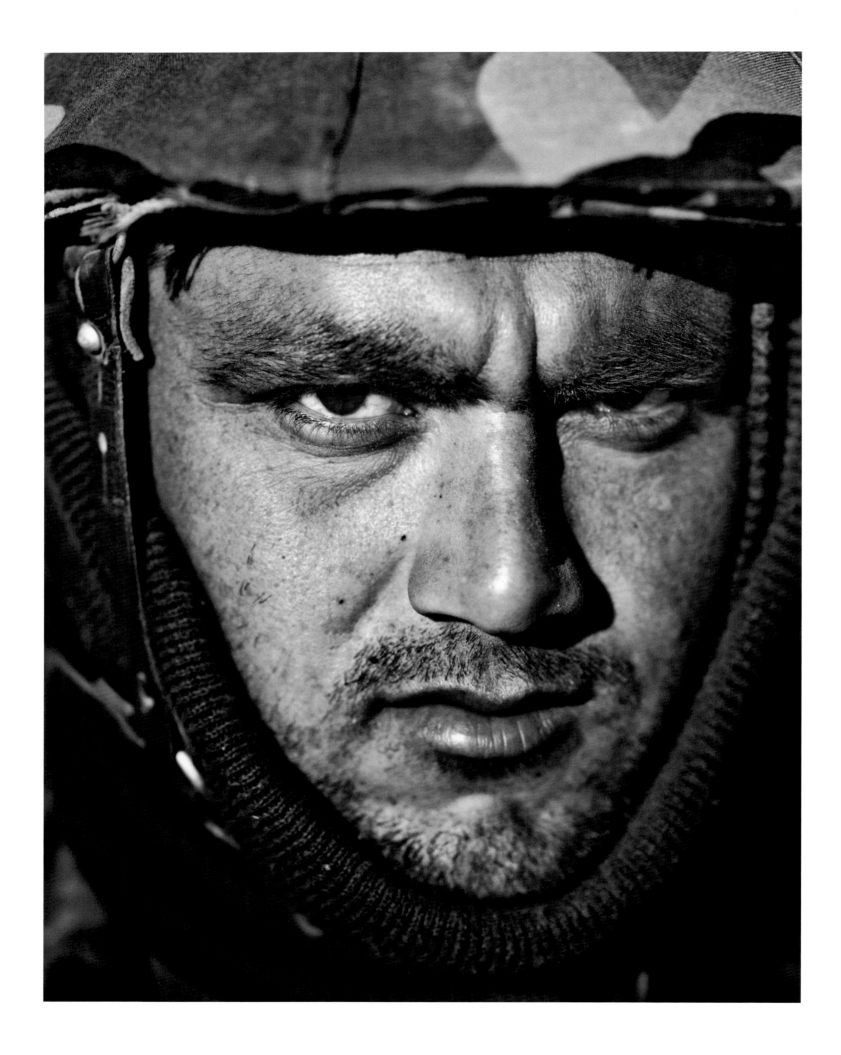

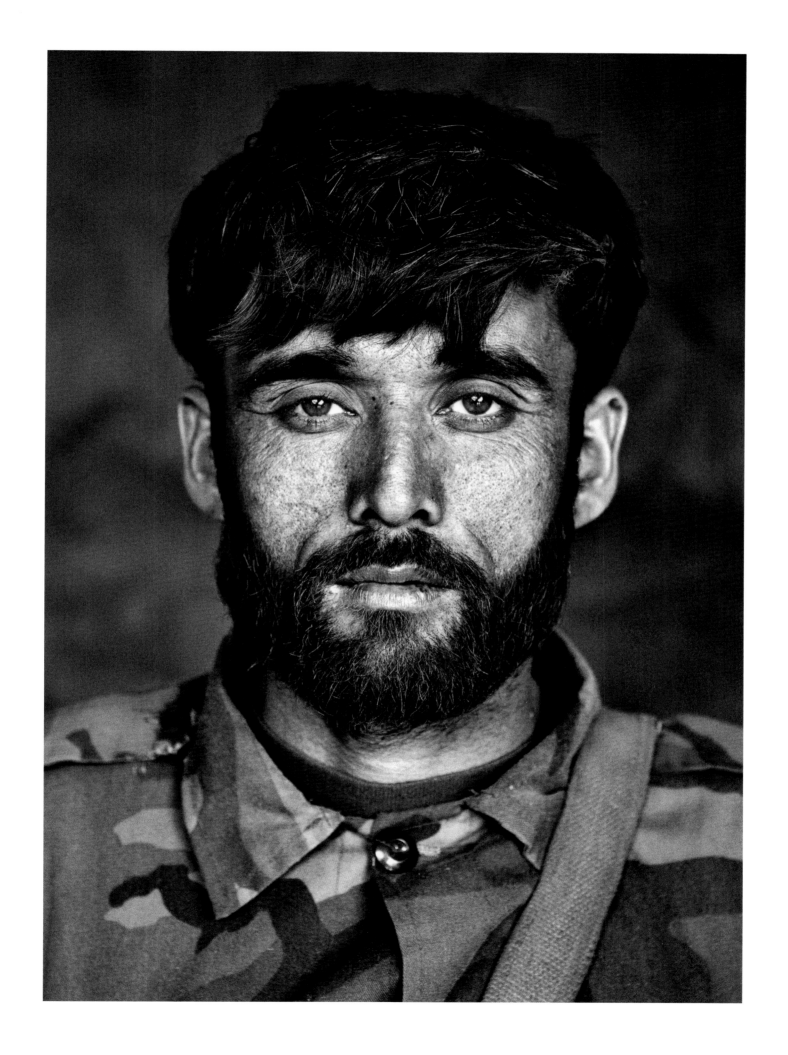

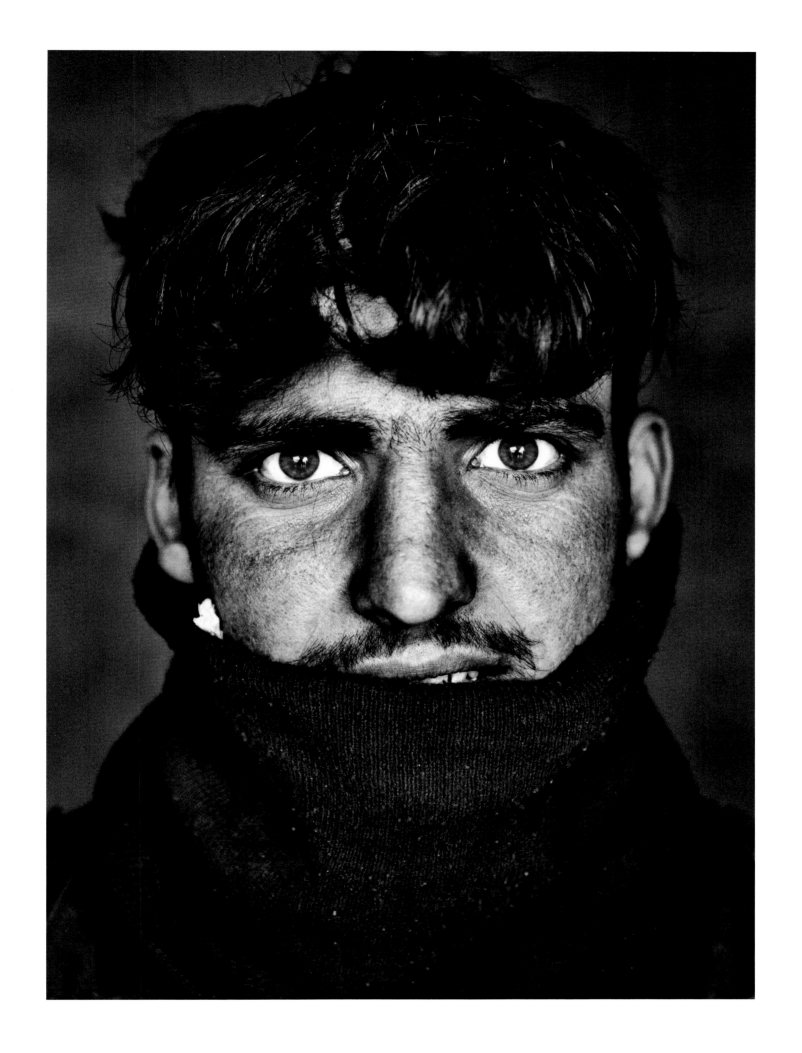

FOB Edinburgh

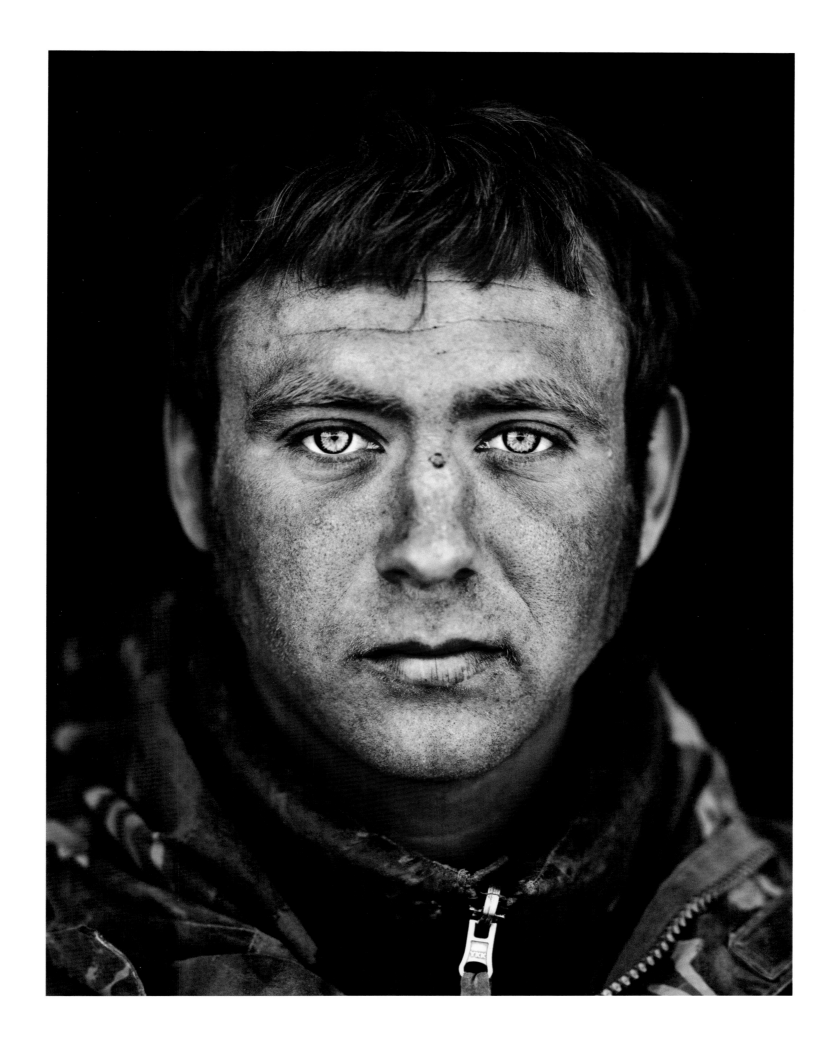

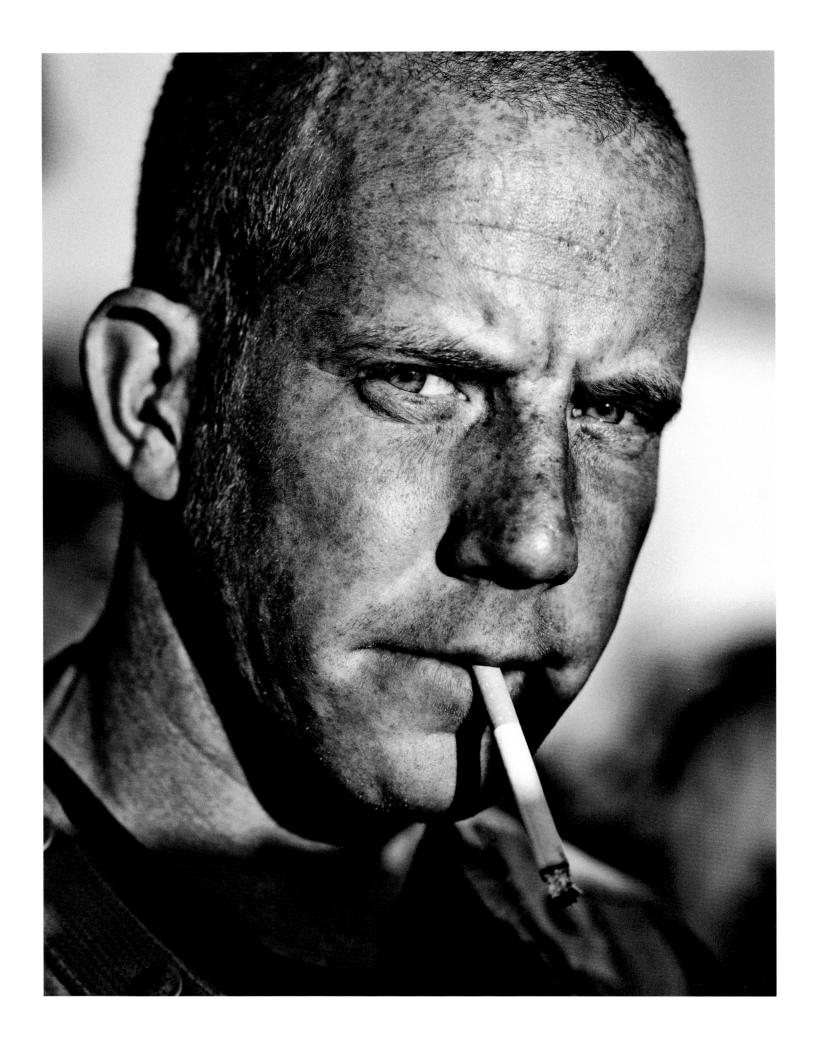

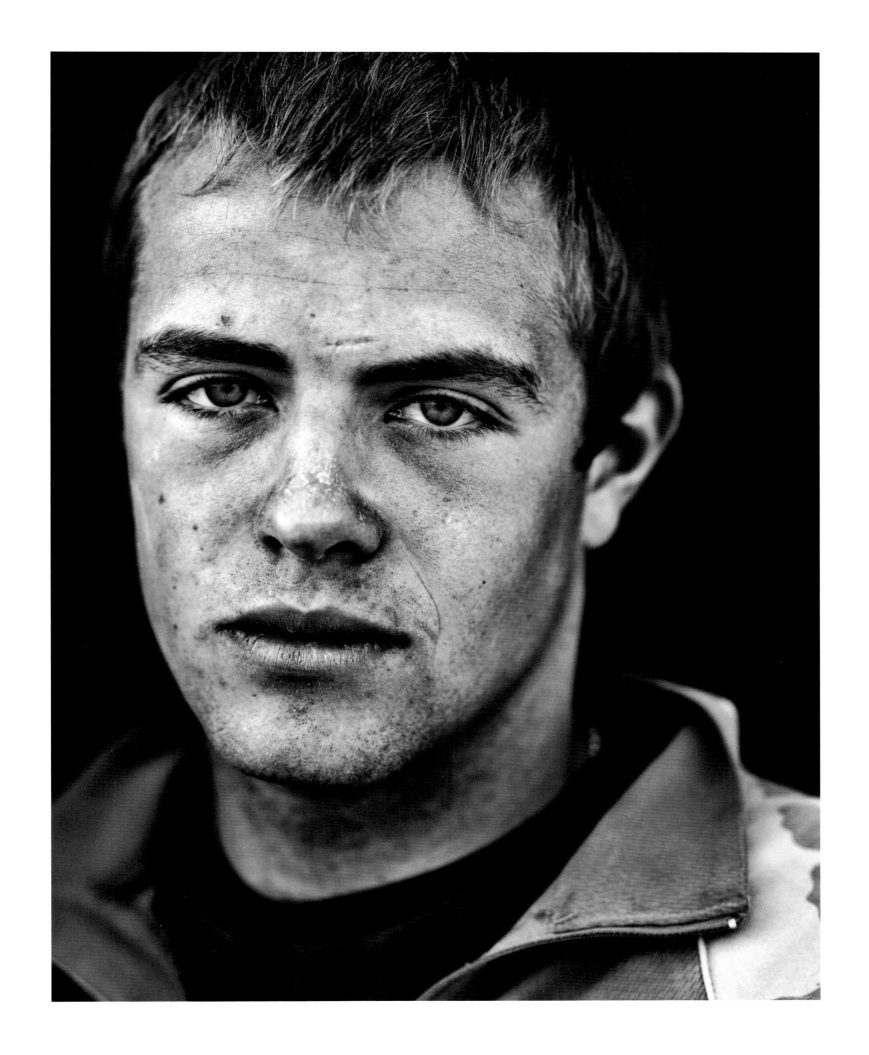

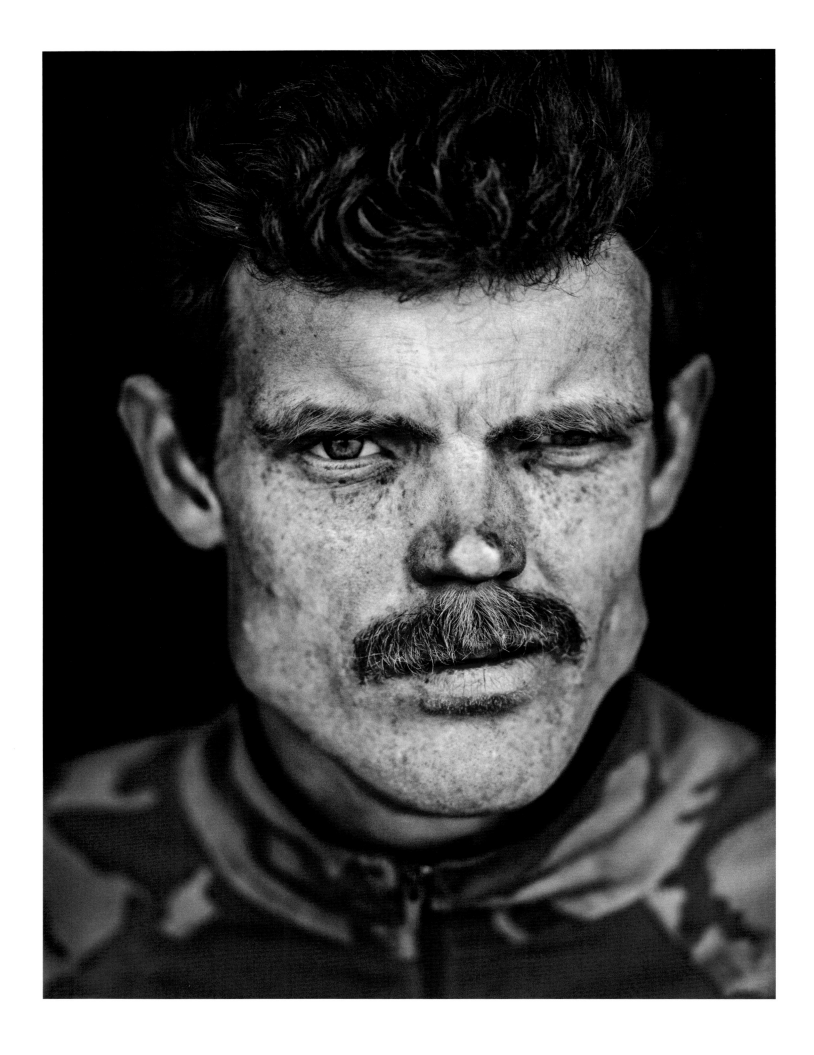

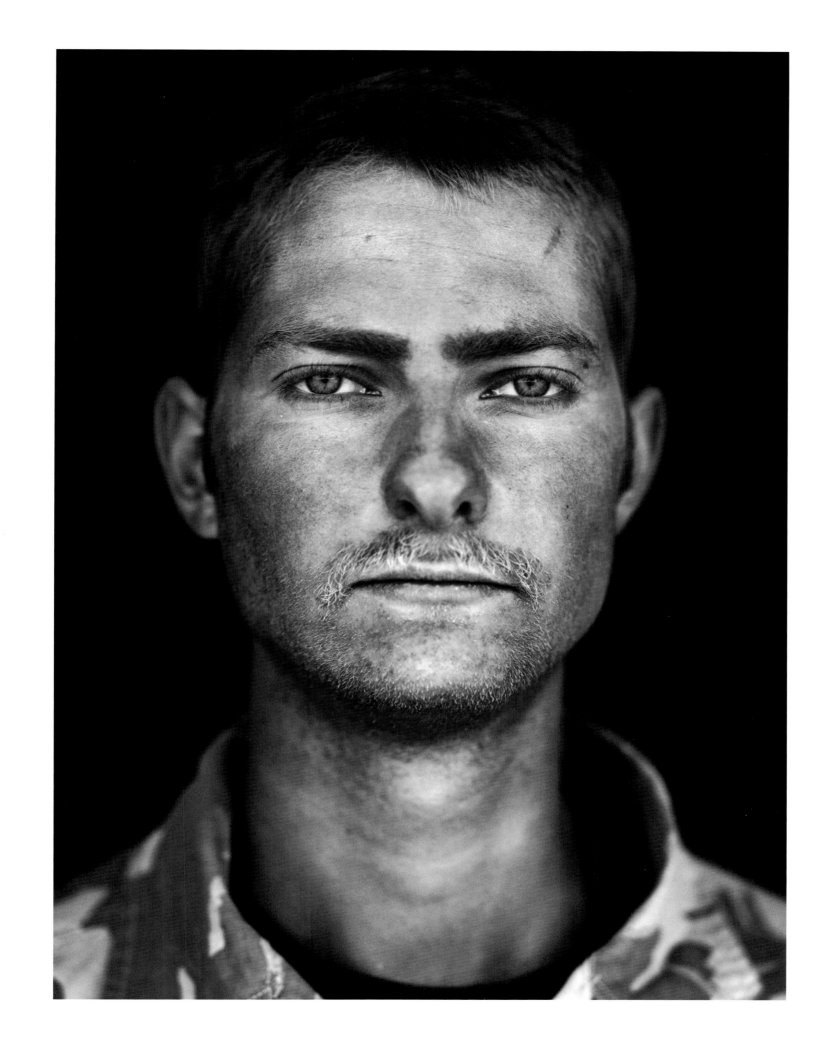

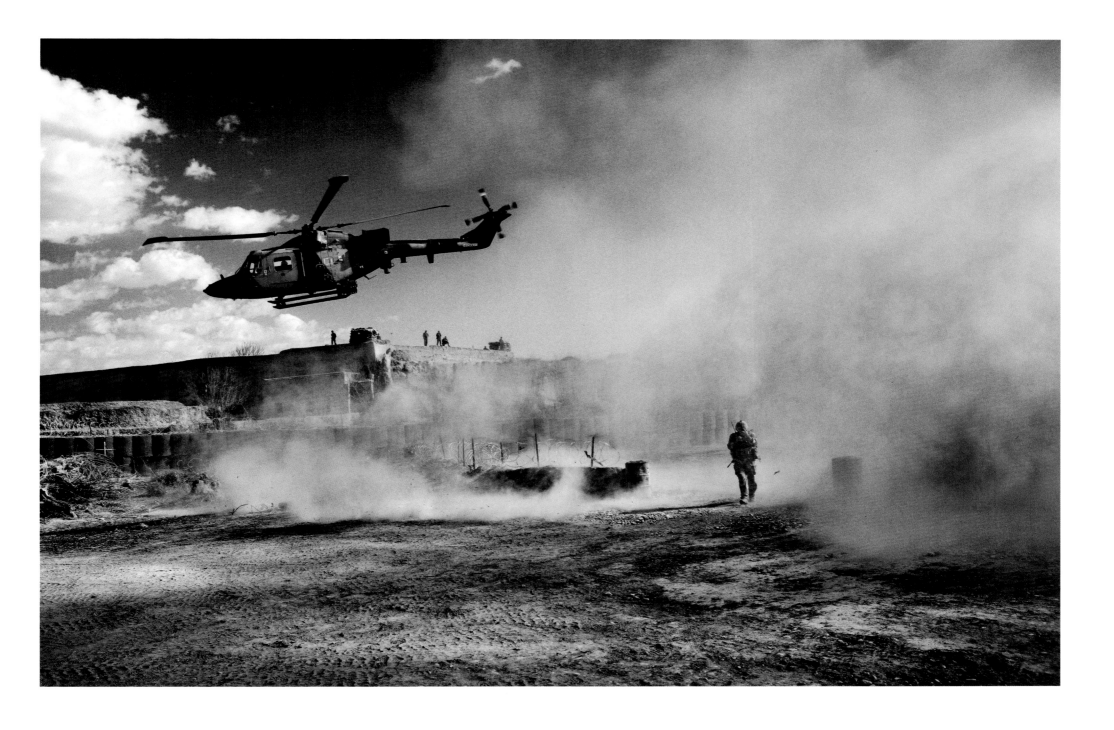

Musa Kala

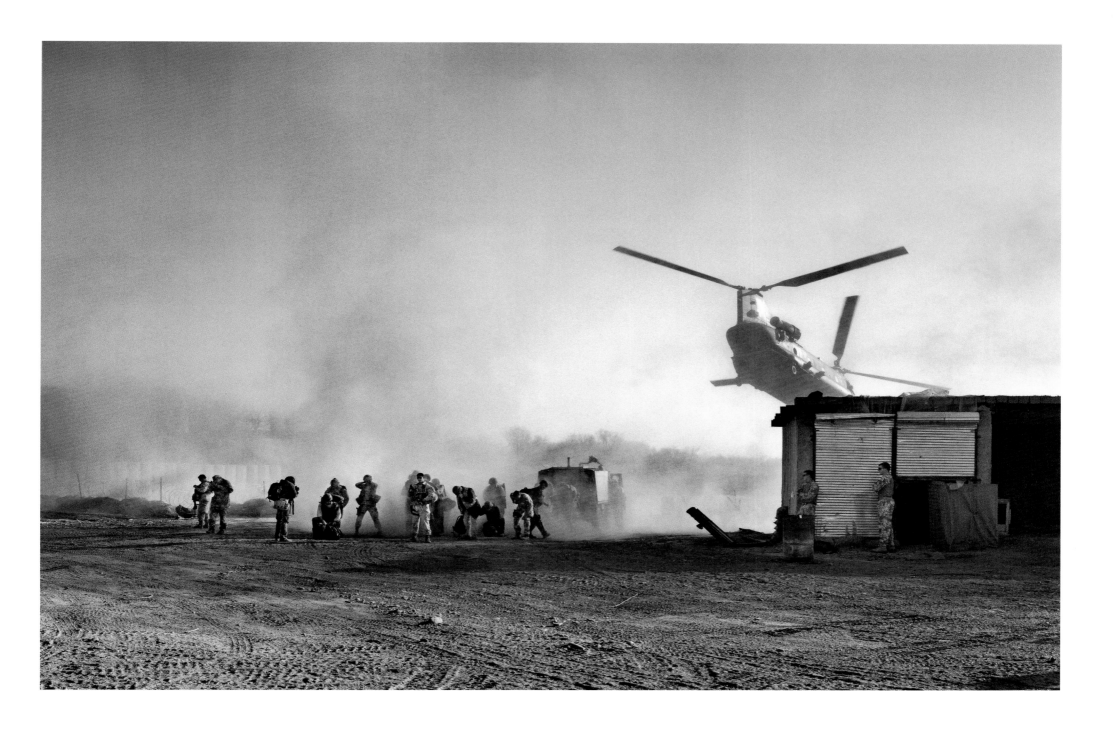

Musa Kala

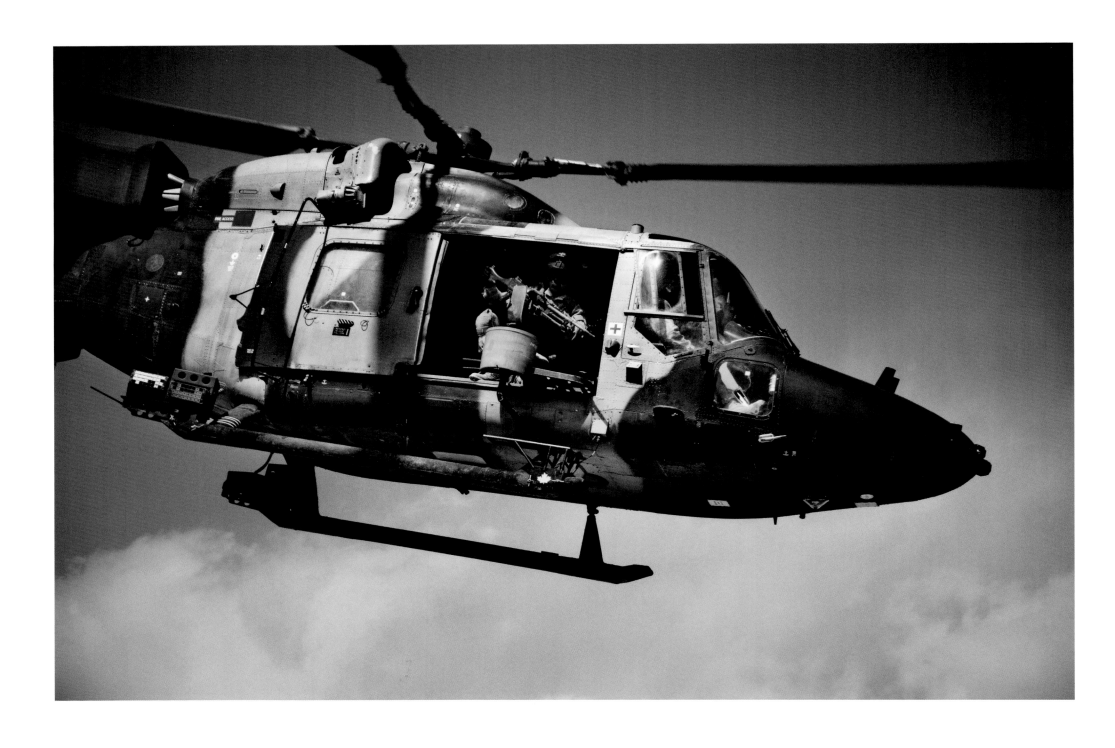

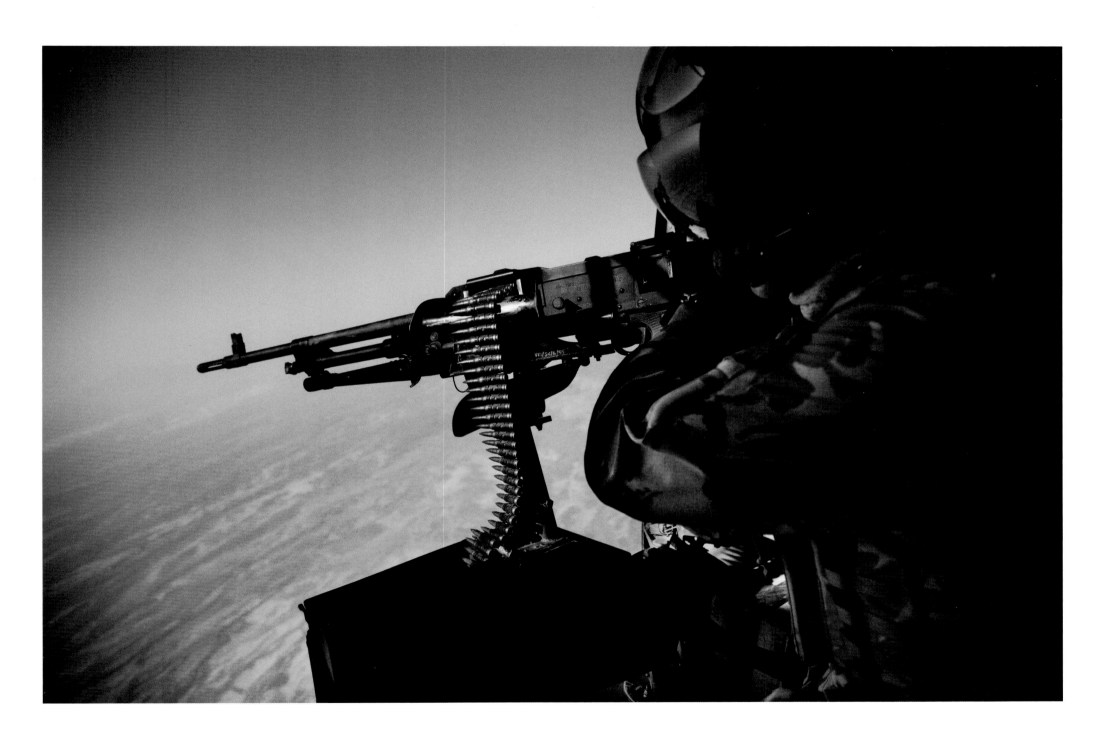

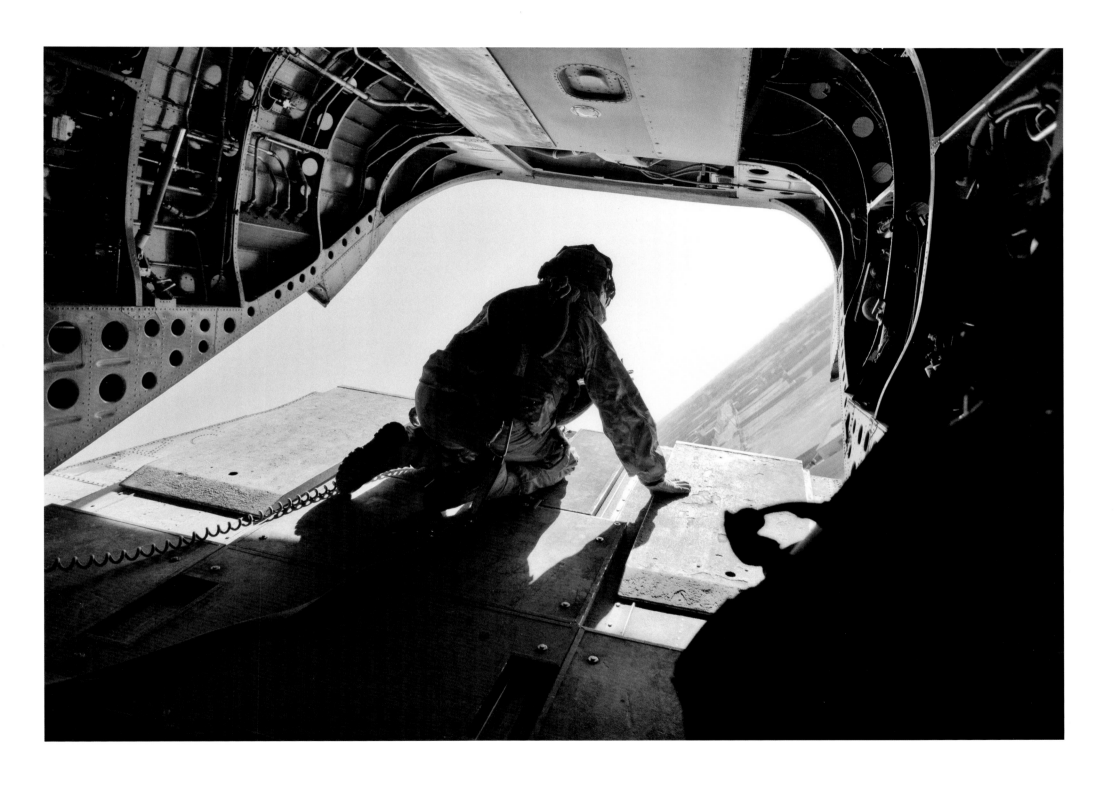

Flight from Lashkar Gah to Musa Kala

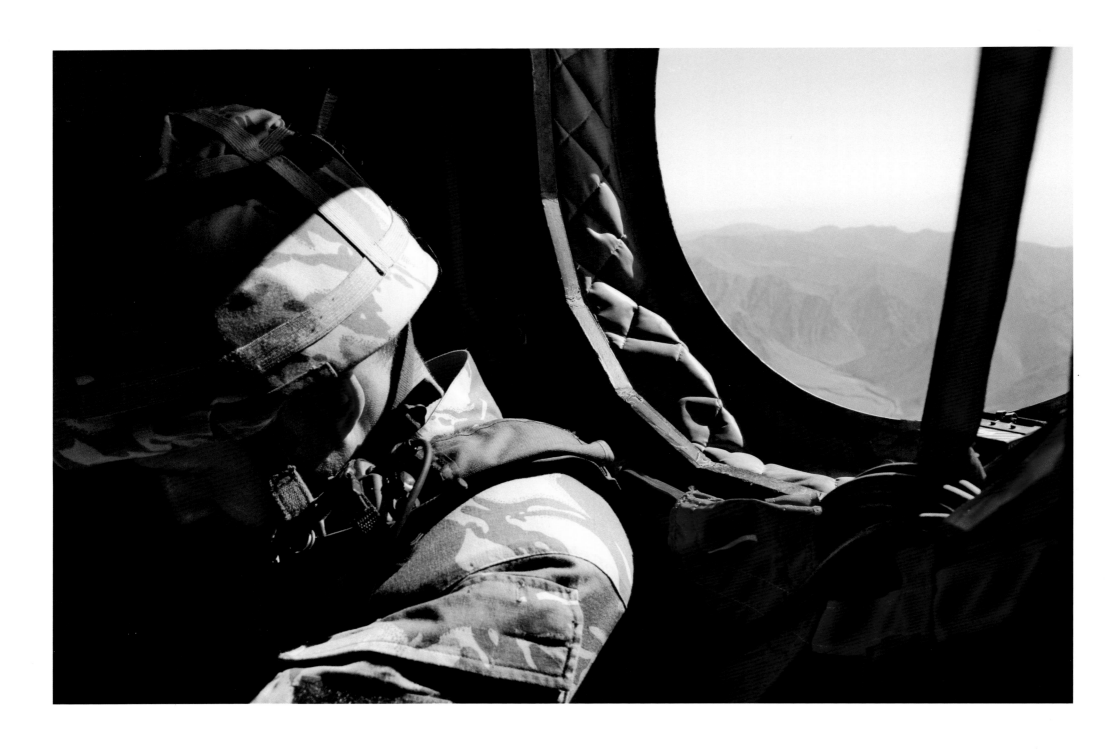

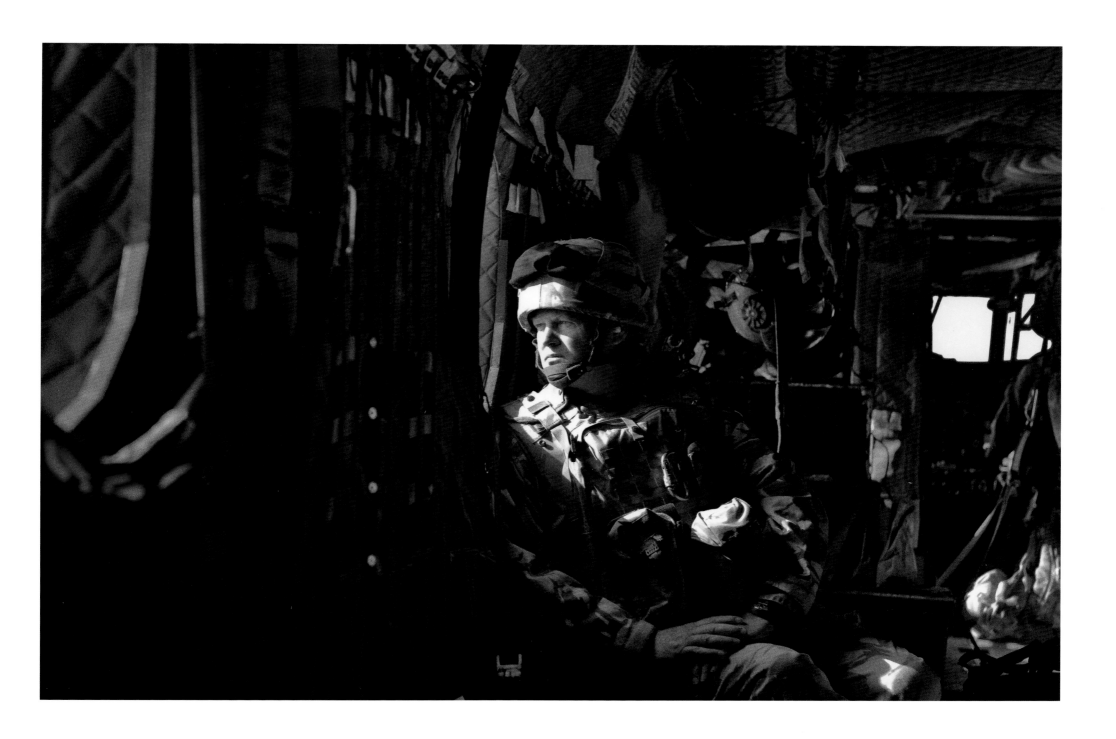

Brigadier Andrew Mackay

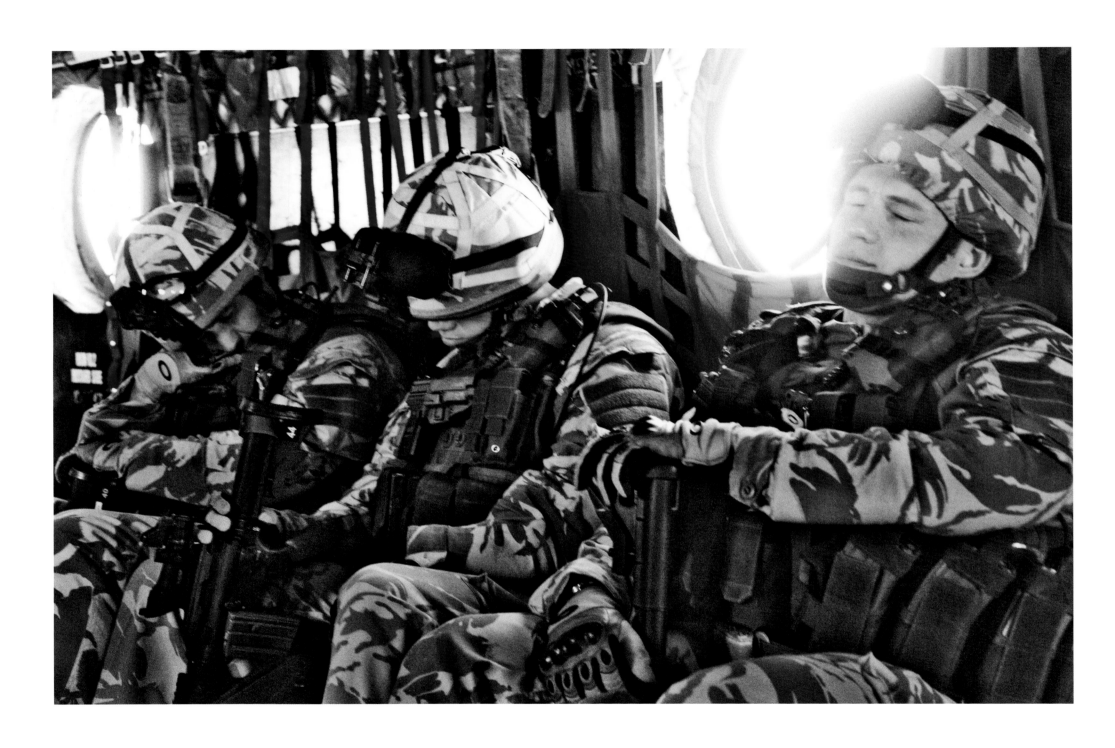

Close Protection officers

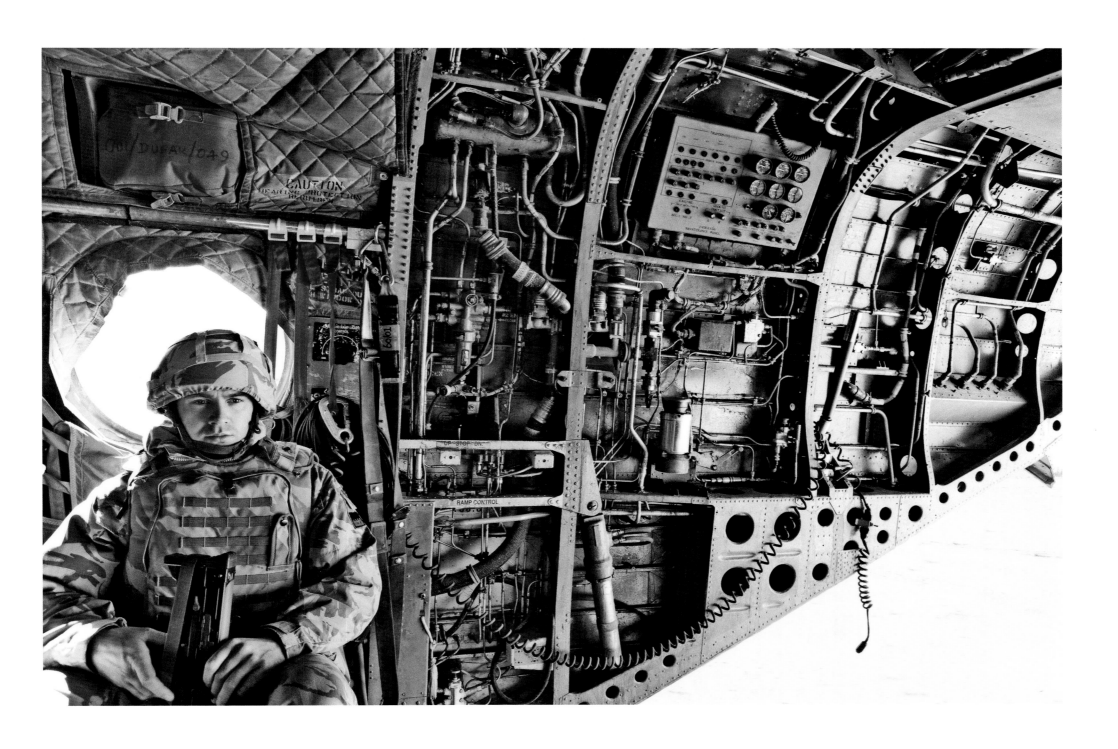

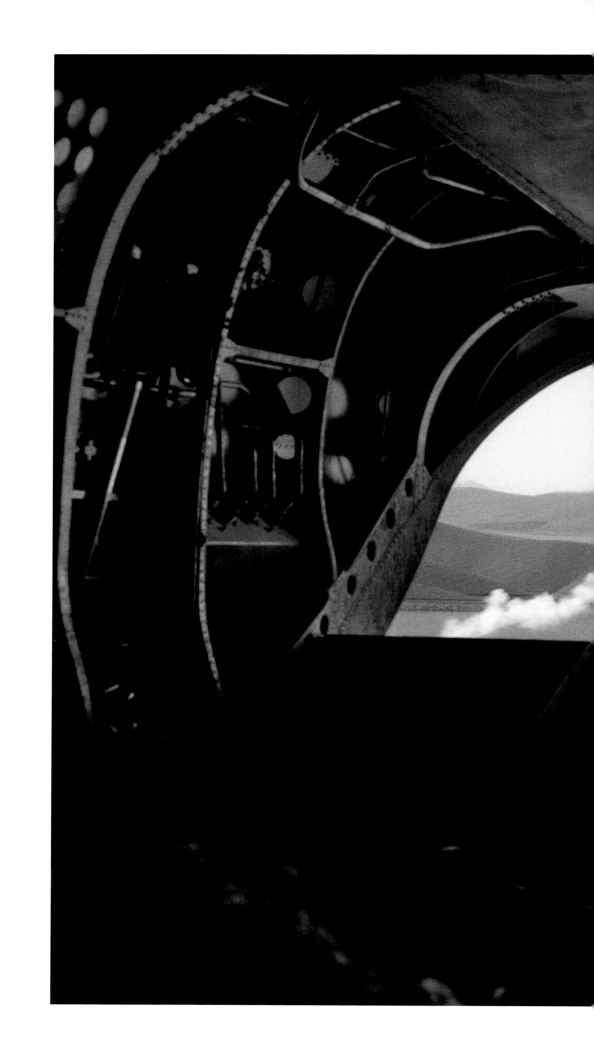

Flight leaving Kajaki

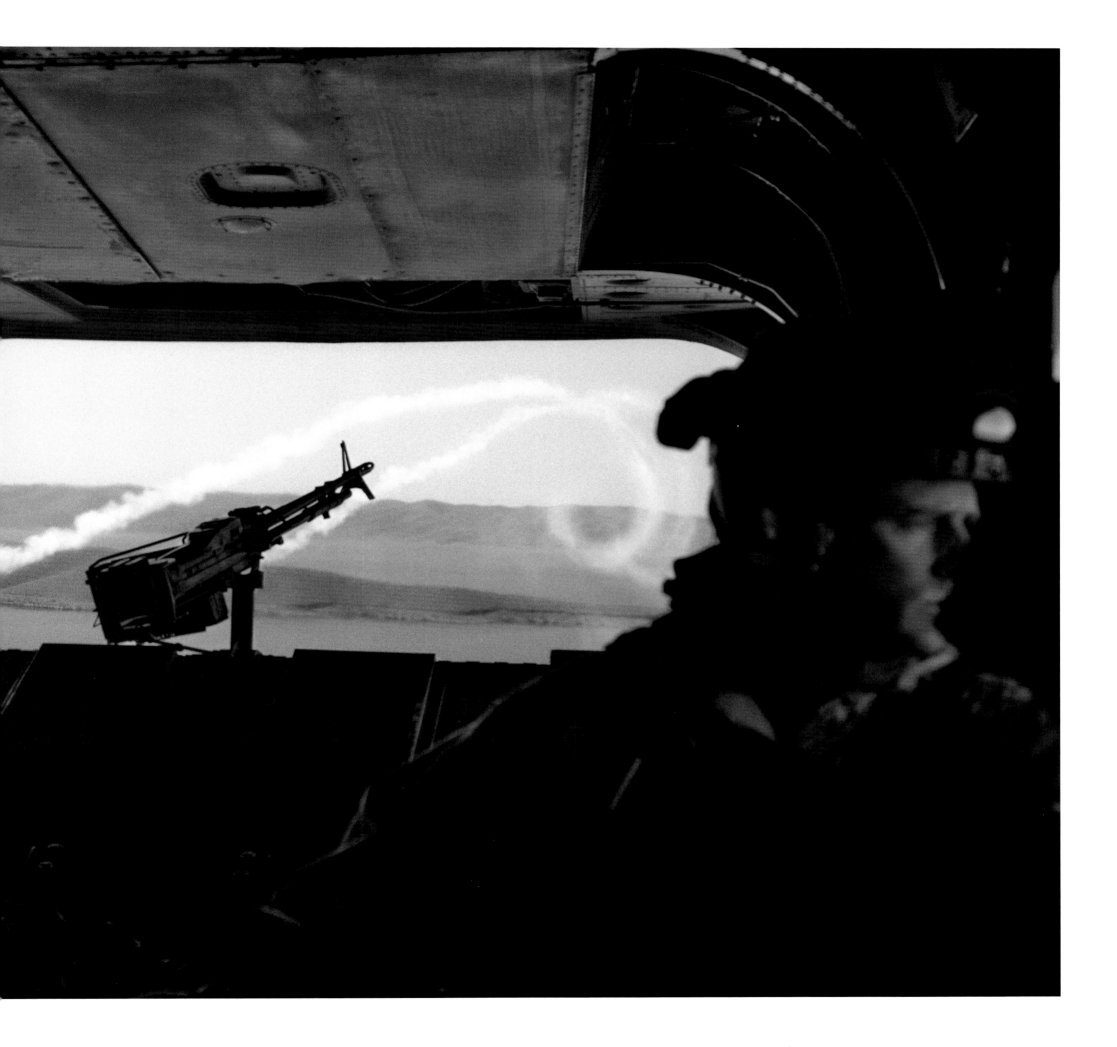

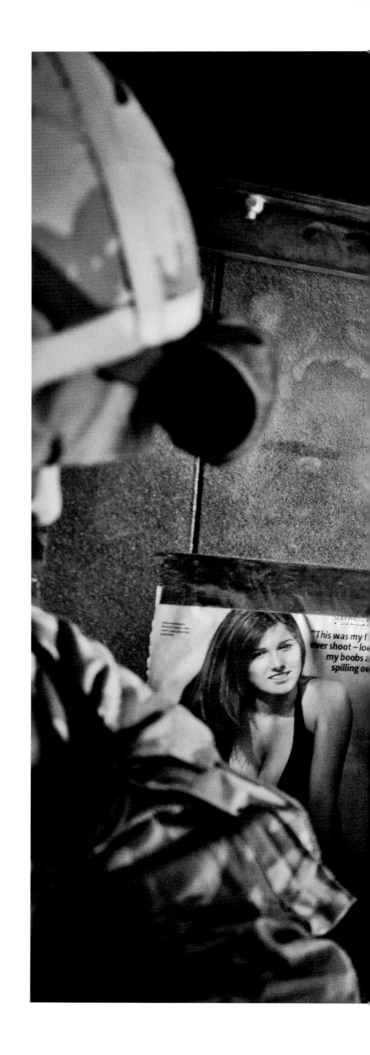

MASTIFF vehicle, Garmsir

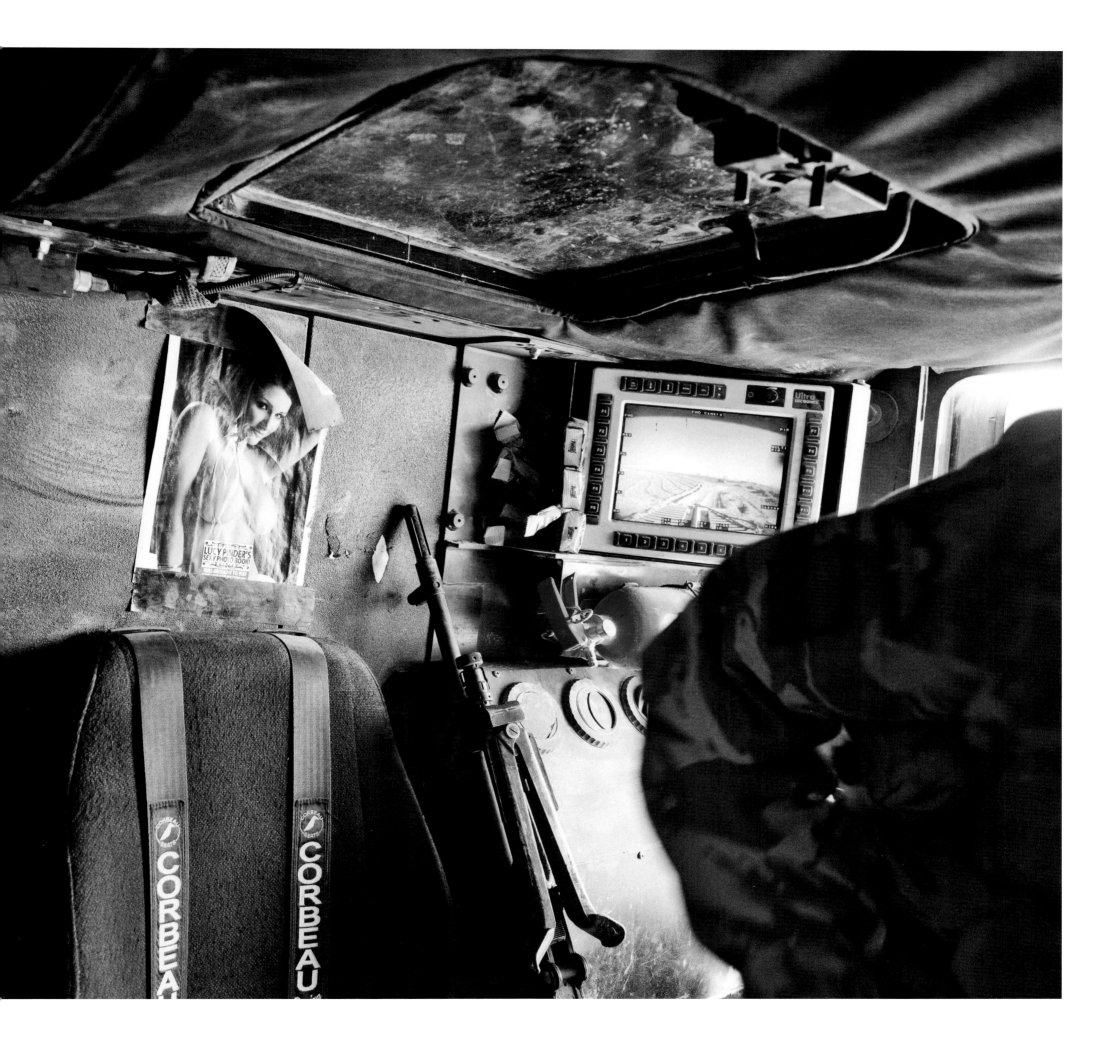

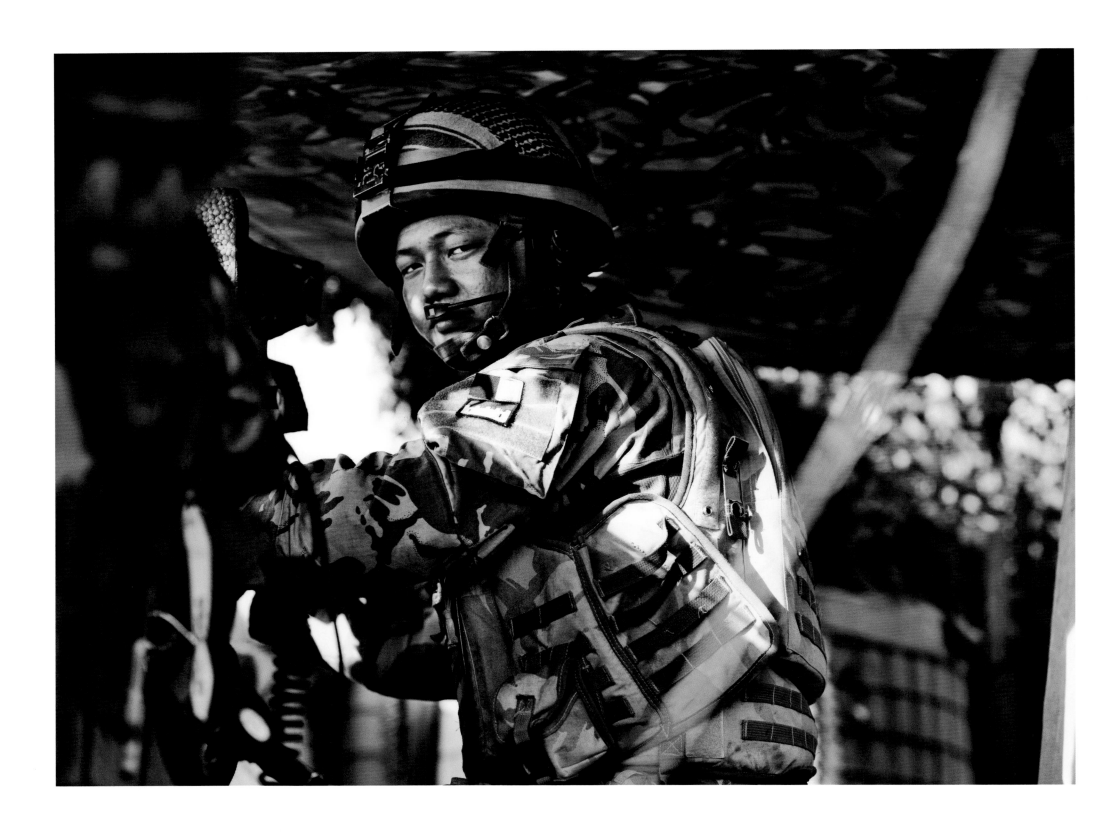

JTAC Hill, Garmsir

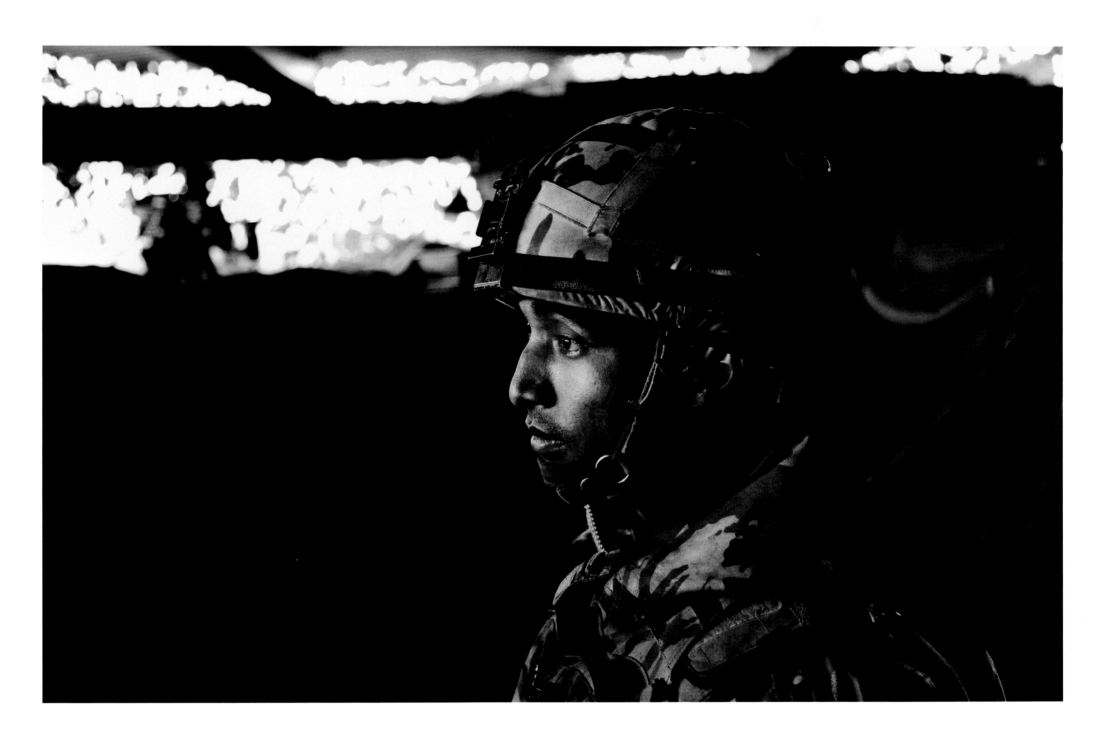

Checkpoint Balaklava, Garmsir

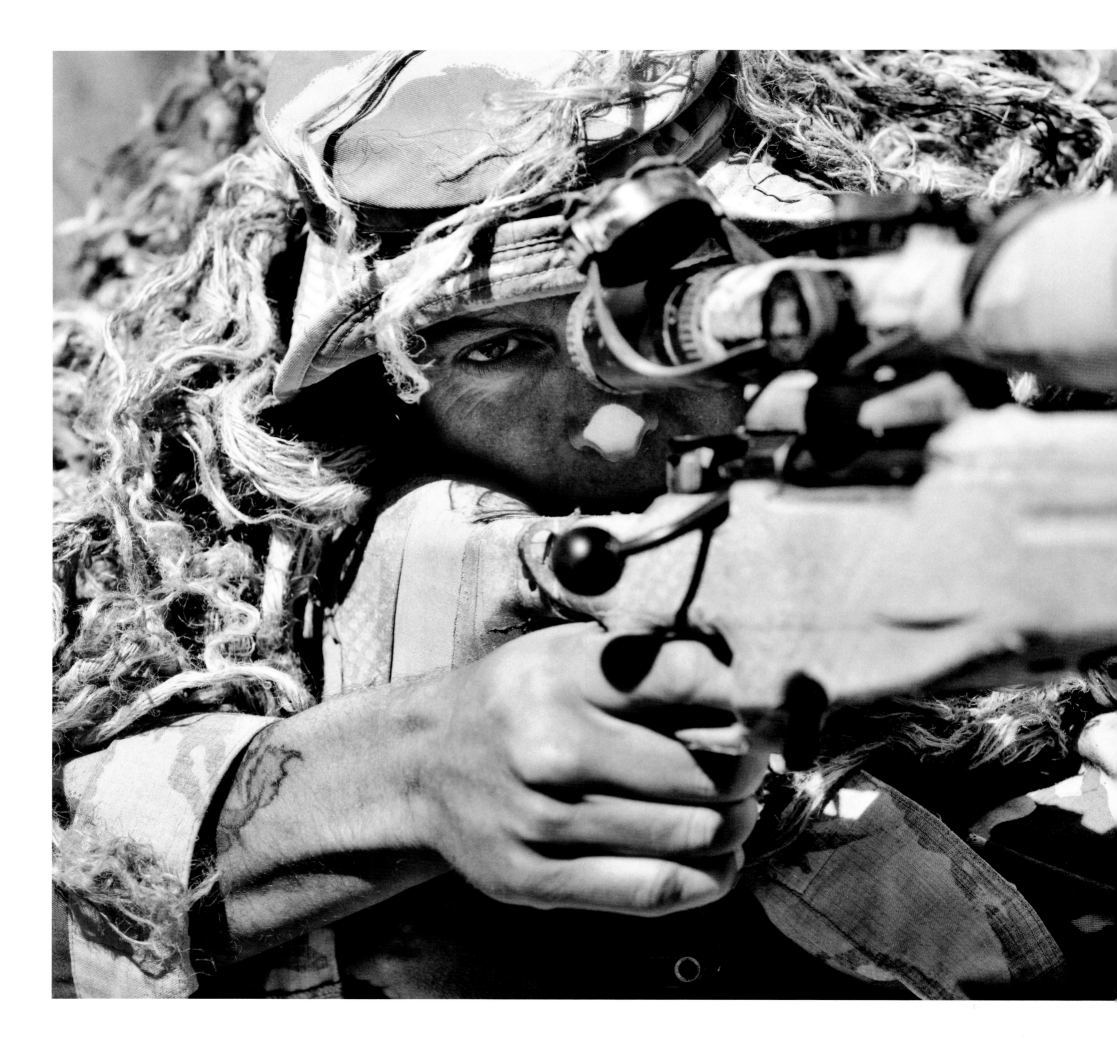

Sniper, Kajaki

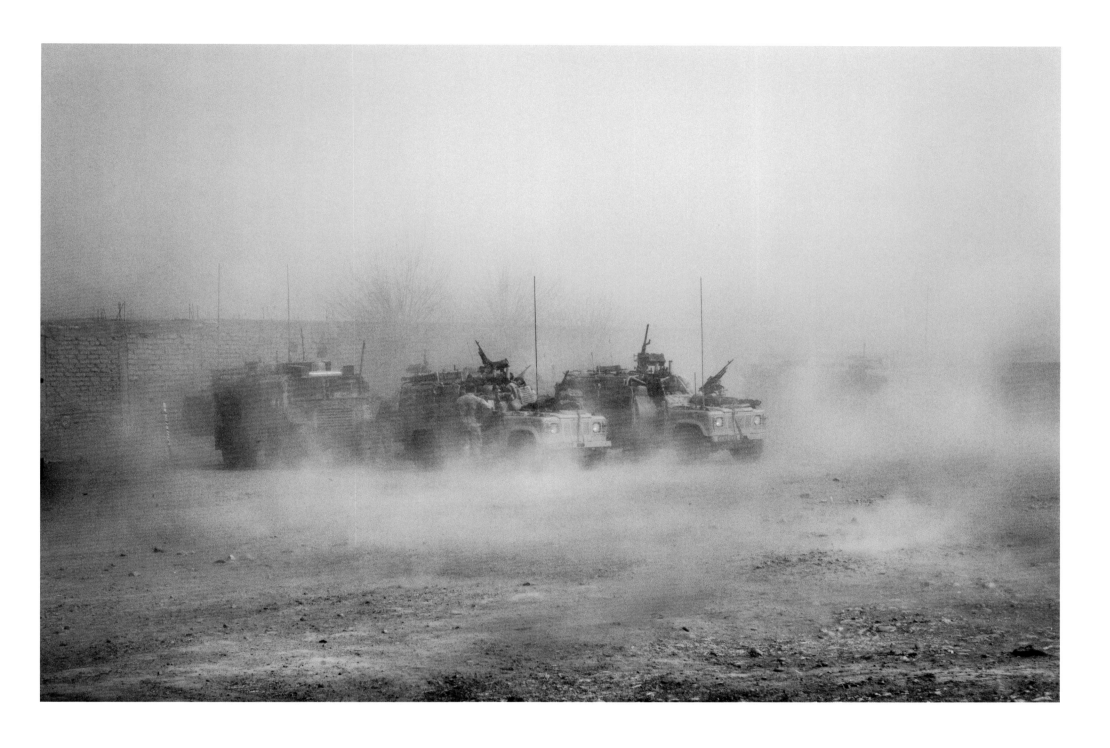

Musa Kala

FOB Edinburgh

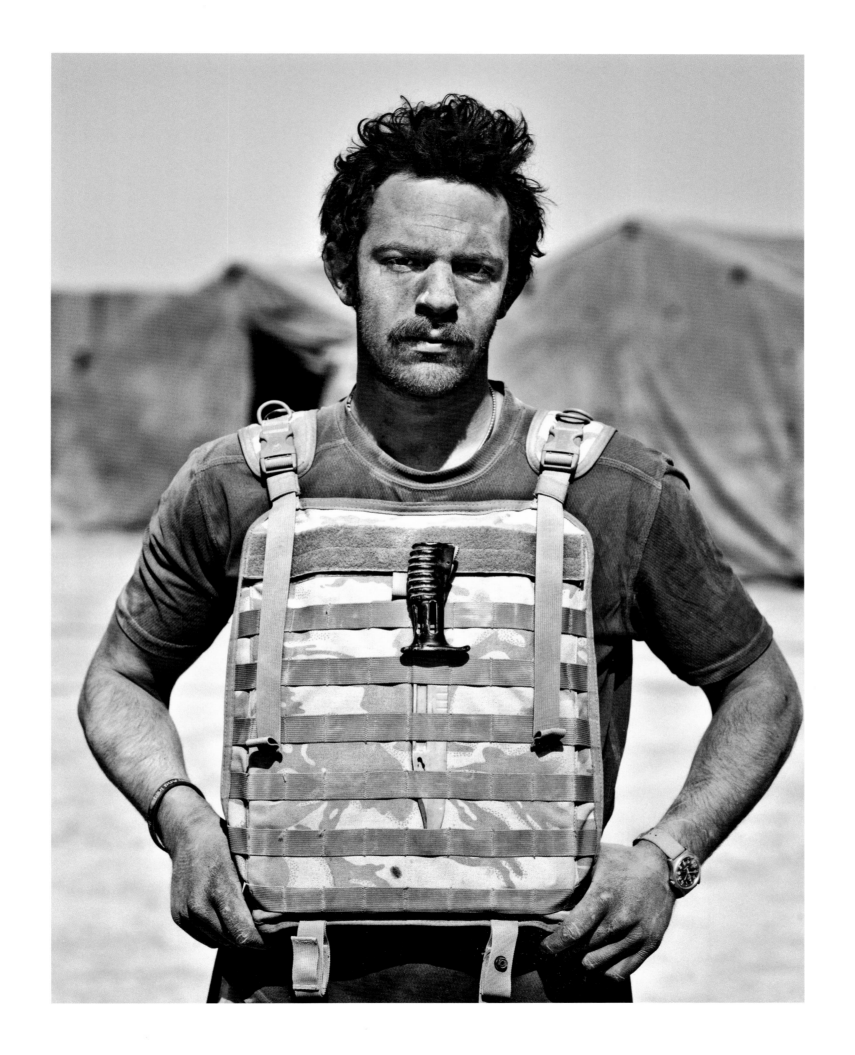

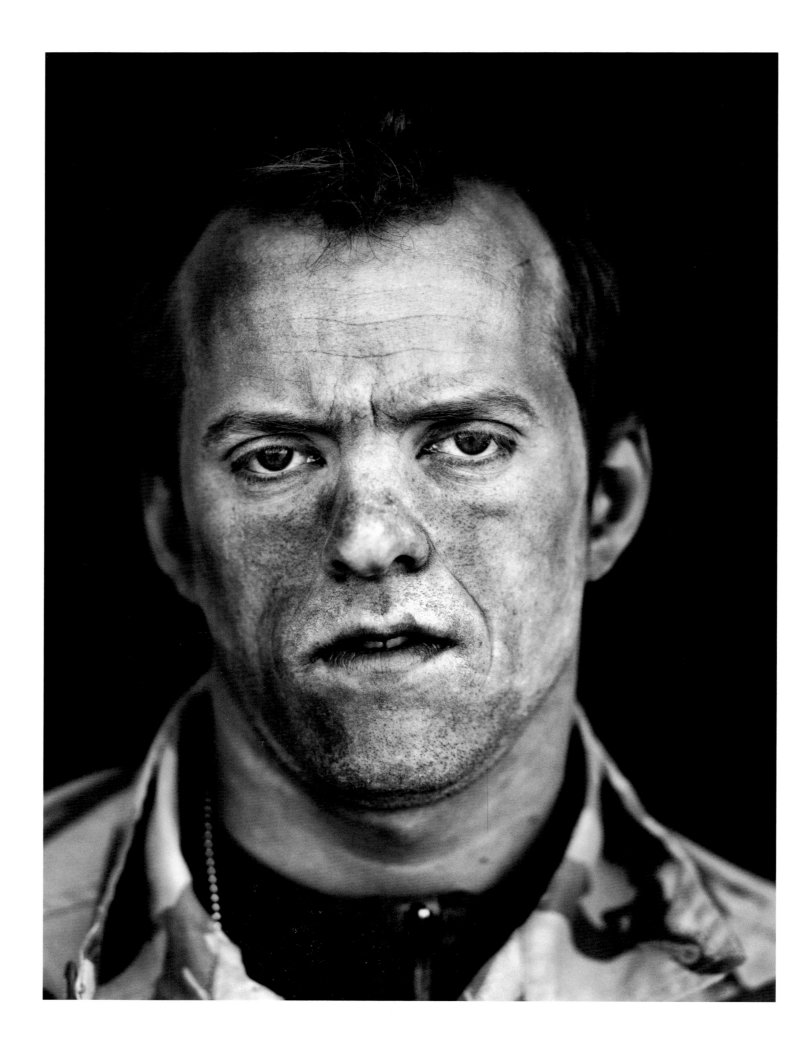

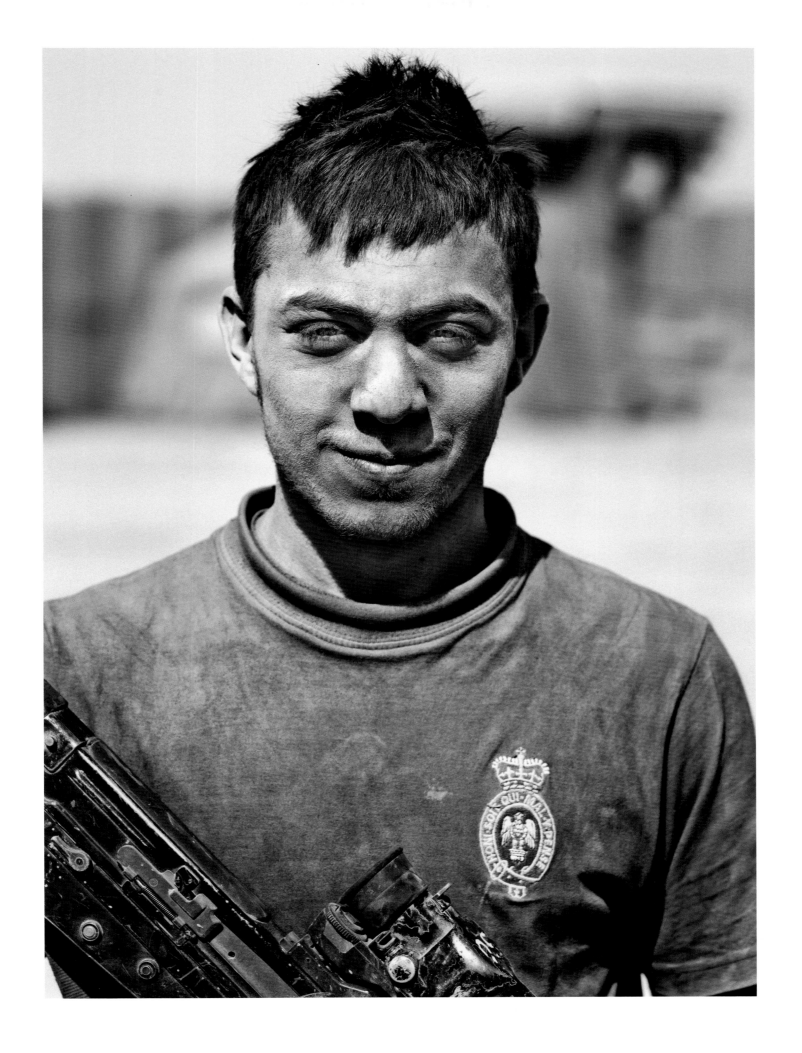

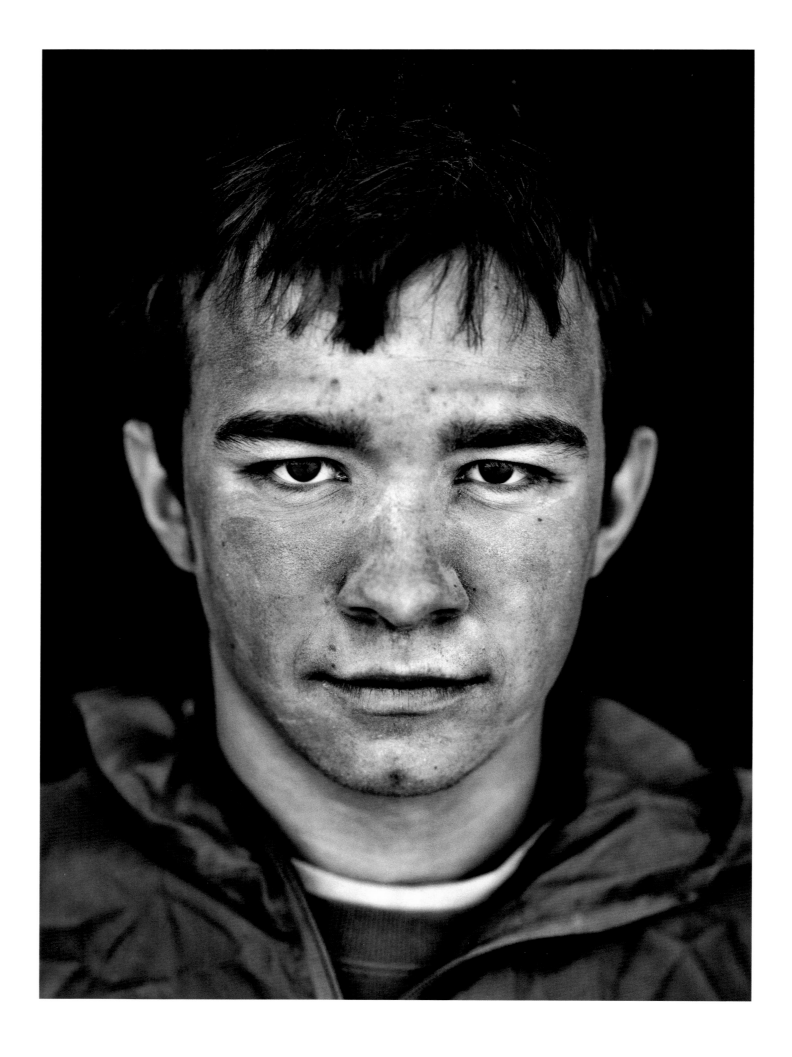

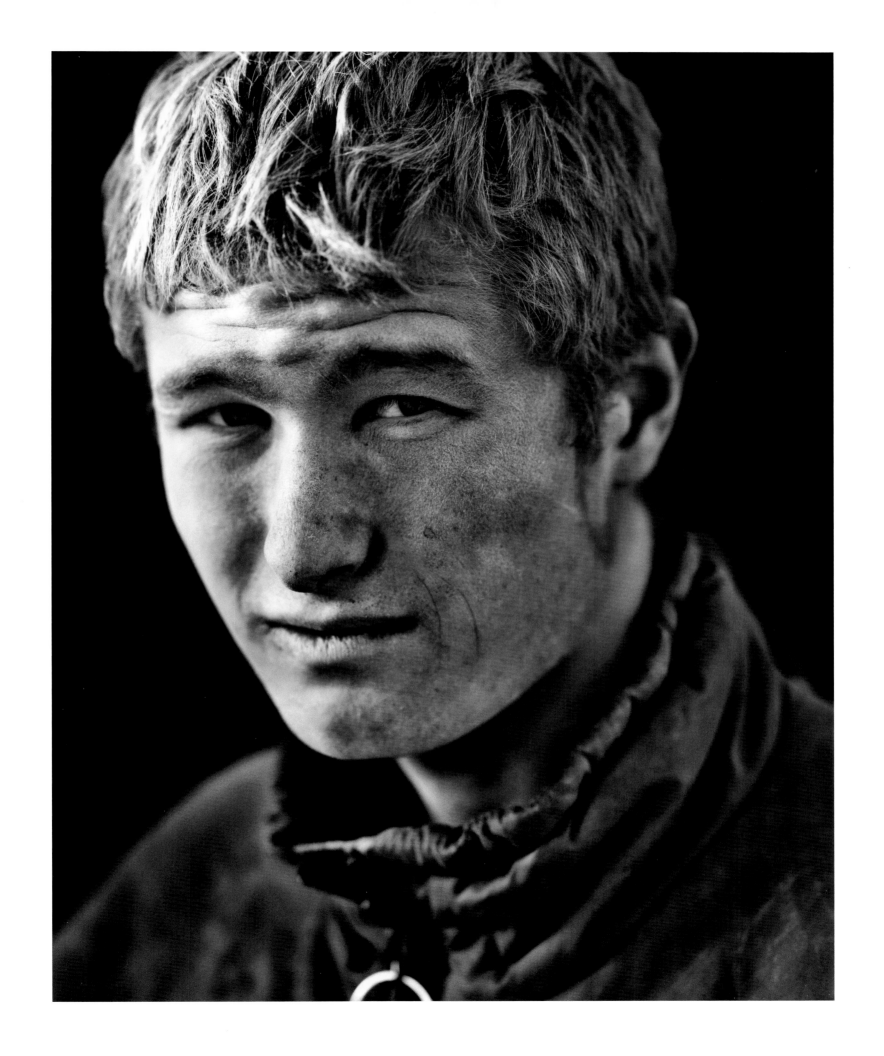

Pages 144, 145, 146 & 147: FOB Edinburgh
Page 149: JTAC Hill, Garmsir

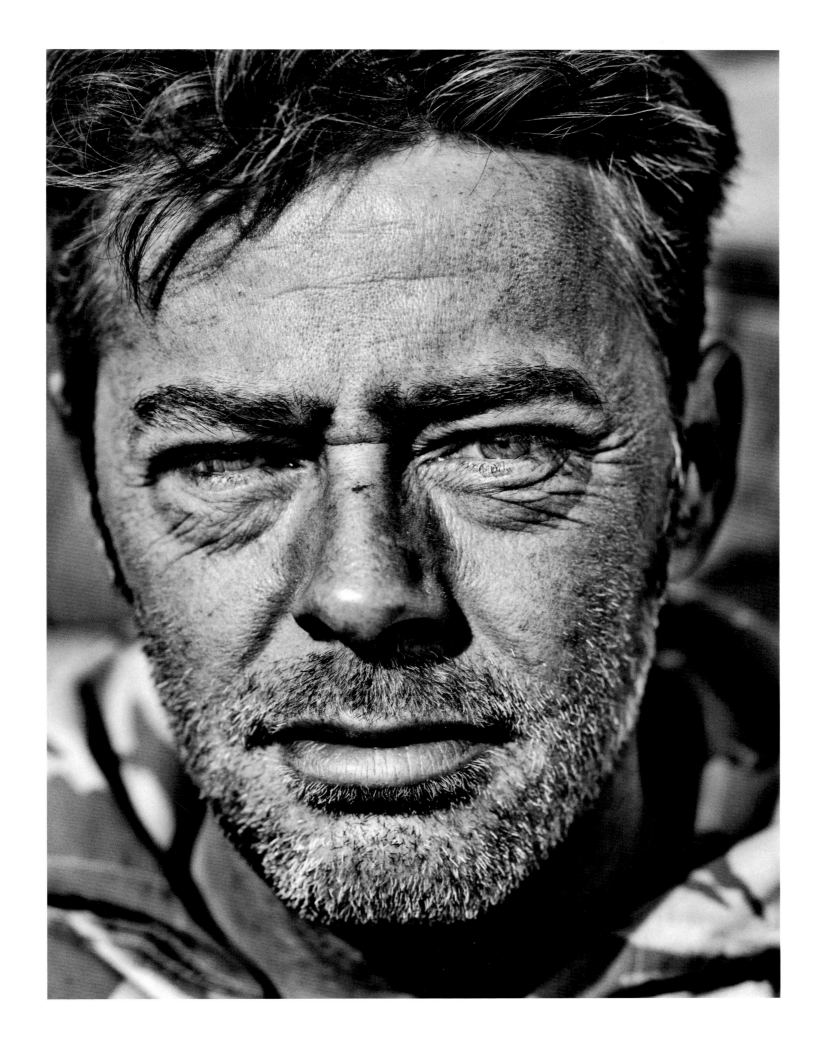

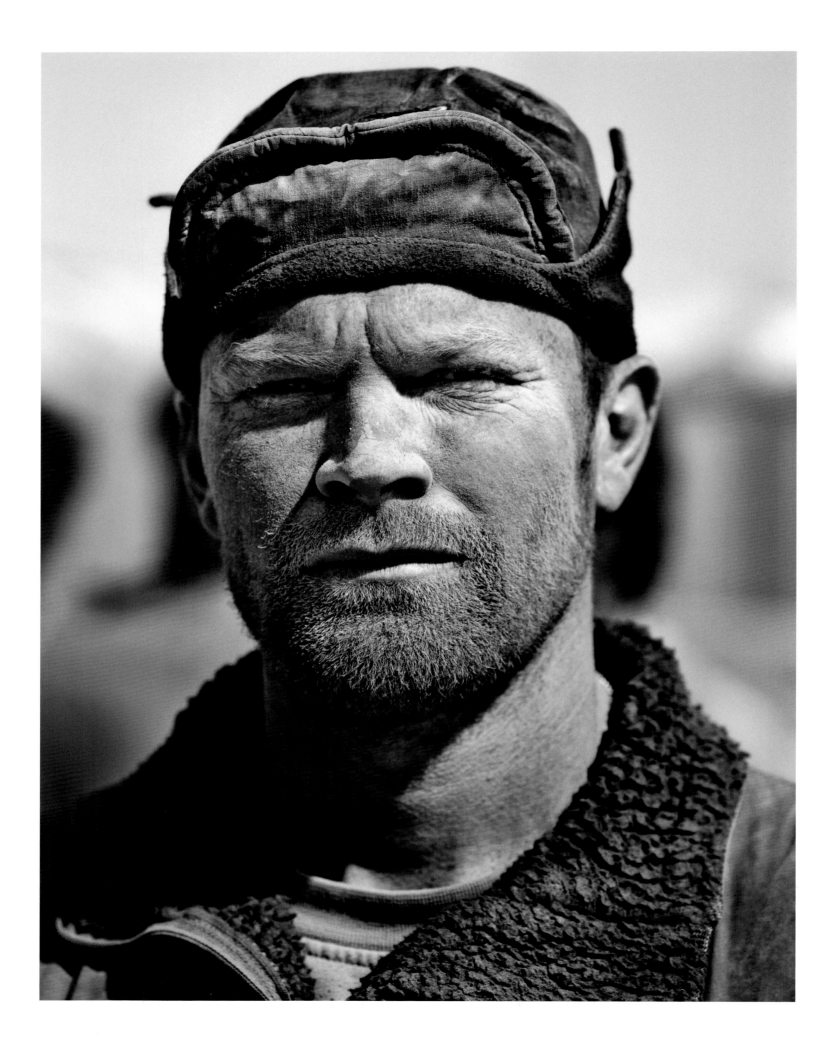

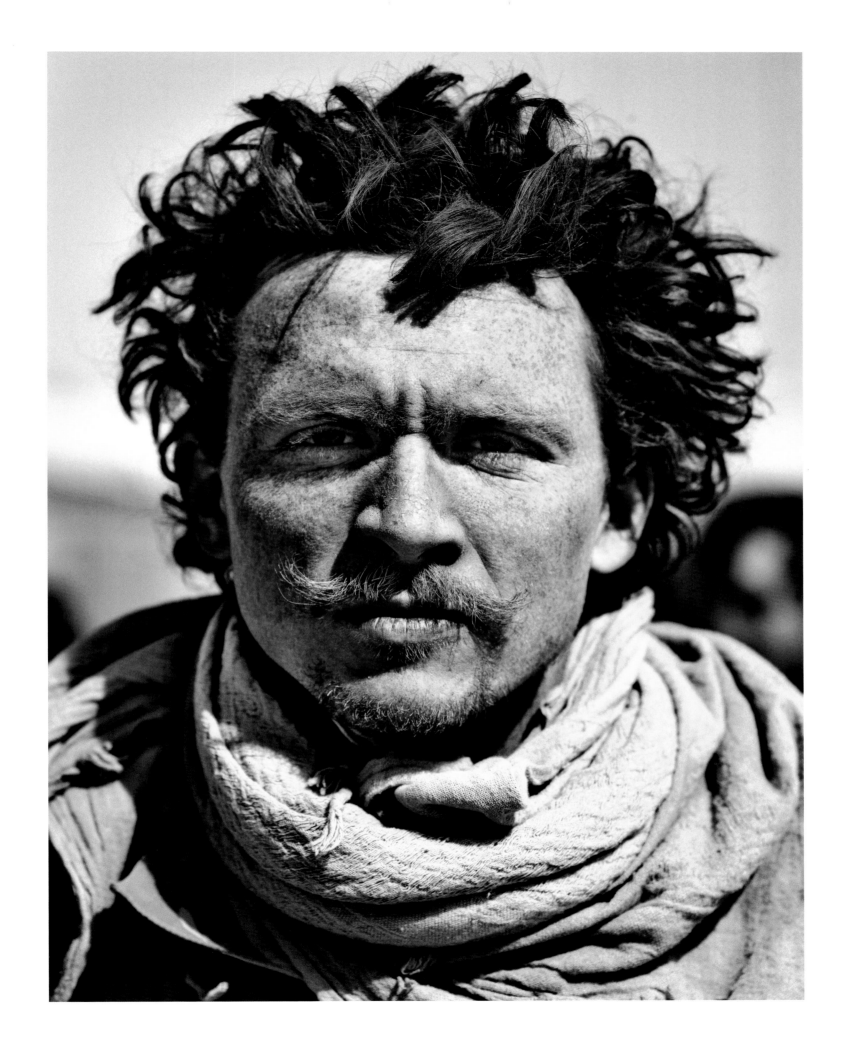

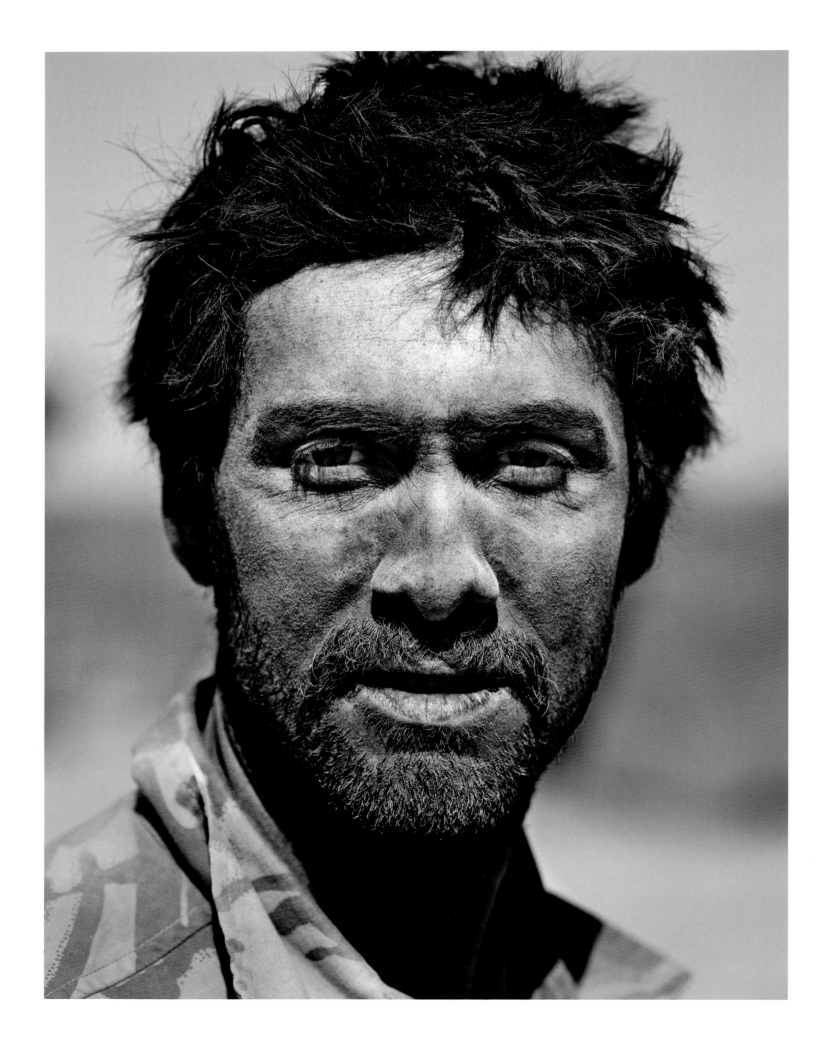

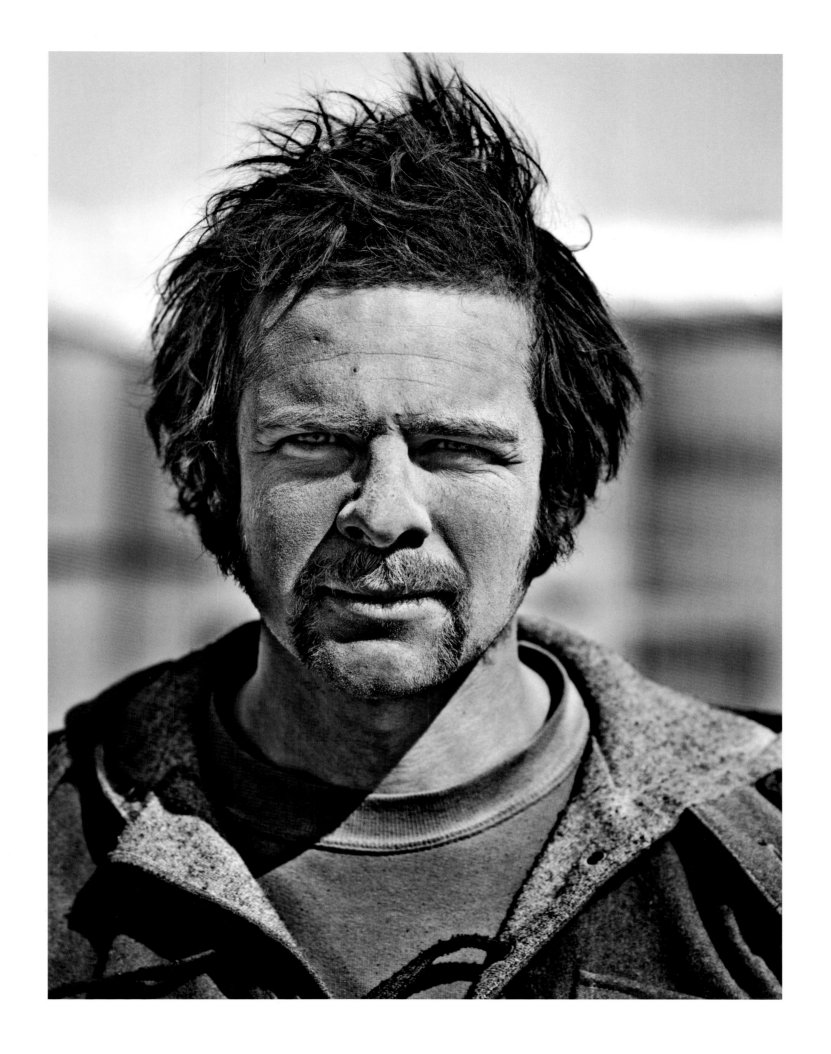

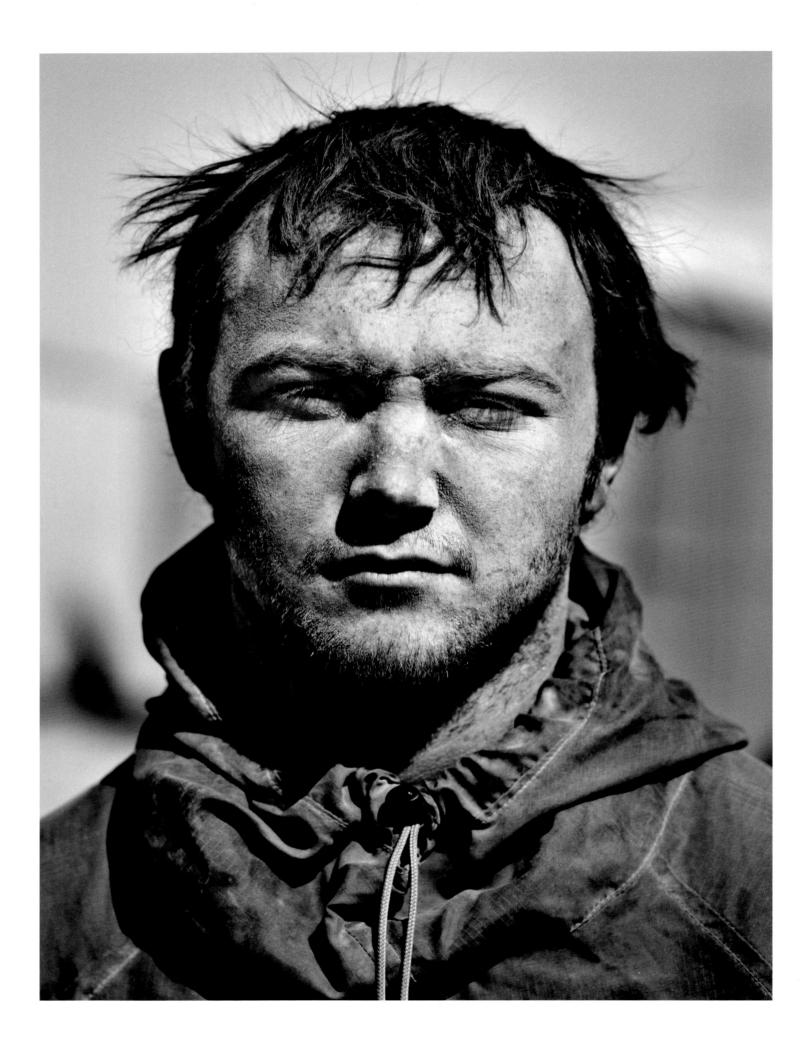

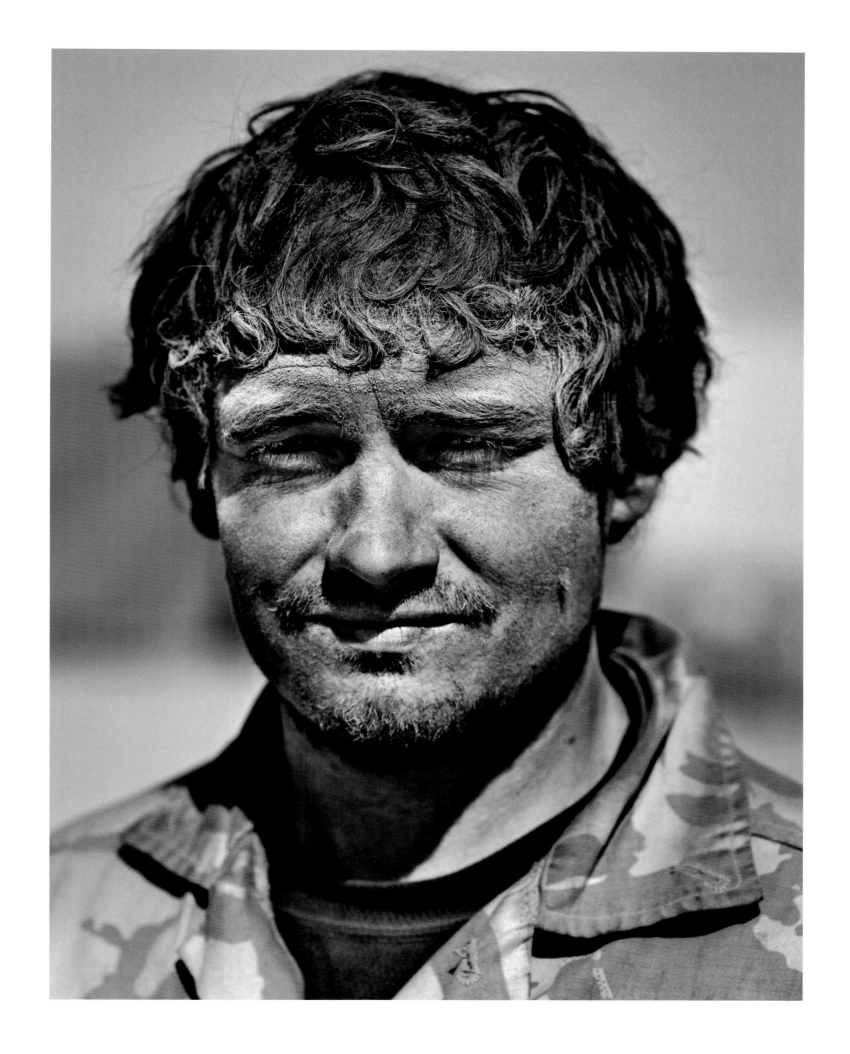

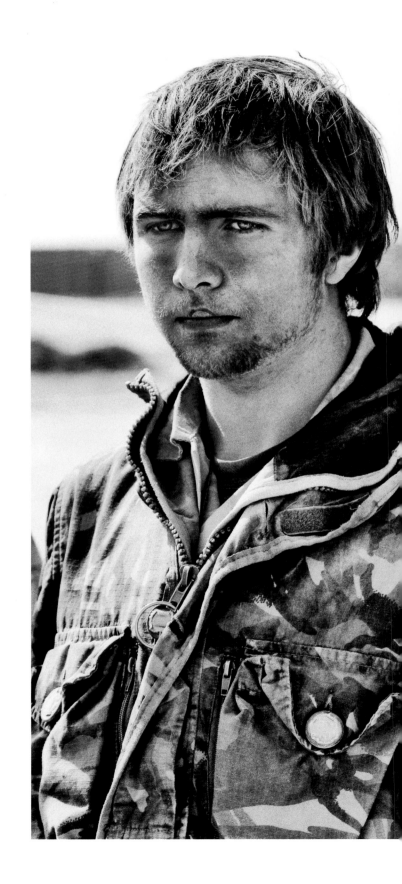

Pages 150, 151, 152, 153, 154, 155 & 157: FOB Edinburgh

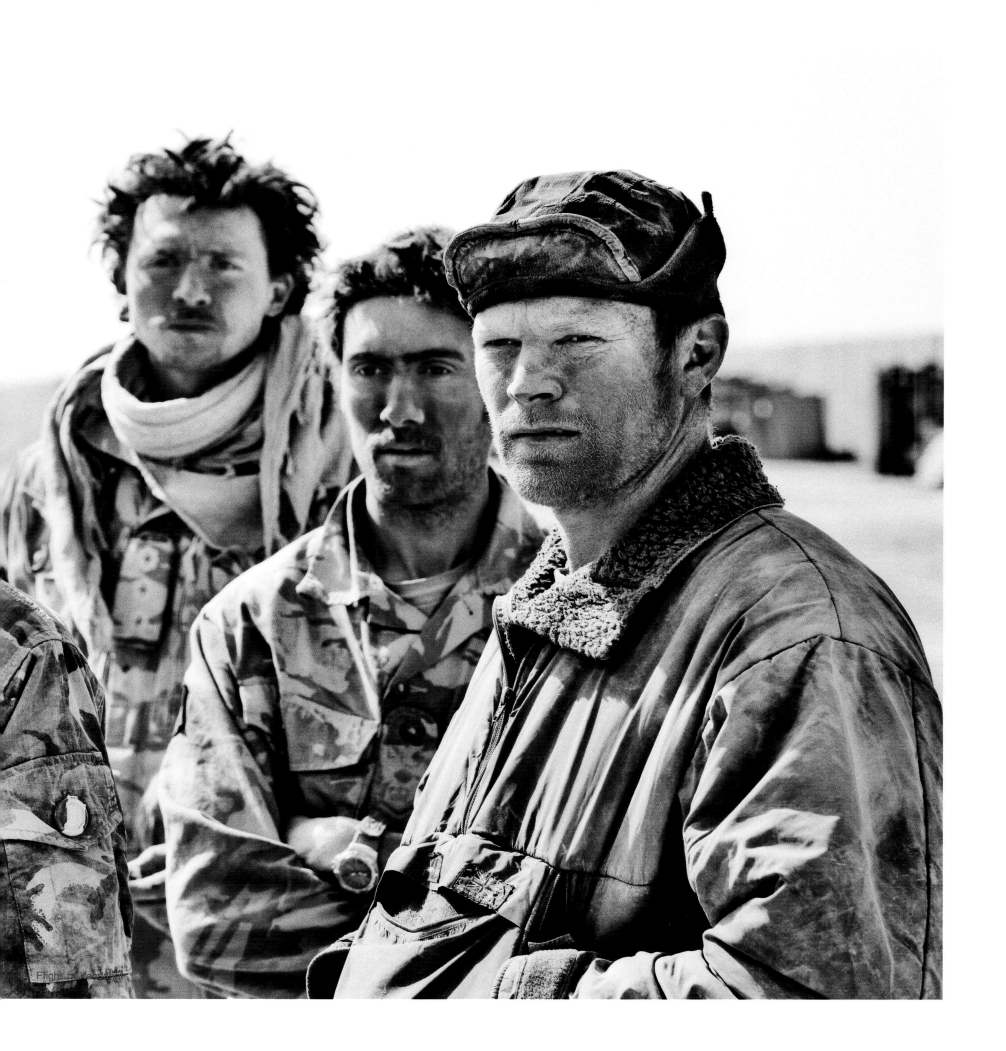

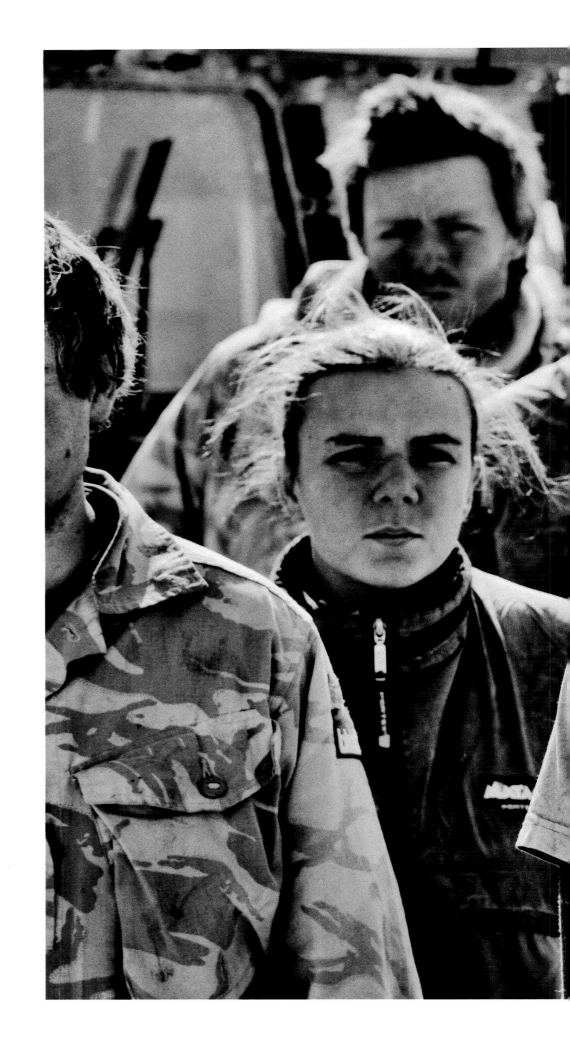

FOB Edinburgh

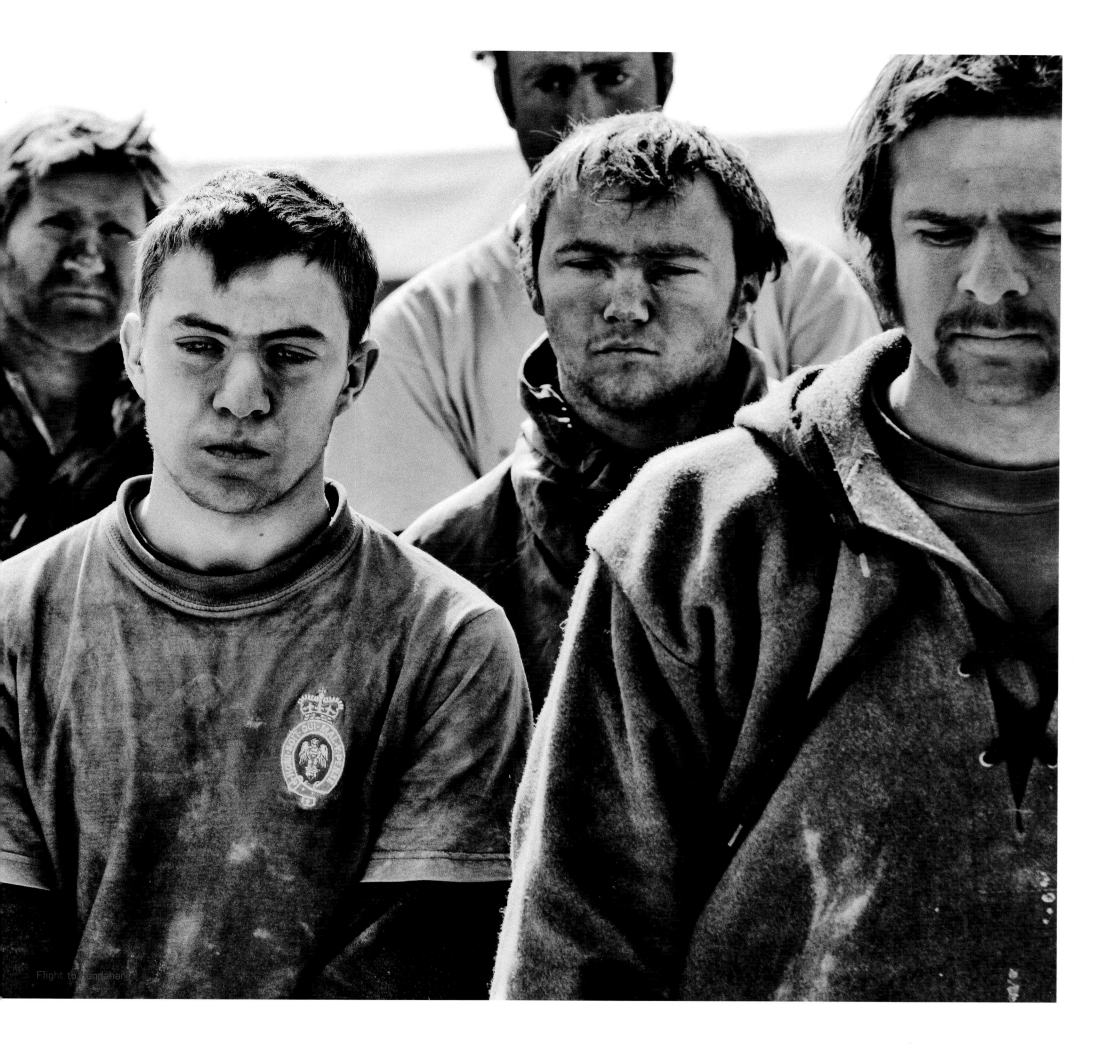

Flight to Kandahar

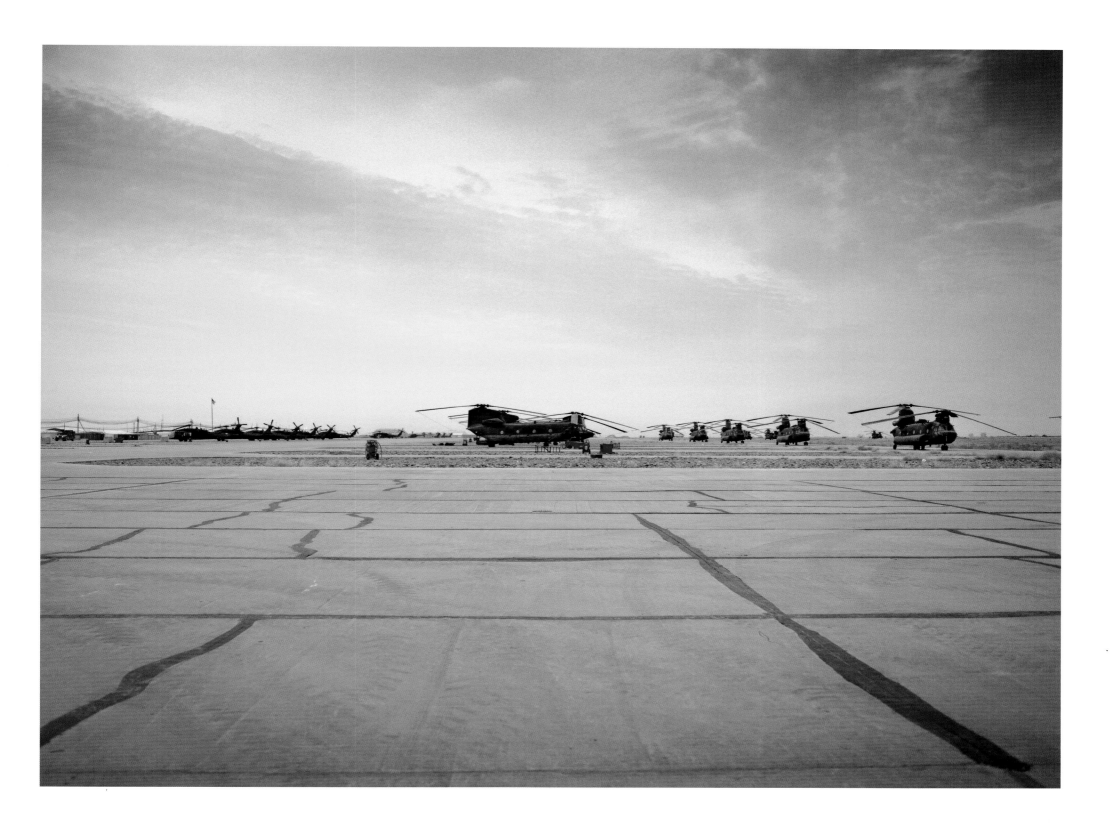

Kandahar Air Field

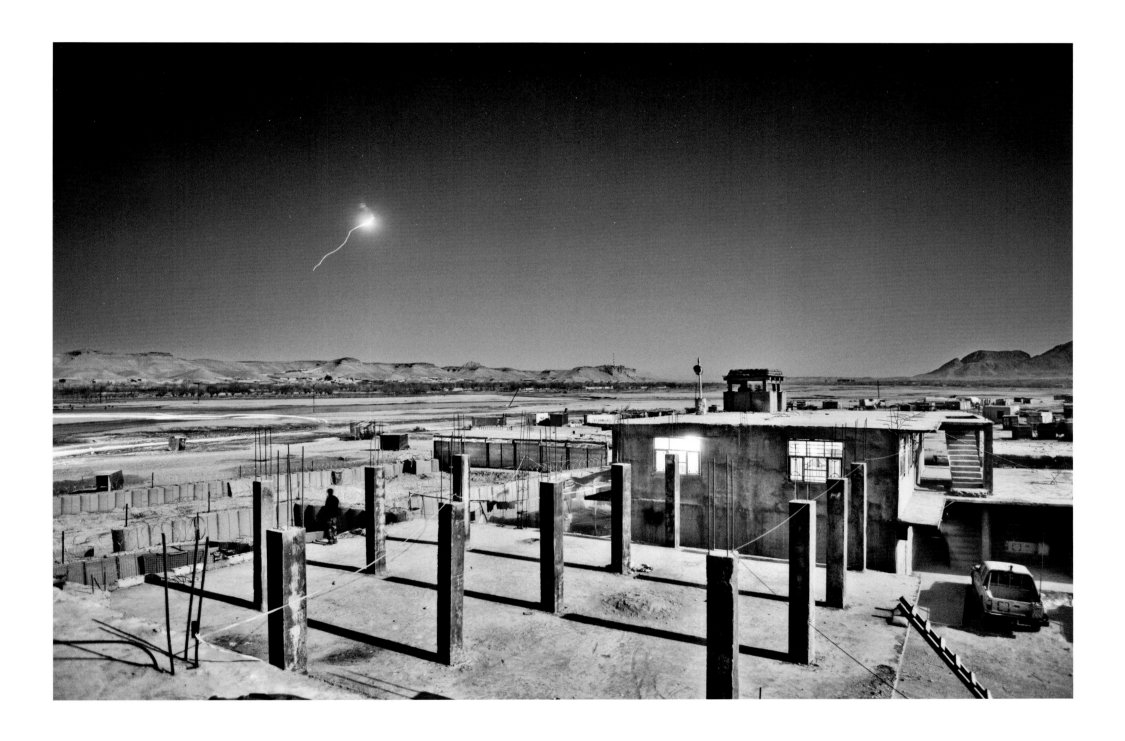

Musa Kala

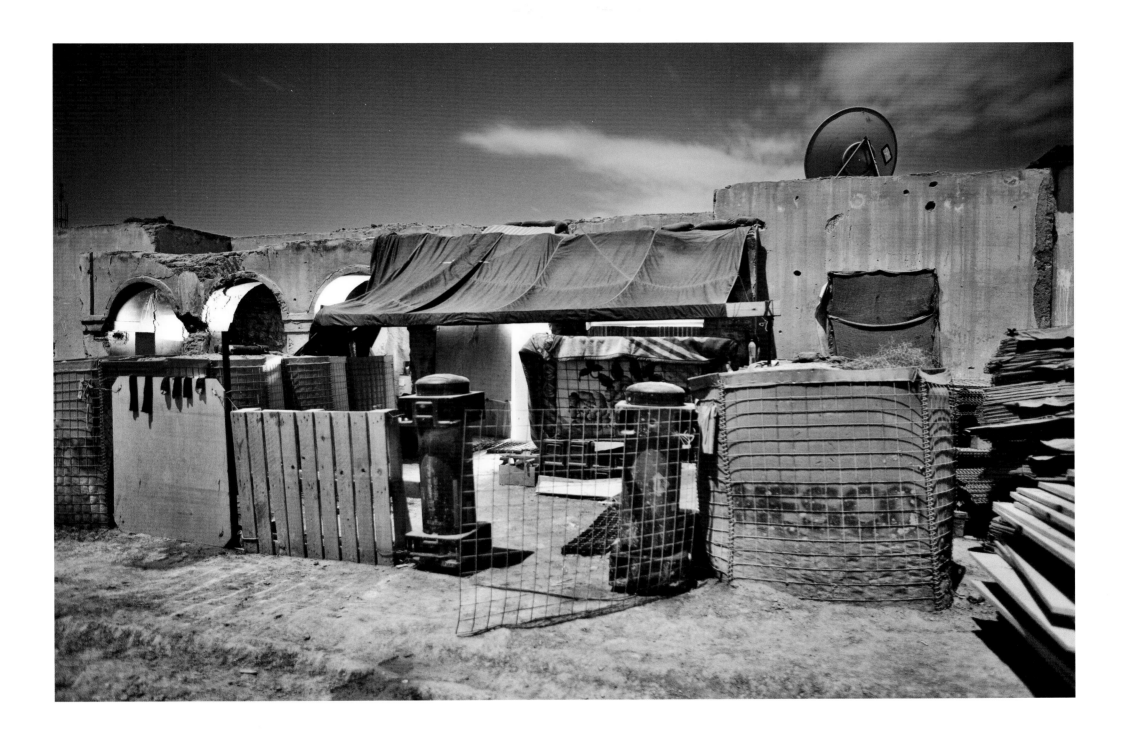

FOB Delhi, Garmsir

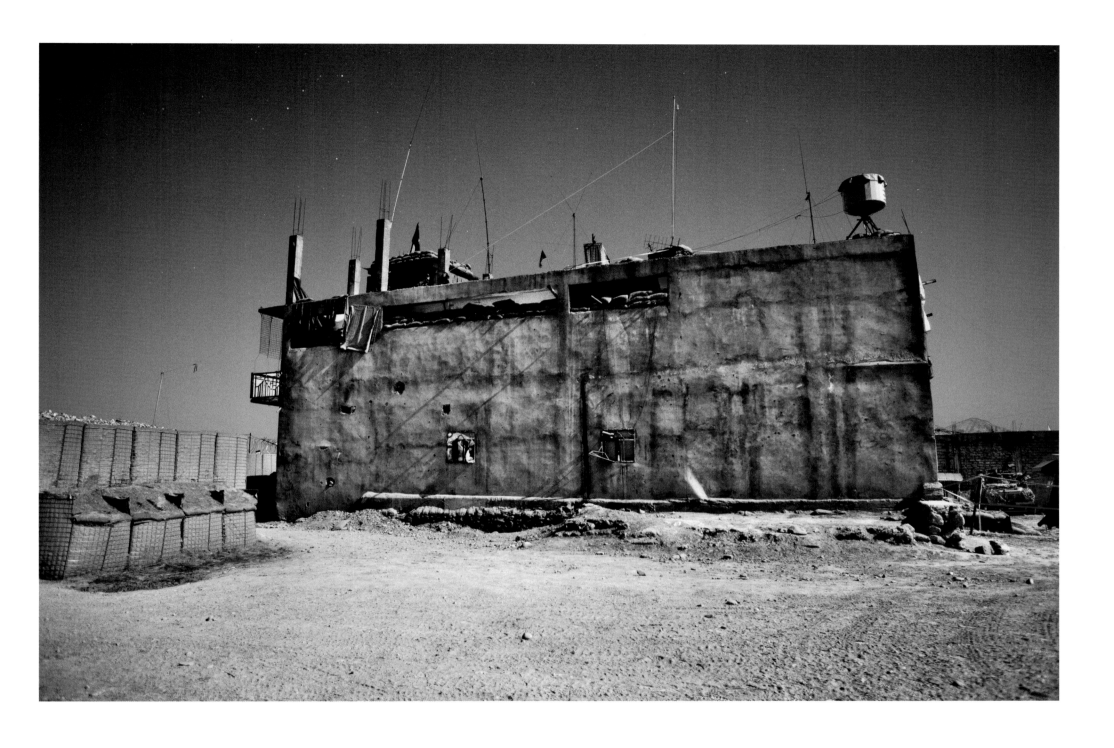

Musa Kala

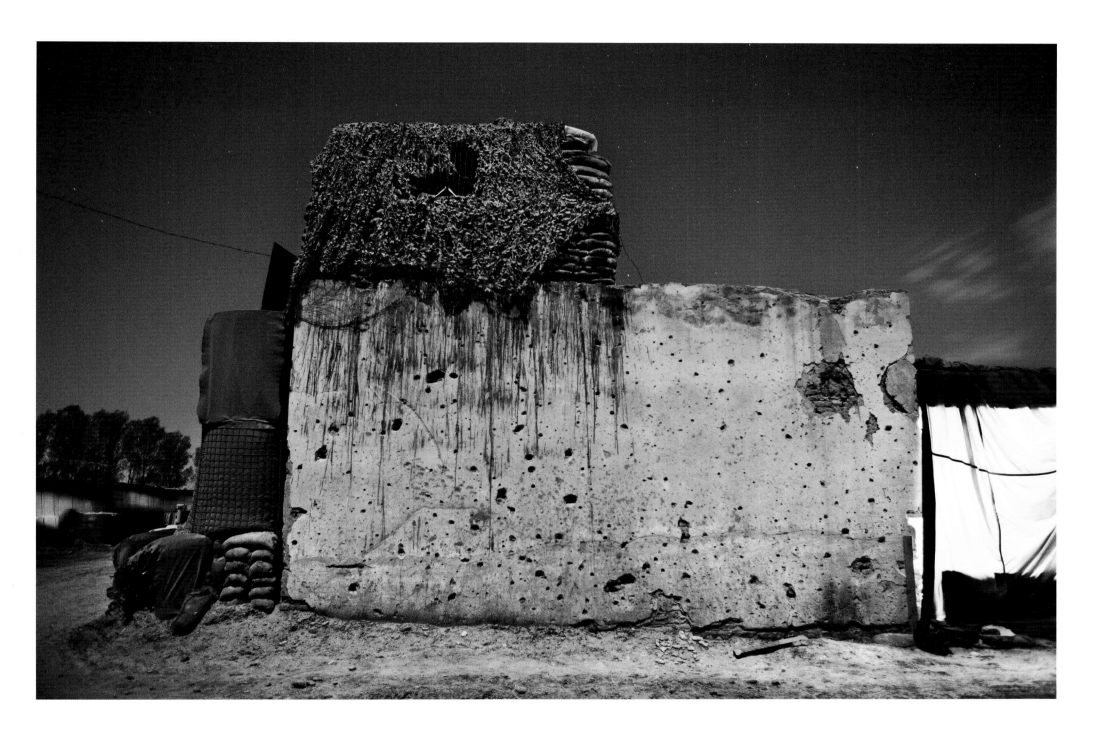

FOB Delhi, Garmsir

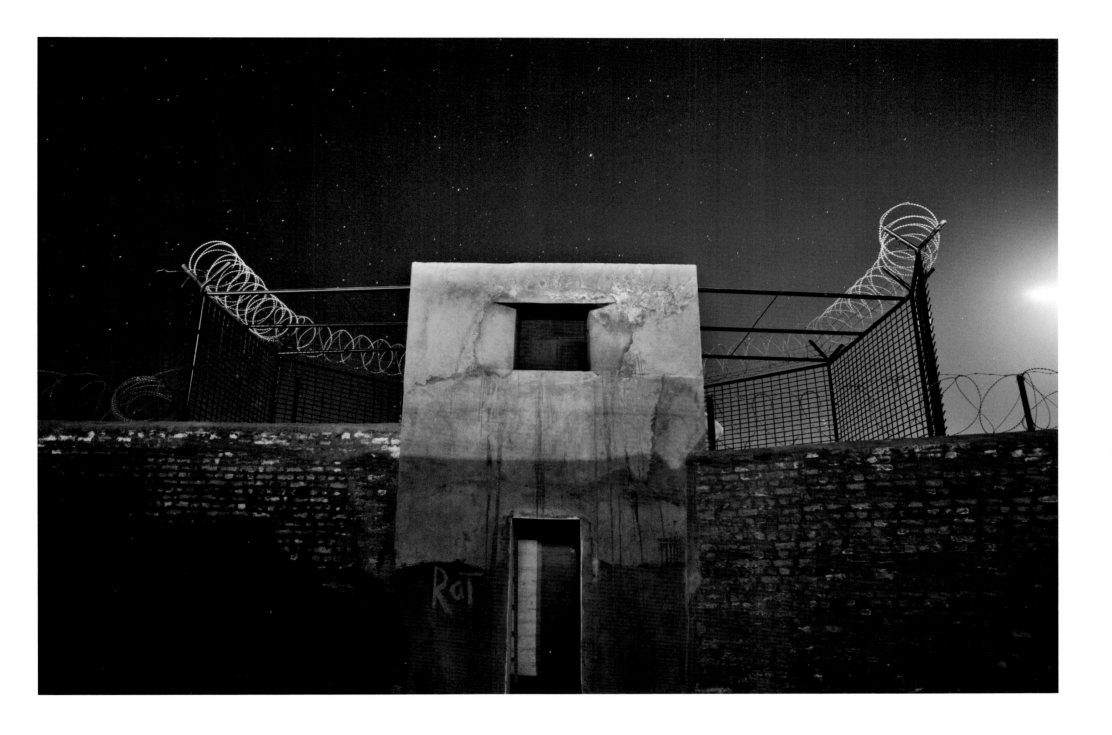

Lashkar Gah

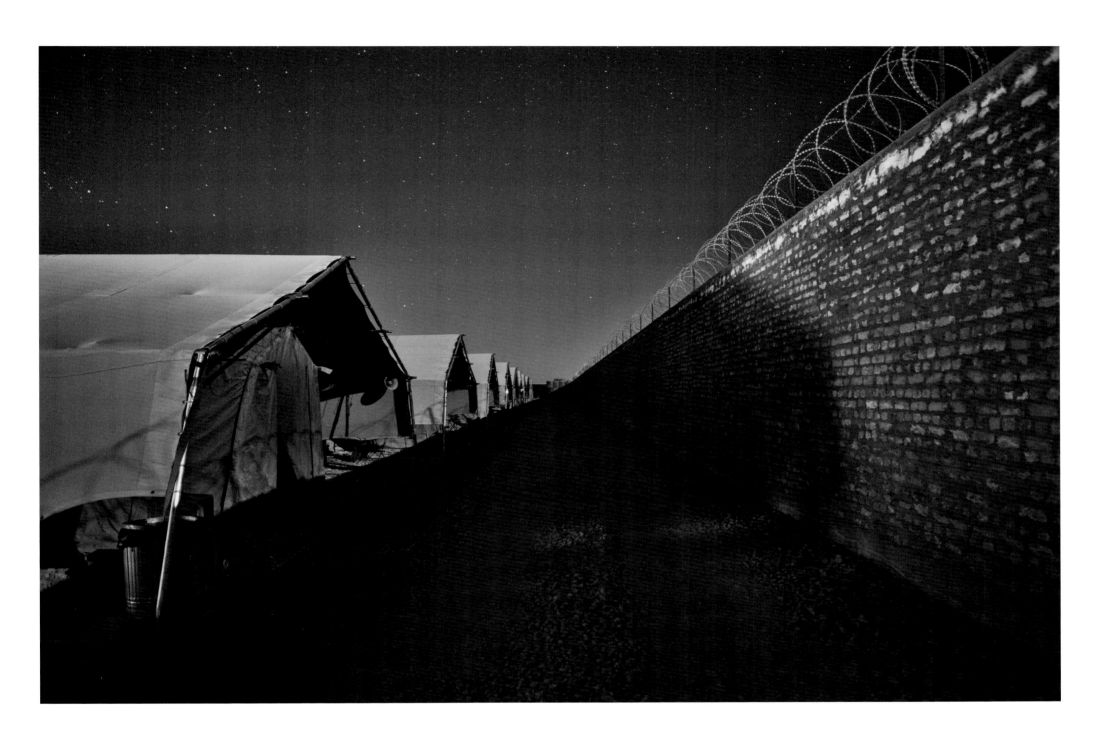

Grenade Alley, Lashkar Gah

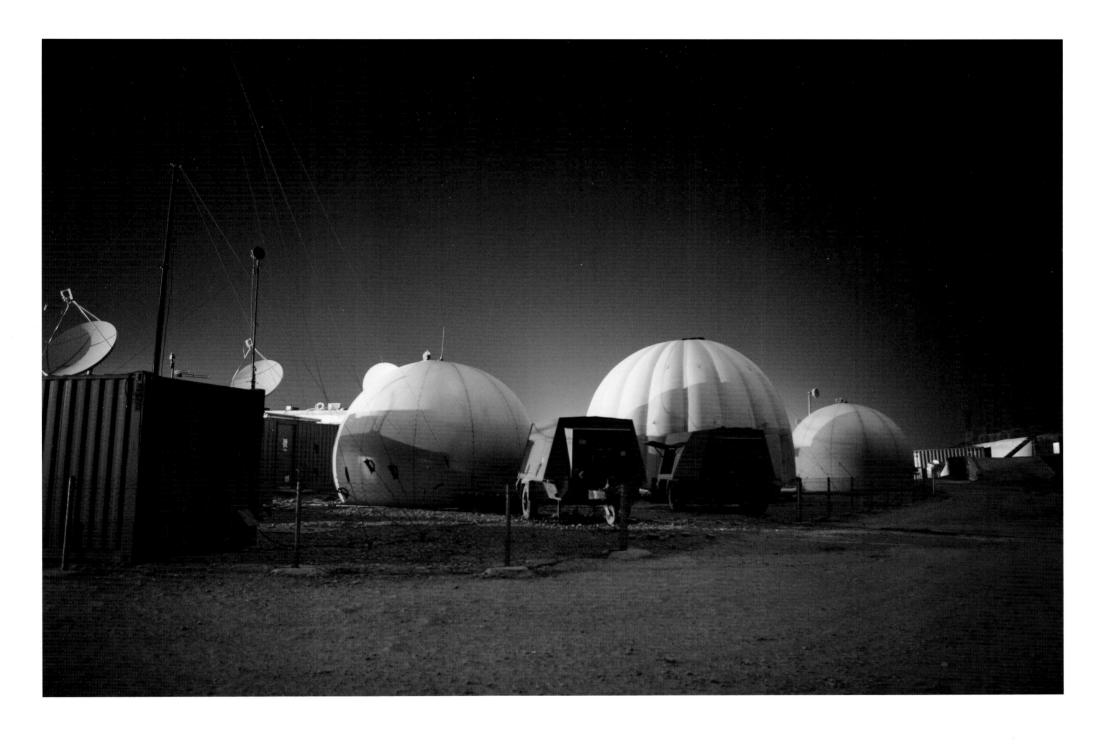

Lashkar Gah

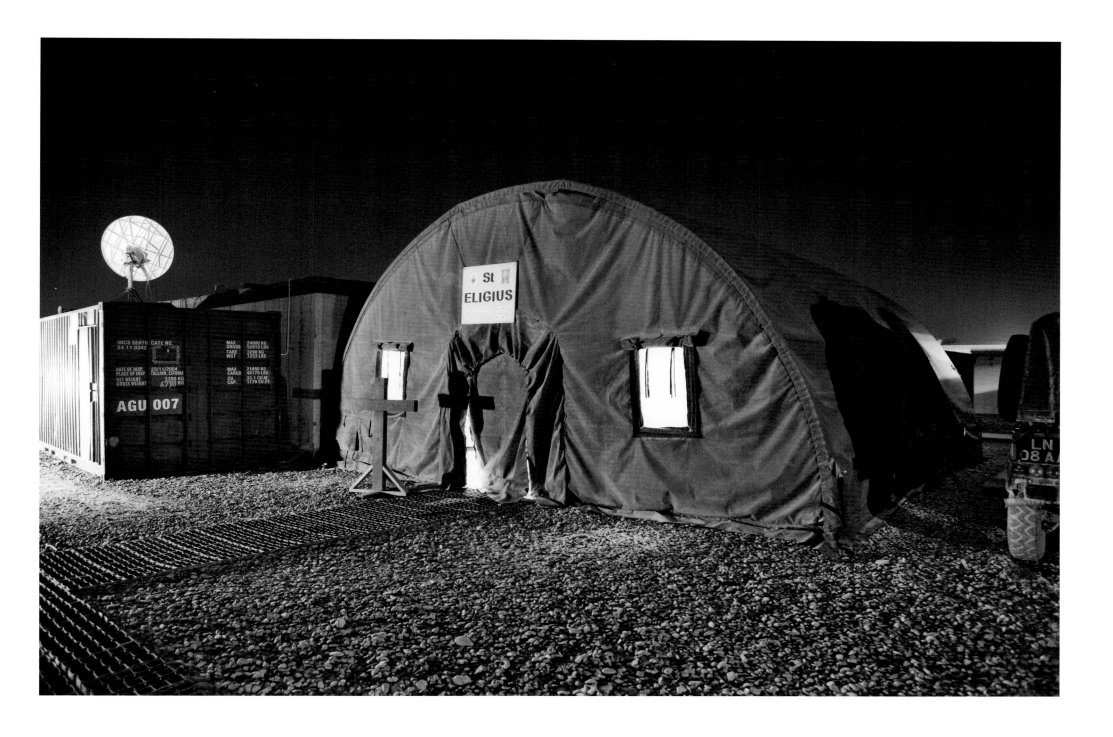

Lashkar Gah

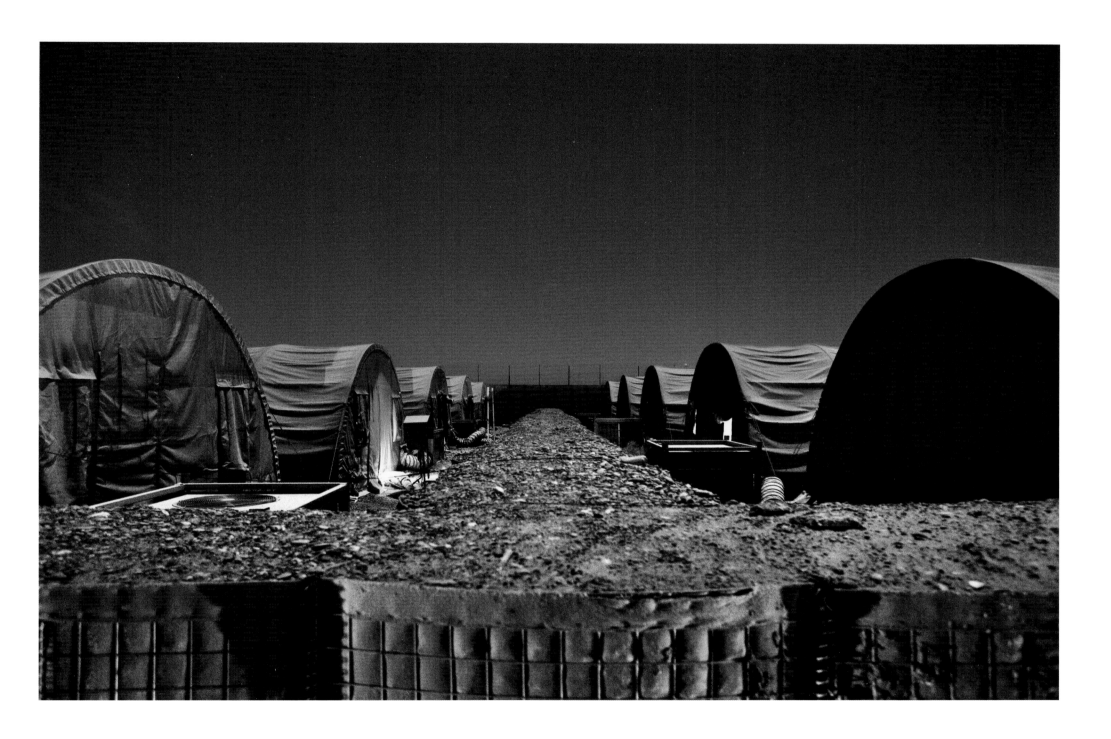

Lashkar Gah

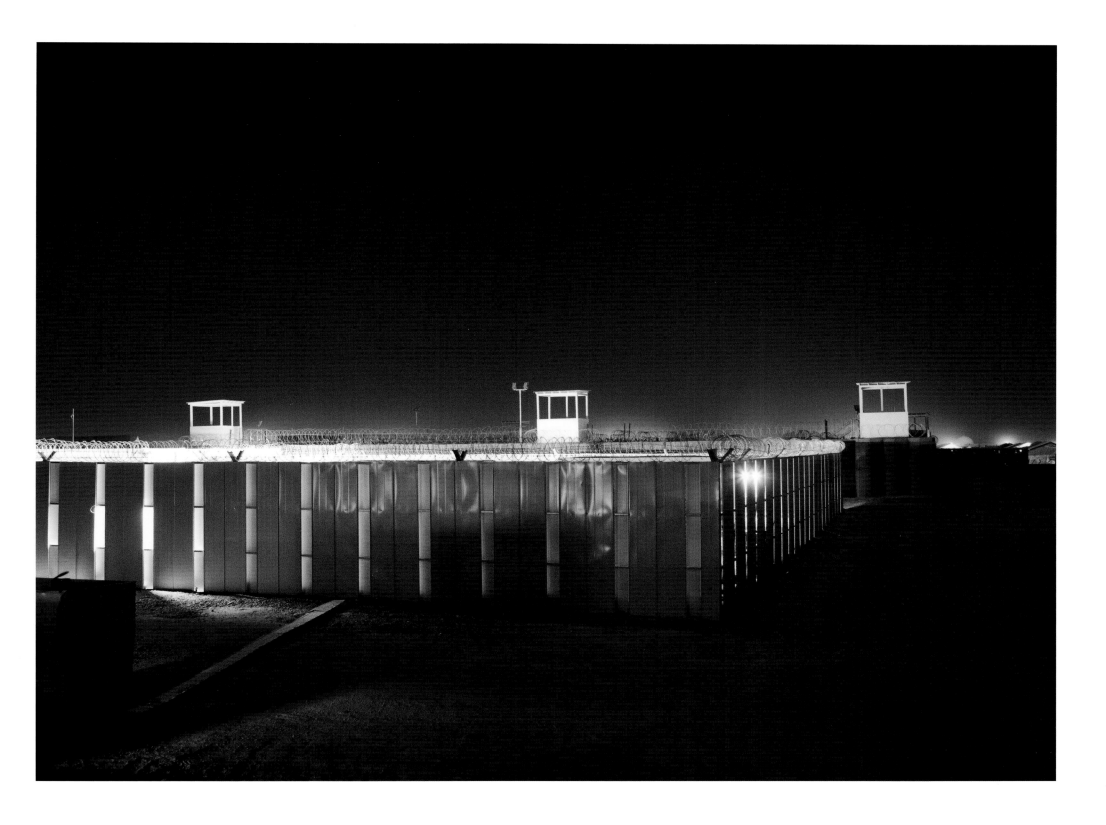

Camp Bastion

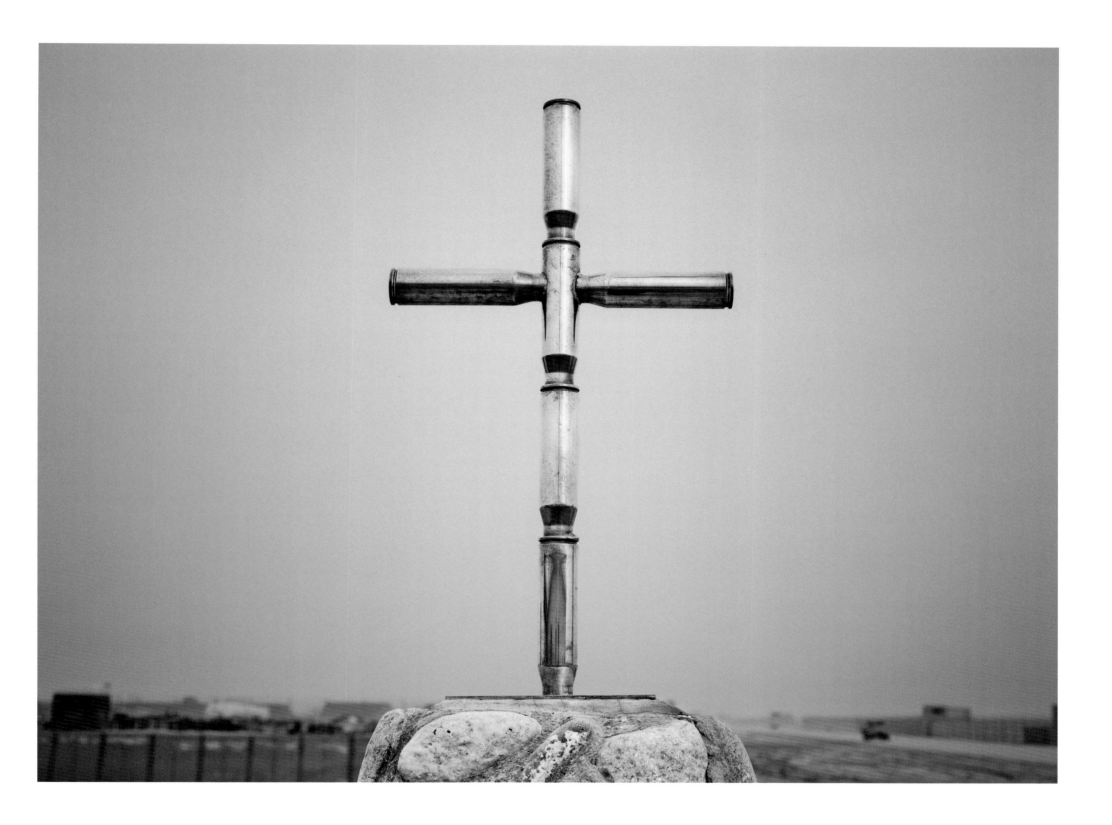

Camp Bastion

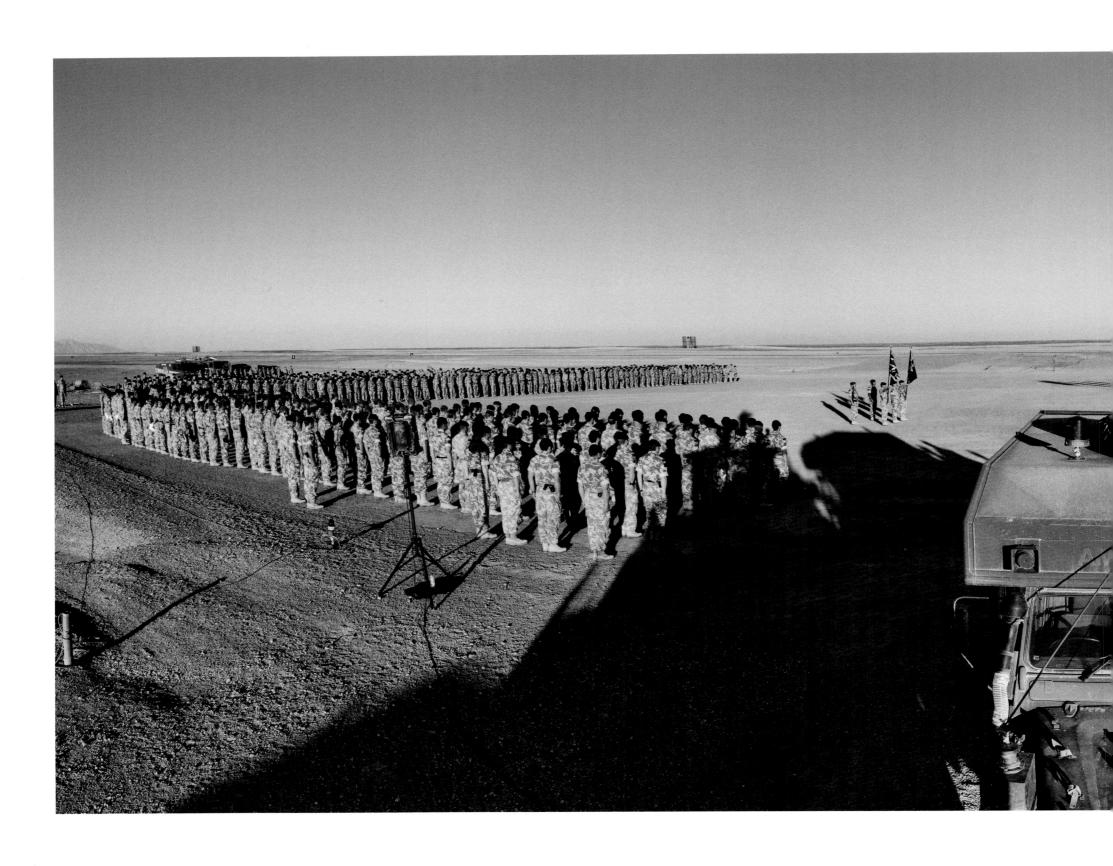

Repatriation Service for Corporal Damian Mulvihill, Camp Bastion

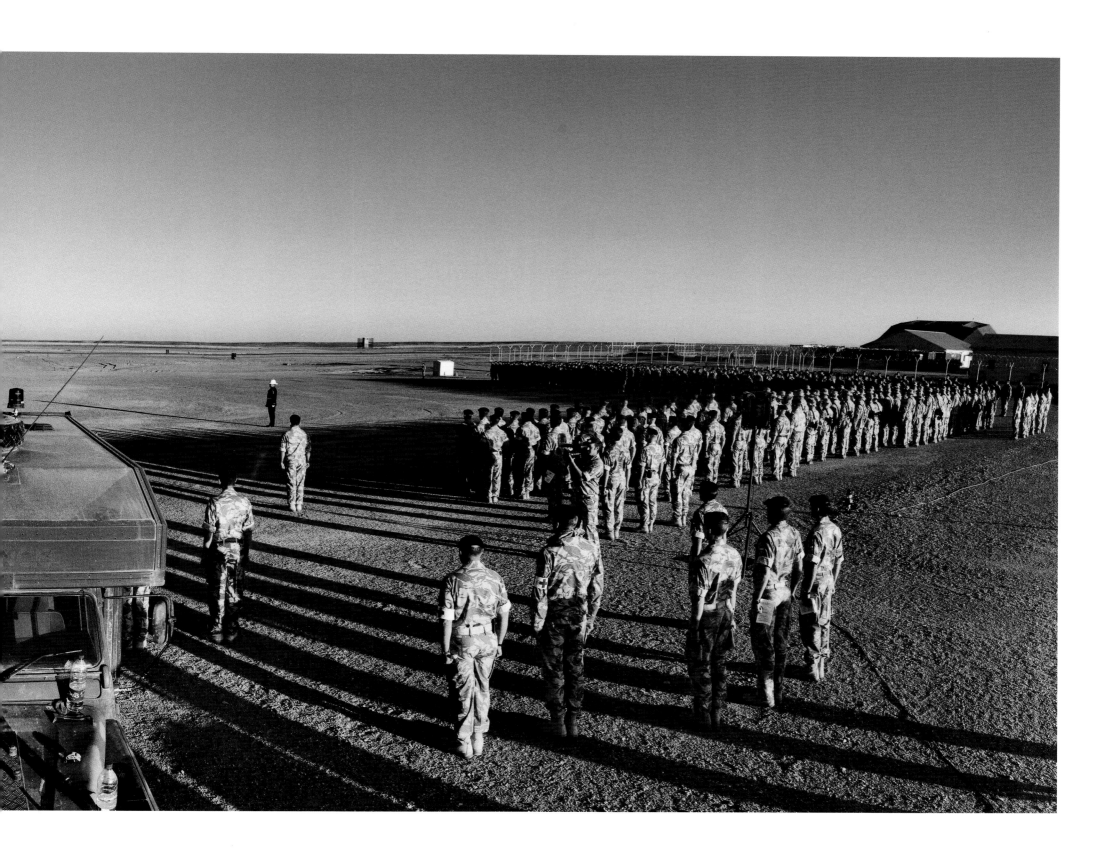

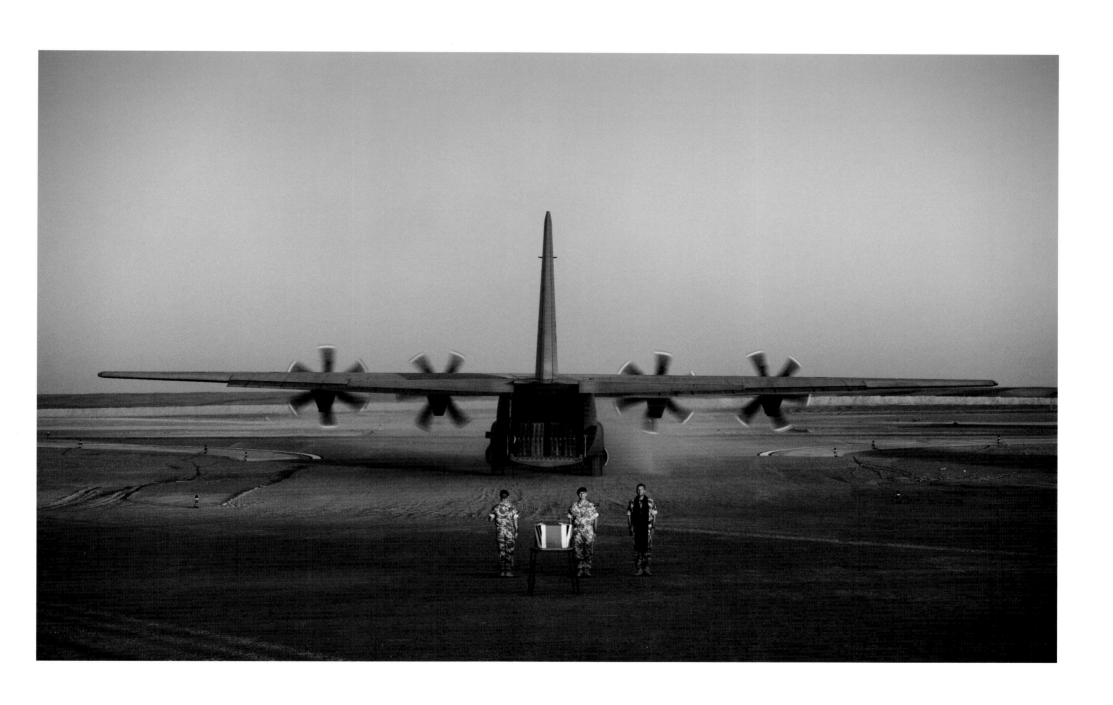

Repatriation Service for Corporal Damian Mulvihill, Camp Bastion

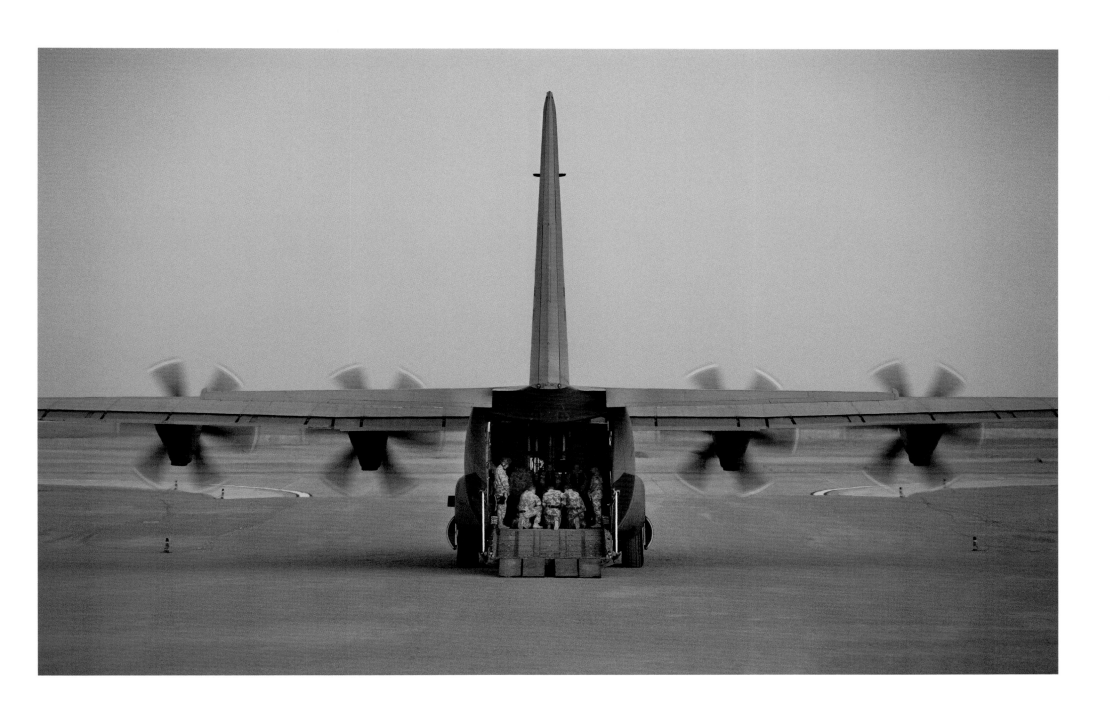

Repatriation Service for Corporal Damian Mulvihill, Camp Bastion

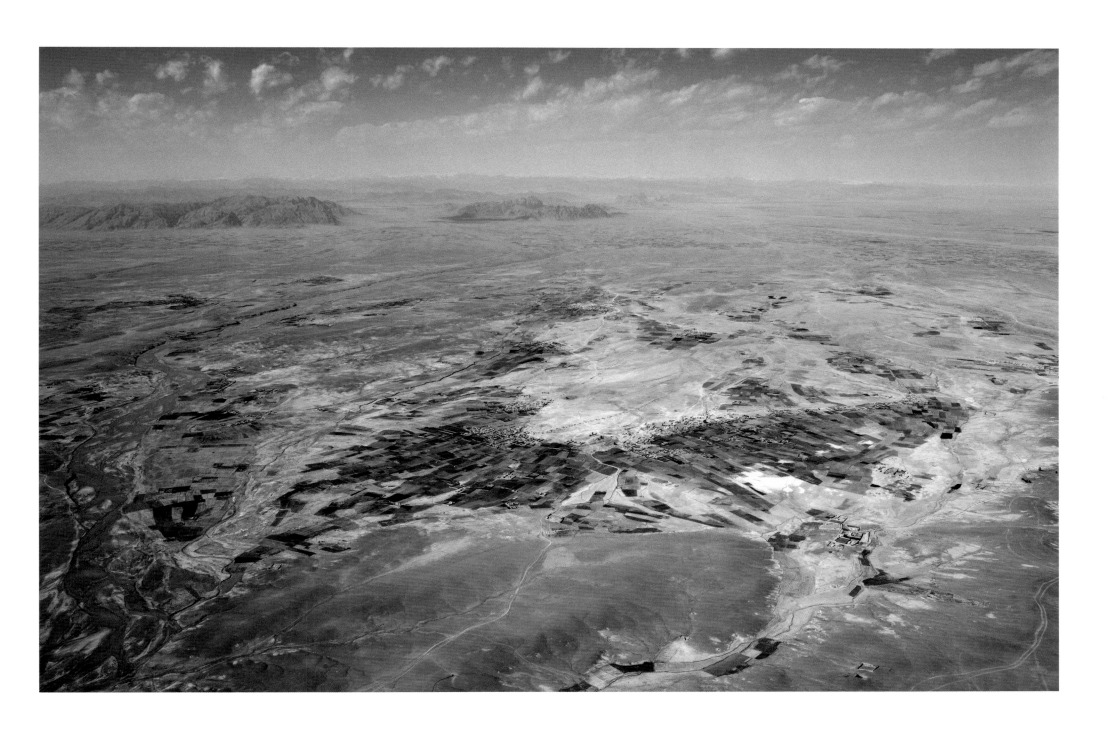

Helmand

ACKNOWLEDGEMENTS

To Andrew Mackay, Euan Goodman, Mark Holborn, Dave Wharf, Andrew Griffin, James Eyre, Ben Bathurst, Catherine Collins, Cathy Calvin, Bet Seuell, Jesse Holborn, Eric Joakim, Brian Tinsen and Phase One,

To all the men and women I photographed and to all those that helped me during my time in Helmand,
To the family of Corporal Damian Mulvihill,
To Sarah, Max and Tom for your encouragement, support and love,

Thank you, RW

The publishers would like to make it clear that a portion of the author's profits will be going to a charity of 52 Brigade's choosing.

Published in 2008 by Jonathan Cape

9 8 7 6 5 4 3 2 1

First published in Great Britain by Jonathan Cape, Random House,
20 Vauxhall Bridge Road, London SW1V 2SA

The Random House Group Limited Reg. No. 954009

A CIP catalogue record for this book is available from the British Library

ISBN 978-0224-08749-0

Edited by Mark Holborn
Design Holborn
Production Director: Neil Bradford
Printed in Italy by Amilcare Pizzi, S.p.A., Milan